abstract painting

abstract painting

concepts and techniques vicky perry

WATSON-GUPTILL PUBLICATIONS/NEW YORK

Dedicated to Madeline, whose eyes sparkled,
and Lenny, whose strength inspired.
And to the memory of Kermit Swiler Champa.

© 2005 by Vicky Perry

First published in 2005 by Watson-Guptill Publications
Nielsen Business Media, a division of The Nielsen Company
770 Broadway, New York, NY 10003
www.watsonguptill.com

EXECUTIVE EDITOR Candace Raney
EDITOR Julia Moore
DESIGN Areta Buk/Thumb Print
PRODUCTION MANAGER Hector Campbell

Library of Congress Control Number: 2005928205

ISBN: 0-8230-9542-8

Printed in China

First printing, 2005

3 4 5 6 7 8 9 / 13 12 11 10 09 08 07

contents

preface *by Barry Schwabsky* 7

1 what is abstract and what is real? 8

2 the tradition of abstract painting 16

3 the psychology and physiology of seeing 22

4 painting with oils 30

5 painting with acrylics 42

6 color 54

7 form 64

8 texture 72

9 composition 80

10 pictorial space 92

11 brush and easel paint construction 100

12 poured paint 112

13 staining with paint 122

14 painting in layers 130

15 approaches to the practice of painting 142

16 beyond technique 150

pigment properties 154
supplies 155
sources of quoted material 156
index 159

acknowledgments

Thanks to Jeff, for standing by me, and, for offering me a close look at their work, artists Pat Adams, Walter Darby Bannard, Lucy Baker, Jane Callister, Karin Davie, Paula DeLuccia, Kevin Finklea, Joanne Greenbaum, John Adams Griefen, Rainer Gross, Peter Halley, Gilbert Hsaio, Suzanne Joelson, Jonthan Lasker, Pat Lipsky, Joanne Mattera, Melissa Meyer, David Miller, Irene Neal, Laren Olitski, Larry Poons, David Reed, Gary Stephan, Barbara Takenaga, Rich Timperio, Francine Tint, and Josette Urso. Thanks to Evan Wilson for freely sharing years of experience and a deep appreciation of oil painting; Christopher McGlinchey, conservation scientist for The Museum of Modern Art, New York; the paint manufacturers Robert Doak, Richard Frumess of R&F Handmade Paints, Robert Gamblin of Gamblin Paints, Arthur Graham of M. Graham Paints, Mark Golden, Mike Townsend and Scott Bennett of Golden Artists Colors, and Carl Plansky of Williamsburg Paints for their perspective as paintmakers and artists; Bruce MacEvoy of Handprint.com; Judth Tolnick for giving an unknown kid a break; Candace Raney. Katherine Happ, and Hector Campbell at Watson-Guptill for all their assistance; Julia Moore, my editor, for imparting shine, sparkle, and clarity to the manuscript; Areta Buk for creating a masterly design and layout; Barry Schwabsky for writing an introduction that condenses the scope and intent of my endeavor with jewel-like crispness; Melanie Basner, Beatrice Berle, Kate Chila, Meg Cottam, and Janet Rodriguez; the critical joy of Anti-Flag; and the uncritical joy of Vera, Alison, and Truman.

preface

Barry Schwabsky

I once suggested that organizing a group exhibition of abstract painting was like convoking a church of atheists. On what basis could they join together, since what they agree on consists mostly of what they reject? Likewise, one might have thought, a book on the techniques of abstract painting would be like a guide to ritual for freethinkers. Isn't the whole point to do it differently?

After all, the modernist attitude to technique is supposed to be flexible and undogmatic. An artist—painter or otherwise—should find her own notion of art and in the process discover the technique by means of which it can be articulated. This is the meaning of the famous admission by Clement Greenberg that "the onlooker who says his child could paint a Newman may be right," to which he added the proviso that "Newman would have to be there to tell the child exactly what to do." The technique was not the cause of the work; on the contrary, the work—meaning, essentially, an activity of the mind and eye—made the technique.

Modernism has meant, among other things, that no technique handed down by school or master should constrain the freedom of the artist's development. Today, art schools do not inculcate rules or methods but rather attitudes toward the exploration of artistic questions. In theory, they also provide opportunities to learn specific techniques for those students whose development demands them. But this teaching usually takes place in an ad hoc, clearly supplementary manner—and this part of artistic training seems to become more and more rudimentary as time goes on.

This leaves the contemporary artist in a quandary. However insouciant her way of working may appear, it must always be meaningful. Because technique can never be a given, it always communicates something. The meaning of Newman's work changed as deeply when he switched from oil paint to acrylic as Philip Guston's did when he changed from abstraction to representation. Technique is the primary vehicle for the art's content, above all when the art is abstract, though not only then. The very thing that is most crucial for the artist is the least talked about. Perhaps it's because of the idea that technique should not be learned. One artist's technique is irrelevant to another artist, it might be thought, to the extent that the content of their work is distinct, and positively dangerous if the content is similar. A shared technique would tend to efface their artistic identities.

Non-practitioner critics like myself, of course, have our own reasons for wanting to peek through the studio keyhole. And history proves our curiosity to be well founded. Understanding how Mondrian did it, how Pollock did it, becomes even more important to understanding their work as time goes on. The same will be true, I'm sure, of today's painters. But those painters themselves need hardly be so anxious on the subject of technique. Who can artists learn from if not each other? A schoolchild would hardly be interested in having Barnett Newman tell him how to paint, but a colleague would be very curious indeed—just one time, of course—and might even want to try it. There is still much to be learned by imitating. Part of what one learns is how imitation is always interpretation, therefore inevitably different from what is being imitated. Artists are always concerned to differentiate themselves from their peers, and above all from those with whom they have the most in common. But in order to do so, they need to understand their colleagues' work—and that means understanding it down to the level of the tactile, to know what it feels like to make a painting that way. Here, then, is the reason abstract painters will want to read about how other abstractionists make their paintings: in order to do it differently.

1

what is abstract and what is real?

Art no longer cares to serve the state and religion, it no longer wishes to illustrate the history of manners, it wants to have nothing further to do with the object, as such, and it believes it can exist, in and for itself, without "things". . . feeling, after all, is always and everywhere the one and only source of every creation.

Kasamir Malevich, artist

The great power of abstract painting lies precisely in its ambiguity, its seeming to reference everything and nothing simultaneously. The hold that specific, everyday imagery once had on our senses has been loosened by decades of exposure to abstract art, which, as an art form, expresses a shift from outward-looking to self-reflecting. Sometimes we experience a sense that an abstract painting is meditating on its own creation—and thinking too, for these artworks are full of decisions. Driven by ideals, abstract painting is deeply invested in the philosophical dilemmas of its age. This is true even when painters try to free themselves from theory.

THREE DIMENSIONS OF A PAINTING

I discuss painting in terms of three optical dimensions: form, color, and texture. Form includes lines and planes. Color is obvious. Because paint has thickness and because our binocular vision discerns the construction of paint layers, texture is included

as an essential dimension. These three dimensions are present in every square inch of every painting. Although we can distill paintings' variables to the three dimensions of form, color, and texture, none of these categories functions independently in the painting itself. Form and color are indivisible; texture is not something "over there," but is essentially the terrain we enter when we interact with the painting.

IN THE STUDIO

This book is a practical source of techniques and ideas. It examines abstract painting from the perspective of being in the studio and of bringing our whole selves to bear on the act of painting. In the studio, we assume that art is a function of decisions; the field of battle is between entropy and created order.

For example, when I visited Jonathan Lasker's studio, the artist discussed the difficulty of working up an actual painting to a clean state of

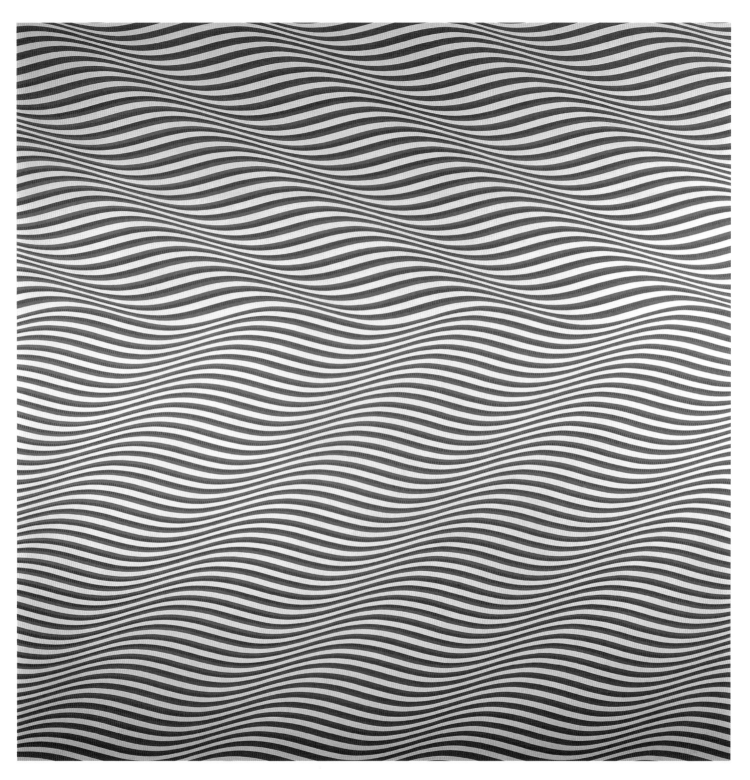

Bridget Riley, *Cataract 2*, 1967, oil on linen, 76³/₄ × 77¹/₈ inches (194.9 × 195.8 cm.). © the artist. Collection of the artist.

Riley: "Painting is, I think, inevitably an archaic activity and one that depends on spiritual values. One of the big crises in painting—at least a century or two, or maybe three, centuries old—was precipitated by the dropping away of the support of a known spiritual context in which a creative impulse such as painting could find a place. This cannot be replaced by private worlds and reveries. As a painter today you have to work without that essential platform. But if one does not deceive oneself and accepts this lack of certainty, other things may come into play." Riley adds, "Properly treated, formalism is not an empty thing but a potentially very powerful answer to this spiritual challenge."

Jonathan Lasker, *For One Who Shaped Countenance*, 1999, oil on linen, 60 × 80 inches (152.4 × 203.2 cm.).
Courtesy of Sperone Westwater, New York, and the artist.

Lasker: "I use abstraction to depict other things. I use abstract images as figures, as forms, as potential real world space such as a landscape or interior space. I use abstract forms to represent." The paintings proceed from a long chain of image-forming effectors, starting with the primal memory that wills Lasker's wrist to carry on such-and-such a scribble. What follows are refined doodles, then a small painting. Lasker makes yet another paint-study of exact proportions. The final, scaled-up painting is a distillation of many intuitively considered moments.

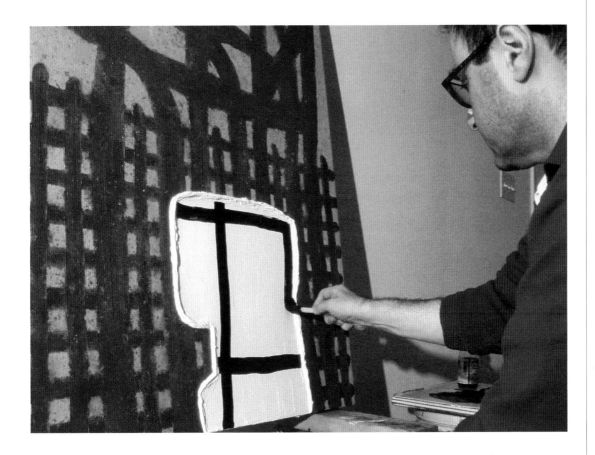

Lasker has developed a practice that includes both the conventional painters' tools—bristle brushes—and unconventional implements. The artist is shown here applying black oil paint thinned with linseed oil, using a sponge brush. The effect is a flat, neutral, almost industrial look that mimics a magic marker. He insists on having a broad set of techniques that respond to the specific touch of oil paint. Lasker's search for an expanded vocabulary engenders this observation: "I have painted unhappy marriages of the biomorphic and the decorative, the mark of the 'loaded brush' and the geometric, the psyche and popular culture."

finish, an undertaking largely invisible to the outside world and definitely an example of inspiration meeting damage control. That day, one unfinished painting contained a large form of titanium white, painted the day before. This white form exemplifies the constant threat of chaos in the studio. Lasker pointed to a small smudge on the outer edge of the white form, saying "I'll have to touch that up." An insect had landed in the wet paint and its beating wings had left a pattern of struggle. That smudge will be touched up with the same care that Lasker lavishes on his brushes and with the assiduousness that has led him to keep a respirator on hand for solvent-heavy procedures.

WHAT IS ABSTRACT AND WHAT IS REAL?

What is abstract in abstract painting? Does "abstract" mean "not real"? Most painters whose work falls within the accepted sense of abstract will say that their work is more real, more honest, more truthful than other painting styles (or, at least, equally real). Paradoxically, what has been called "realism" is, in fact, in many senses abstraction.

Abstract is an art-historical invention, and perhaps the term is a misnomer. Historically, the word refers to form only, not to color, and not to texture. But why single out just one of the three visual components—form—as the only indicator of a painting's relation to the everyday? The colors are real. The textures are real. As counter-examples, in black-and-white photographs and in Fauve paintings, we recognize everyday forms but with "unreal" colors. Are the art photographs or Fauve paintings "abstract"?

The term *non-objective* is sometimes offered as a superior term to *abstract*. But that presumes we can point to a truly "objective" painting style. A canvas—a flat surface—cannot be objective because it cannot capture all the force of human vision. Not wishing to rewrite art history here, I will continue to use the term *abstract* in its conventional sense, that is, concerning form only. However, there are more similarities between the abstract and other forms of painting than there are differences.

"The important thing for critics to remember is the 'subject matter' in abstract painting and the abstraction in representational work."

Fairfield Porter, artist

Ingrid Calame, *g-kgg-kooo-kggkooo-kggkoo*, 2003, enamel on aluminum, 48 × 48 inches (121.9 × 121.9 cm.).
Courtesy of James Cohan Gallery, New York, and the artist.

Calame's work is largely representational. The forms are traces from real-world spills taken from sidewalks and other out-of-studio encounters. Calame invests these forms with colors so that her constellation of spill-shapes punctuate the picture plane and create pictorial space.

ABSTRACTION AS PRACTICE, NOT DOCTRINE

Abstraction can be a temporary condition for a painter's practice. Painters move freely in and out of degrees of representation. Indeed, a good number of the painters I visited while writing this book indicated that some part of their work is fed by life studies or even serious efforts that must be called "realist." For example, a meticulous realist study may "soak up" creative nervous energy that, undischarged, would diminish the artist's ability to keep his or her abstractions "fresh," and thus avoid the danger of overworking the abstraction.

Some artists, critics, and historians have held that the only viable painting of our time is abstract.

> Everyone knows that the future belongs to surface and color, self-generating and self-sustaining abstractions bound together in an undeniable presence that makes itself felt as art. Everyone knows that illusionism gets in the way of an uncluttered, pure expression of surface and color.
>
> *Frank Stella, artist*

Such exclusivity may spring from the empirical evidence of viewing art. But this sentiment closes the gate on possibilities along which today's abstraction can proceed. Committing in doctrinaire fashion to abstraction as a superior art form misses the inherent beauty of abstraction coexisting with other ways of image-making.

OUR PATH

It's safe to assert that the techniques residing under the term *abstract* are more diverse than those for other classes of painting. This book covers some areas in depth, but others can be mentioned only in passing. As a whole, chapters move from general to specific and back to general, in the categories presented below.

ART HISTORY AND VISUAL PSYCHOLOGY AND PHYSIOLOGY Art history looks at the traditions of abstraction in art of the comparatively recent past. Visual psychology and physiology study the event of seeing, from retinal stimulation, through autonomic events, to subconscious and conscious associating. The second two chapters are devoted to these topics.

OIL AND ACRYLIC PAINT SYSTEMS Although paint systems such as encaustic and mixed media are effectively used in painting, oil and acrylic paints are still the dominant expressive mediums in use today. For this reason, chapters 4 and 5 concentrate on the materials and tools associated with them. The discussion is thorough at a basic level, but specialized texts should be consulted for comprehensive information on oil and acrylic paints and other mediums.

DEVICES *Devices* refers to those design tools used in all visual art, from the primary formalist tools (color, form, and texture) to the integrating devices of composition and pictorial space. Chapters 6 through 10 discuss concerns specific for the painter of abstract forms.

TECHNIQUES Traditional painting techniques deal with methods that employ brushes, canvases or panels, and easels, focusing on hand work and paint construction. These are covered in chapter 11. Process painting techniques are also covered—those operations that involve pouring, staining, scraping, layering, and other non-brush applications of paint—in chapters 12 through 14.

APPROACHES As artists, we may approach our work instinctively or deliberately, from a sense of research or of exorcism, ambitiously or laconically. Abstract painting proceeds within the context of ideas, beliefs, and emotions. The two final chapters touch on how painting grows from the individual painter's psychological makeup.

WHY TECHNIQUE

Technique is always on display. Obvious aspects of an abstract painting's creation—brushwork, for example—transmit a visceral scenario of the hand in action. Viewers will often re-create the action of creation in their minds, our empathy for the work and its creation being instinctive and subliminal.

> [A]s I contemplate the blue of the sky I am not set over against it . . . I do not possess it . . . I abandon myself to it and plunge into this mystery, it "thinks itself in me."
>
> *Maurice Merleau-Ponty, phenomenologist*

Knowledge of materials is crucial to painting. Now more than ever, however, craft can be eroded by these materials-based conditions:

- Easy availability of store-bought materials, such as tube paints, distances us from an intimate knowledge of our material.
- As often as not, the creative urge is at odds with purely technical concerns. During creation, the eye wants to be pleased; we may know a paint structure is unsound but ignore this knowledge out of impatience.
- Painting's conceptual side has been emphasized at the expense of teaching about materials handling. If studio skills, especially materials handling, continue to be de-emphasized, fine art conservators will consider contemporary painting to be their "job security." Negotiating between inspiration and material limits requires the talents of both craftsperson and visionary.

Consider this example:

> [Mark] Rothko's relationship with his materials is ambivalent. The Harvard murals are perhaps one of the starkest reminders of what can happen when untested modern materials find their way to painters with a reckless disregard for technical matters. . . . Within five years [the murals] were deteriorating fast; by 1979 they were ruined and were removed from view. . . . The predominant colors were dark pink and crimson. But you would never know that now: they have turned light blue.
>
> *Philip Ball, art historian*

CONTENT'S RELATION TO "NATURE"

Does abstract art relate to nature—our surroundings—or is it totally self-contained? Some artists have attempted to make abstract art that was pure—cleansed of reference to commonplace experience, to nature. Individuals of idealist temperaments held that depiction of nature was in some sense false, that it was a substitute for nature. Subject matter or references to anything beyond the edges of the canvas or panel were believed to compromise the integrity of the painting.

But is it possible to make a painting that does not, in any way, relate to or associate with everyday experience? When viewing art we decipher and measure what the work means to us. Meaning is something our minds build by connecting one experience with another. Is it ever possible for a non-representational work to have "meaning" if it refers to nothing?

Consider that associations develop between the ocean of everyday sensory detail and elements in an artwork, though the sensory background is so deep as to be subconscious. From these associations, we internalize concepts of "line" or "direction" or "temperature." An abstract painting will have forms that we associate tightly or loosely with our everyday existence. An example is the way a drizzled, glossy line of color resonates like honey or oil. Or how the staccato rhythm of linear, parallel forms evokes drumming. When we say a black line in a Mondrian painting "cuts across" the work, our terminology reveals how we are associating.

But there is more to the story than one-way references. A deeply moving artwork transcends the simple triggering of associations. Its visual strength will overpower the references, and we will carry the memory of that painting. From then on, our everyday experience will be checked against the power of that artwork. Such cycling between art experiences and other experiences develops a rich network of visual memories.

> Everything I paint comes from something in the real world: a place, a thing, a person, an idea, any kind of potential source. If a source for a painting seems especially compelling or rich in possibility, I try to make other images that go to that point. To make this clearer: as a discipline to the primacy of meaning, I try to find other visual threads that run to and from my subjects. . . . Everything in the world connects to everything else. From simple physicality to the most mandarin intellectual constructs, everything is linked. By thinking and looking hard enough, I believe it's possible to build extraordinarily visual connections.
>
> *Thomas Nozkowski, artist*

THE AESTHETIC DIALOGUE

One's encounter with a painting can bear similarities to an interpersonal encounter. On first viewing, we sense discovery—as when meeting a stranger. Subsequent viewing of it brings familiarity and, perhaps, fondness.

> When you look at a great painting, it's like a conversation. It has questions for you. It raises questions in you.
>
> *Kenneth Noland, artist*

Pat Lipsky, *True Lad*, 2002, oil on canvas, 60 × 72 inches (152.4 × 182.9 cm.). Courtesy of Elizabeth Harris Gallery, New York, and the artist.

Lipsky has chosen a restricted field within which to pursue a single-minded practice. This rigorous discipline gives the paintings a fierce glow akin to a self-critical, unblinking gaze. Lipsky says: "In order to move forward you always have to give something up. I had experienced this more than once and then read it in Henry James. For example, I had to give up the 'painterly look' to get more cohesion and unity in my new work. It was sad not doing all those painterly licks, but what I needed the work to be, what I wanted it to say precluded that look. So you always give something up when you move forward. And it's sad." Writes Donald Lindeman: "In 'True Lad' . . . the space of the painting opens up, reminding us (not without a touch of sly humor) of [Lipsky's] versatile knowledge of the ways of picture making, and her ability to throw us off balance just when we might have figured we were on solid ground."

The aesthetic dialogue is intersubjective: Both painting and viewer must come together to create meaning. An interaction takes place between expressive potentials in the painting and latent memories within the viewer. An empty canvas is, for the painter, alive with future potential. Kandinsky felt this.

[T]he [picture plane] . . . is also a living thing. This can be partly explained as association or as transference of [the artist]. . . . [T]his fact has deeper roots and the [picture plane] is a living being. For a person who is not an artist, this assertion may appear strange. We must, nevertheless, definitely assume that every artist feels—even though unconsciously—the "breathing" of the still untouched [picture plane].

Wassily Kandinsky,
pioneer abstractionist

Because abstract paintings are pictorially ambiguous in a way that realist paintings are not, abstractions' formal elements associate only loosely with our experience. As with any dialogue, there will be differences in volume, complexity, and even direction. As painters, we have some intuition about the kinds of dialogue that a painting will engender. But the painting is like language, and "All grammars leak," as anthropologist and linguistics scholar Edward Sapir contends. So each viewer will interpret the work uniquely.

Finally, no book can bring about the creation of art. As artists, we may follow recipes or whispers, but art happens in a way that swallows up intentions. Technique is what painters use until art arrives.

One must really be engaged in order to be a painter. Once obsessed by it, one eventually gets to the point where one thinks that humanity could be changed by painting.

Gerhard Richter, artist

2

the tradition of abstract painting

When [Mondrian] paused before a small batch of [Jackson] Pollock [paintings], [Peggy] Guggenheim rushed over and said, "Pretty awful, isn't it? That's not a painting, is it?". . . . Later [Mondrian] was still in place, still absorbed. Guggenheim returned . . . Mondrian turned to her, unflustered, and said: "I have a feeling that this may be the most exciting painting I have seen in a long time, here or in Europe."

Carter Ratcliff, art critic and historian

We admire art that solves visual problems—problems of how far art can be pushed—and we recognize that a driving force behind the making of art is to discover the never-before-seen. But we cannot appreciate true innovation unless we have a context for it. That context is tradition. If, as abstract painters, we are to push the envelope, we must have a firm grasp of painting tradition.

WESTERN EUROPEAN ART

In this section, I briefly introduce the tradition of abstraction in Western art. Abstract forms are, of course, central to much pre-modern art. Moreover, abstract artists share the "language" of geometric and biomorphic forms used by religions, crafts, and sciences.

There was a time when abstract painting was regarded as a radical art that was breaking with tradition. Such is no longer the case. An abstract artwork today must find its place within the context of nearly a century of non-objective art. For instance, certain abstract forms, such as Mondrian's grids or Pollock's splatter, will tend to be viewed as visual quotes when used in a painting today.

The traditions of abstraction—from Cubism, Neoplasticism, Abstract Expressionism, Color Field painting, Minimalism, and Postmodernism—guide the ways the techniques described in this book are treated and viewed. One approach to the history of an artistic tradition is to track creative "incidents," or events marking when an artist creates something really new. Such an incident-based history has abstract painting starting in the 1910s with the first non-objective works by Wassily Kandinsky and Arthur Dove.

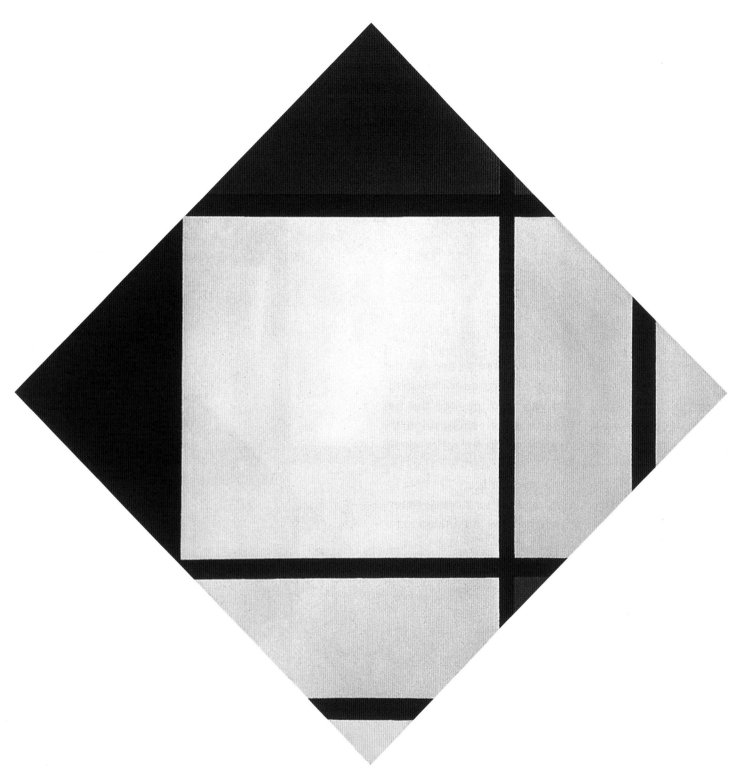

Piet Mondrian, *Lozenge Composition with Red, Black, Blue and Yellow*, 1924–25, oil on canvas, diagonal, 56.25 × 56 inches (142.9 × 142.2 cm.). © 2005 Mondrian/Holtzman Trust, c/o hcr@hcrinternational.com.

This painting suffered damage—a tear in the canvas—while being shipped. Mondrian was despondent: "You will understand I was very miserable about it, my best canvas gone to the dogs." However, he didn't give up on the composition: "I had last year's damaged canvas relined and painted it again, so that it is still better."

Over time, painting often took different directions, which are usually referred to as "styles." The development of various styles may be categorized as issuing from either "platonic" or "empirical" impulses. Platonic innovations seek to create a pure visual expression that distills art to its very essence. This "distilling" methodology is in sharp contrast to the empirical fascination with the multitudinous data of the observed world. The fundamental empiricism of Renaissance verisimilitude and humanist subject matter represents a rejection of the idea-driven, or platonic, basis of medieval art. While using the crude lens of the "platonic" and "empirical" is helpful in organizing our understanding of the development of the abstract painting tradition, we should not lose sight of how these two impulses often mix in the same work. Abstraction—especially as practiced by the Neoplasticists around Mondrian—was the classicists' answer to the invention of photography, whereas Surrealism and Dada were empirical responses to photography.

Toward Abstract Art

Looking now at the events and forces that seem to have led inevitably to the creation of an abstract art can help us to better understand creative incidents. These motivating forces can include:

- artists' economic independence
- the invention of photography
- the search for purity or the essential in painting
- the arrival at final, reductive forms.

While overarching ideas and technical innovation propel a cumulative direction in painting's evolution, meandering experiments surround this larger direction—like streams and rivers eroding a canyon.

ARTISTS' ECONOMIC INDEPENDENCE In the Renaissance, artists' reliance on church patronage began to decline. With the rise of secular courts and a merchant class, painters were presented with increasing opportunities to become self-employed and self-directed. Over time, painters' economic independence was also supported by science. Improvements in materials, such as new colors and ready-made tube paints, led to artistic competition and innovations in both style and subject matter.

Painting developed within the context of ideas about where innovation would take place and thus the search for "newness" became a competitive market motivation for painters. (Painters have continually asked themselves what "problems" needed to be solved in order to promote a sense of originality.) Freedom from the stylistic dictates of the church, then the guild, and finally the Academy gave the artist conceptual freedom to define both content and form.

> Such a move [to redefine art] famously occurred in Paris in the later nineteenth century: the shift away from the Academy proper The hero of the legend is Édouard Manet . . . who was hounded out of the Salon for his daring honesty, only to join forces with a rebel band of Impressionists and end by overturning the tables on the reactionary academicians.
>
> *Julian Bell, writer and poet*

As it became increasingly accepted that painters were free to choose their own subject matter, they were freer to explore their internalized ideals and search for the "truth" or "the real." This paved the way for the ideal of "art for art's sake" at the end of the nineteenth century.

THE INVENTION OF PHOTOGRAPHY Photography's invention created a particular crisis in painting. Verisimilitude would henceforth be overwhelmingly provided by photographic means. Painters were forced to discover a new subject matter that was distinguishable from all that was available to photography.

Abstraction's solution to the crisis in painting that had been precipitated by photography was to allow photography to "own" representations of the material world. Painting, then, could emphasize the physical properties and mechanics of its creation. Painters would create new content that required the vehicle of the painted surface.

THE SEARCH FOR PURITY OR THE ESSENTIAL IN PAINTING Within Neoplasticism, the word "real" connoted a transcendental, timeless reality—not everyday or commonplace experience. To some painters, the "real" came to mean the elimination of details, personal narratives, and illusions of space. We can sense the quest for spiritual wholeness and the influence of twentieth-century Theosophists in the abstract work of Mondrian and Kandinsky. (Malevich's work grew in response to Suprematist ideas.) Spiritual fervor can generate great amounts of focused energy, but idea-driven art runs the risk of transforming itself into a vehicle for covert symbolism.

> A desire to determine all relationships definitely lies at the root of Mondrian's art.
>
> *Kermit Swiler Champa, art historian*

Experience-driven compositions make up yet another form of abstraction. Such works manifest the individual artist's empirical experience of their material and emotional worlds. To this end, some Abstract Expressionists, such as Jackson Pollock, have used the automatist techniques favored by the Surrealists and introduced in abstract form by Joan Miró.

Modernism

In Europe, the notion of "art for art's sake" had been in the air at least since the 1880s. As abstract painting developed—first in Europe, then in New York—this notion remained the primary supporting theme for abstract art. In the exchange that opened this chapter, we can almost see the torch being passed from Europe to America in the encounter between Mondrian, who at the time was newly arrived in New York, and collector Peggy Guggenheim.

Clement Greenberg, the influential art critic, promoted the term *Modernism* for new art that, in his view, reinforced the ideal of art for art's sake. He asserted that painting should concentrate on its essential flatness. An associated notion, Formalism, emphasized the formal aspects of painting and de-emphasized the role played by extrinsic content, or subject matter. Formalism holds that visual forms incite aesthetic responses or feelings. The eye is supreme, and "taste" develops through direct experience with artworks.

The notion of essence, the idea that a select few elements are intrinsic to painting, led Greenberg and his adherents to stress flatness in painting. But this emphasis is problematic, as texture and literal objecthood were being investigated by painters.

Minimalism

Minimalism proceeds logically from Modernism's stress on intrinsic or essential elements. Even though several modernist critics disavowed Minimalism as the logical progression of Modernism, Minimalism carried the idealism set in motion by the early abstract painters who set out to create a "purified" painting.

Minimalist or reductive painting has theatricality. When the viewer encounters such a work of art, he or she meets up with it at "center stage" and intimately engages with it in a room (a "theater") with no distractions. The *present-ness* of a reductive painting makes it immediate. This immediacy echoes the effect that early Renaissance naturalism must have had when it made a religious image powerfully "present" to viewers who had no previous exposure to realistic painting.

Almost by definition, this reductive style was not a highly fertile arena for painters. It came to signal, for some, a dead end.

Postmodernism

How did artists get past the "final" forms of Minimalism? Individual artists began to make a break from the seemingly unstoppable momentum of painting's history, which was to find essential form. A paradigm shift, known now as Postmodernism, signaled the break. It is not surprising that a reaction to the modernist movement would set in during the 1960s; by that time, once-subversive, avant-garde modernism had become a rigid formalist doctrine. The positive effect of Postmodernism was the de-emphasis of the sanctioned essentials of painting, its flatness and optical space. We can feel a restorative balance as

Friedel Dzubas, *Bird of Paradise*, 1958, oil on canvas, 95 × 48 inches (241.3 × 121.9 cm.). Courtesy of Jacobson Howard Gallery, New York and London, and the estate of the artist.

Art critic and historian Piri Halasz: "There's . . . a very tough, gritty quality in the way those little pats of paint are ever so gently savaged onto the canvas, and the overall forms nailed in. It's this union of tough and sweet that is so unsettling and exciting."

John Adams Griefen, [untitled], 2004, acrylic on canvas, 71.5 × 53.5 inches (181.6 × 135.9 cm.). Courtesy of the artist, Salander-O'Reilly Galleries, New York.

No title or any other distraction interferes with experiencing the color of the work—color applied with a freshness akin to the speed of light. The artist himself states: "I just did the black painting. Slipped and nearly fell into it. Painting is supposed to be a cerebral activity. What a mess but I did it. As of now it looks like Caravaggio's sweet violence."

Historical abstraction initially reflected ideas about an idealist ethos and transcendent realities. In contrast, Halley's work is more deadpan in nature. Halley remarks, "I still feel a bit self-conscious about [my use of abstraction], because it also meant an attack on what was a truism in the New York art world: that abstract painting was uplifting, or that art could be spiritual. It was a broad attack on dearly held values, but I thought it was needed." This "flight from transcendence" is somewhat in line with Stella's remark, "What you see is what you see." Unlike Stella's, Halley's work has references. The geometry is comprised of simple symbolic forms that point to non-utopian, base-level realities—almost sociological diagrams. As a re-examination of Minimalism, and with their infusion of Pop colors and allusion to media-drenched culture, these paintings bridge a large conceptual gap between the sublime and the ordinary.

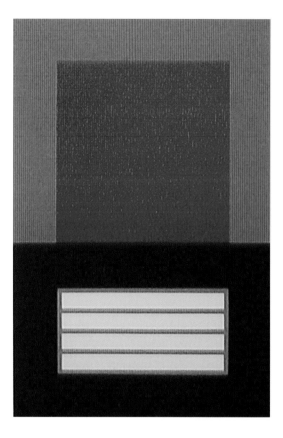

Pop Art and other anti-modernist forms flaunted their humor in the face of the apparent pomposity of late modernism. Gone was a "willing acceptance" by painters to make "pure" paintings.

> [My painting] was a polemic against this annoying modernist development that I hated. And, of course, the assertion of my freedom: "Why shouldn't I paint like this and who could tell me not to?"
>
> *Gerhard Richter, artist*

Postmodernism is more than a reaction against modernism. Postmodernism sanctions a democracy of form and a pluralism of technique. It works as an umbrella within which both traditional abstraction and anti-modernist traditions—notably Dada, Surrealism, and Pop—can co-exist. The liberating force of Postmodernism is the realization that painting styles can be used as design elements (in the way composition, scale, and pictorial space are considered formal elements) that are to be used, combined, selected, and juxtaposed. Previously, we could say that a "dictatorship of form" held sway when painting styles were defined by their formal

qualities (Mannerism, Impressionism, Cubism, and the like). Today an appraisal such as the one that follows is fully credible.

> [A]bstraction is a possibility rather than a necessity, and is permitted rather than obliged. In fact, the art world as I see it—and as I now think it sees itself—is a field of possibilities in which nothing is necessary and nothing is obliged. Heinrich Wölfflin famously [said] that not everything is possible at every time. It is a mark of what I have termed the posthistorical period of art that everything is possible at this time, or that anything is.
>
> *Arthur Danto, art historian*

Far from experiencing the end of art, we've experienced the end of style-defined-by-form. Postmodernism is a style of styles. And it is in its infancy.

ABSTRACTION WITHIN POSTMODERNISM What is "Postmodern abstraction," and how is it different from "Modernist abstraction"? The return of representational painting has not demolished abstraction. Rather, Postmodern abstraction highlights ways that abstract painting references the world. Ambiguity has always been a powerful part of the abstract experience. In a sense, a new type of ambiguity is now available with which the painter can compose. This new ambiguity can be paraphrased as, "How is this painting referencing? What type of code does it use?"

We are at a point in the tradition of abstract painting where many mechanics of referencing are possible. Consider a spectrum of referencing modes. This spectrum ranges from purely non-objective abstraction, loose associations in Abstract Expressionism, symbolism, signage-like elements such as letters or icons or diagrams, realistic rendering, and appropriation. A painting may:

- use signs, icons, and colors loaded with associations;
- involve some performance-like techniques in its creation—a practice or methodology;
- use a conceptual framework that distances the painter from excessive retinal control of the final painting (rather than introducing randomness through physical distance between hand and canvas);
- manifest an interest in "low" culture and exhibit a democratic taste of the pure and impure;

- use appropriation;
- create an innovative dialogue with the history of painting.

> At their best, paintings are dramatic events.
>
> *Jonathan Lasker, painter*

Postmodernism has reinvigorated the possibility of a narrative element in abstract painting. This development opens the door for art that may reference the commonplace visual experience to any degree of specificity. Art may also reference various mixed points of specificity—a type of abstract/realist Cubism. The Postmodern tolerance of many conjunctions is extremely fertile.

Beyond Postmodernism
Since numerous styles and mixings are possible, there is the potential for more complex structure—and more confusion about what constitutes a painting of "quality." With this open-endedness, how can we evaluate quality in painting? The answer lies in looking at higher-level structures, inventing new relationships that seem, at first, to be mistakes and, perhaps most importantly, finding synthesis where we thought we saw only the irreconcilable. Perhaps today we must speak not of finding essence, but of creating essence.

> [T]he problem of abstraction . . . is thus not "dead"; it needs only to be reformulated . . . we need to think in terms of "potentials" and "inventions," not absence and loss, in terms of life and not the retrieval of lost memories. . . . Let us then . . . find new ways to keep alive the kinds of encounters and connections from which new ideas come.
>
> *John Rajchman, scholar and critic*

Brice Marden, *Chinese Dancing*, 1993–96, oil on canvas, 61 × 108 inches (154.9 × 274.3 cm.). Courtesy of Matthew Marks Gallery, New York, and the artist.

The pictorial space of the painting flows from an intuitive drawing that establishes complete balance of visual weight on both vertical and horizontal axes. Marden's painting speaks a universal language of visual journey as lines cover ground in a meandering tour. Marden's work exemplifies the act of painting that survives the end of art history.

3

the psychology and physiology of seeing

The retinal image is the one optical image never intended to be looked at; for the brain's purpose is to reconstruct the external world, not to show us the distorted and degraded image on the retina.

John Mollon, authority on color perception

Human sight is a complex partnership of the "exterior" world, our eyes, our mind's visual processing centers, and our individual pool of previous viewing experience. We all appreciate the mind's willful behavior in "filling in the blanks" (think of a Rorschach test) and the mind's insistence in associating forms and colors with memories. The retina itself performs considerable conditioning of light even before its signals leave for the brain. As such, it can be said that visual sensations must first be "parsed" and "organized" before they become perceptions in the brain.

The fact that non-representational works of art do not offer the distractions of a specific narrative gives them an extreme "opticality." This same fact makes some knowledge of visual psychology and physiology particularly relevant. Painters, either consciously or unconsciously, communicate through a nearly universal system of visual perception that is the result of human evolution. As painters we should not assume that we are slaves to the realities of physiology, however, for cultural influences can be and continually are summoned to override the retinal mechanisms.

[Abstraction] made strenuous demands [on the viewer], because it is hard to see marks standing free from the surface on which they lie . . . this rigor could be seen as revolutionary, one requiring a major historical shift from an art of representation to one of presence.

Julian Bell, painter and writer

VISUAL PSYCHOLOGY AND PHYSIOLOGY

It is helpful for all painters—but especially for abstract painters—to use the body's visual mechanisms deliberately and consciously to organize visual data. We have several powerful formal means to do this: visual grouping, manipulating perception of space, allowing for object recognition, and utilizing the physiological capacity for perception of light and color.

Vision requires two eyes and two thirds of our brain to function as effectively as it does.

Bruce MacEvoy, authority on watercolor

Gilbert Hsiao, *PP26062*, 2003, acrylic on plastic mounted on wood panel, 11 × 11 inches (27.9 × 27.9 cm.). Courtesy of the artist.

Hsiao: "I'm a visual artist interested in exploring the mechanism of perception. I try to manufacture situations, which will make the spectator become aware of the psychology of visual perception. I think virtually all artists from the Gothic period to the Abstract Expressionists were interested in this. Tintoretto and Cézanne are two artists I particularly admire. . . . I'm coming to discover that my work relates to the rhythms and syncopations of modern music, to visual ideas found in African textiles, to Roman, Medieval, and Renaissance floor motifs, and to various rhythms found in nature and the cosmos."

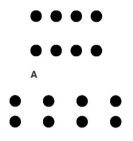

A

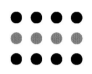

B PROXIMITY

C SIMILARITY

D CLOSURE

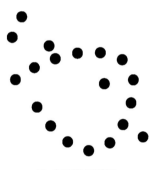

E CONTINUITY

Visual Grouping

According to Gestalt theory, a viewer's mind groups visual forms to achieve simplicity or stability. This is like saying that the mind makes an "abstraction" of visual data and creates something intelligible out of it. The principles of visual grouping listed below are intrinsic to artistic composition, including visual direction and visual weight.

- **PROXIMITY** When objects are close together, they tend to be perceived as a group. The principle of proximity suggests a reading of two rows of four dots in example A and four columns of two dots in example B.
- **SIMILARITY** When one sees sets of objects, these sets are perceived as groups rather than individual objects. In example C, while all the dots are equidistant, we see rows, not columns.
- **CLOSURE** The eye/mind tends to complete incomplete figures, to "fill in the blanks." Thus, in example D we see an incomplete circle rather than a curved line.
- **CONTINUITY** Objects on a line or curve are grouped. This principle is the basis of camouflage. In example E, most dots are positioned along a curve. The numerous members along the curve create a "community" of dots that hold onto the member that exists in close proximity to a "stray" dot.
- **"SENSE"** Once we "see" something recognizable or "make sense of" an image, it is very difficult to see it as we saw it before. For example, once we read the title for Bill Scott's painting (opposite), it is hard to discern those marks as anything except flowers.

Visual direction or assumed movement follows from the grouping operations. Another organizing principle in the way we see things is our natural tendency to detect symmetry—especially vertical, bilateral symmetry. We not only detect symmetry, but we prefer to find symmetrical rather than asymmetrical forms. (Obviously, one could generate designs where one grouping dynamic is contradicted by another.)

The visual systems of grouping and symmetry are not as complicated as they may seem on paper. For the most part, painters have an innate knowledge of how these systems impact the assumed viewer.

Space Perception

Science has shown that depth perception is one of the elemental ways humans make order out of visual stimuli. The binocular aspect of human vision gives us an enhanced ability to perceive distance. With normal vision, we fix our gaze on a reference point in a scene when making judgments about its depth. Obviously, naturalistic paintings must fool the eye/mind into "seeing" depth on a flat, two-dimensional surface. (Note that the system of linear perspective developed in the early Renaissance, which usually employs a single vanishing point, is itself an abstraction from binocular reality.) In fact, truly objective realism is not possible in painting. As a result, the terms *non-objective* and *abstract* are not strictly applicable when used as labels for non-naturalistic painting.

> What we call realism is always an aberration of what is objectively seen.
> *William V. Dunning, artist and scholar*

Over several millennia, artists have devised ways of suggesting space, including, in approximately this order of development:

- **RELATIVE SIZE** In a painting, when one object is larger than another, the larger one appears closer. (Also, the overall scale of the painting conditions how individual forms are "read.")
- **OVERLAPPING FORMS** Space is suggested by overlapping one form on top of another.
- **HEIGHT IN THE FIELD** This principle is born of our imprinted experience of landscape. When forms appear to be "higher," or closer to the customary horizon, we perceive them as being farther away.
- **TEXTURE GRADIENT** Finer textures suggest distance.
- **SHADING** When an object is shaded using changes in value, the form takes on the illusion of "mass."
- **ATMOSPHERIC PERSPECTIVE** Sharp, well-defined contours and hues are perceived as being in the foreground, while hazy, soft colors and contours are perceived as distant.
- **LINEAR PERSPECTIVE** Developed in the Renaissance, this system is based on our perception that parallel lines recede in space, appearing to meet at one or more "vanishing points" along a horizon of space.

Object Recognition

Our ability to distinguish one object as separate from others in the visual field is fundamental to the way we see the world. Recognizing this, painters use the concept of object recognition to develop figure-ground relationships. As painters,

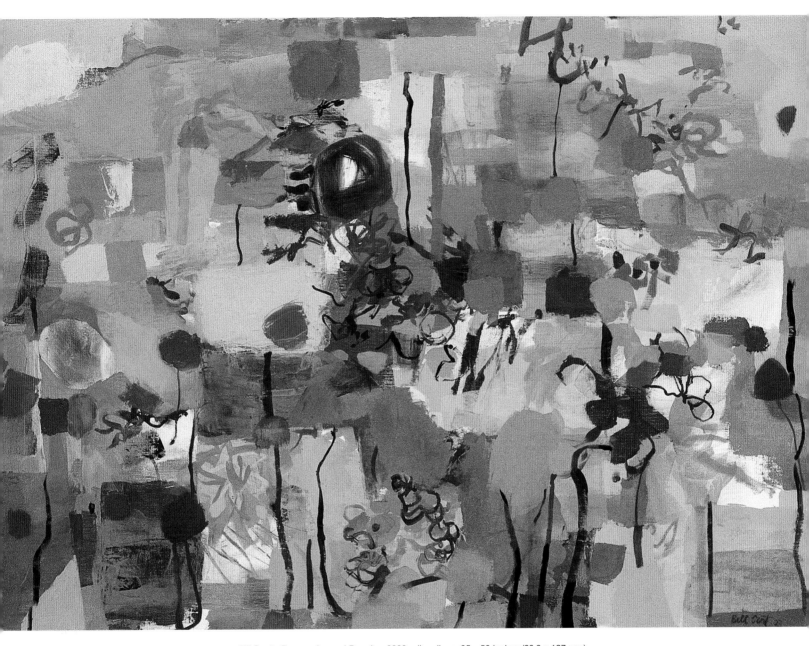

Bill Scott, *Ranunculus and Poppies*, 2003, oil on linen, 35 × 50 inches (88.9 × 127 cm.).
Courtesy of Hollis Taggart Galleries, New York, and the artist.

The saturated colors in this painting allow us to experience the relative effects of warm and cool combinations. Scott's paintings evoke nature, and space is crowded with shapes we recognize as floral clusters. Abundance is felt in the range of hues from deep greens to vibrant orange. A counterpoint to the space generated by color are the lines drawn as if stems were punctuating the structure, giving vertical support and a sense of triumph over gravity.

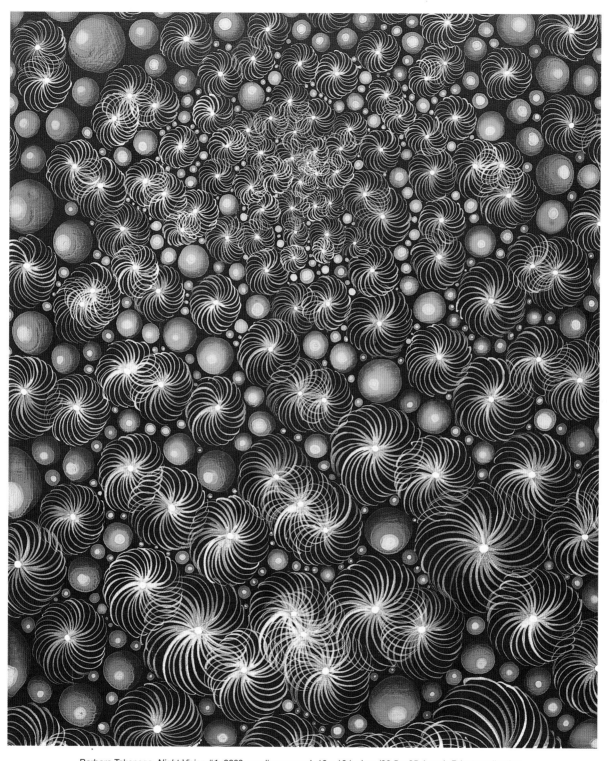

Barbara Takenaga, *Night Vision #1*, 2003, acrylic on wood, 12 × 10 inches (30.5 × 25.4 cm.). Private collection. Courtesy of McKenzie Fine Art, New York, and the artist. Photo © 2003 D. James Dee.

The surface of Takenaga's painting *Night Vision* is slick. With almost no relief, the paint is carefully laid down in thin, delicate strokes to build up detail. From this resolute flatness develops a sense of solid masses floating in deep space. Takenaga uses shading, modeling, atmospheric perspective, and consistent light source, all of which are traditional tools used to create the illusion of three dimensionality. The juxtaposition of spatial illusion and meticulously flat surface is startling.

we have to manipulate the viewer's attention to make a specific part of the painted surface perceived as the object of interest or "figure," while other areas are seen as background. One implication of object recognition is that because the viewer's attention is focused on the object, the ground takes on secondary importance. In this way, we can speak of figures (or other important foci) as having greater "visual weight" than the rest of the painting.

Modern painters have been concerned with making every part of the painting's surface vital. Allover compositions are one way painters undo or subvert the figure-ground way of seeing.

Perception of Light

When compared to our perception of color, luminosity—which is related to value—is visually more fundamental. Perception of luminosity requires only one class of vision cell: rod cells. (To see color we have to have at least two types of vision cells, since color depends on wavelength comparisons.)

Value discrimination probably evolved before color perception and is crucial to depth perception and edge detection. Rod cells in the eye, which are sensitive to luminosity (value) but not color (hue), outnumber cone cells 17 to 1 but are located around the outer edge of a central cluster of cone cells.

Some findings:

- Light-valued forms appear to advance toward the viewer more than similarly sized dark forms on the same background.
- Hues have different degrees of luminosity. Relatively speaking, yellow is light, green and red are medium, while violets and blues are darker.
- We are more highly attuned to differences in value than to variations in hue. When two adjoining color-forms have the same value, we experience difficulty in detecting where one ends and the other begins.

Perception of Color

Three colors—red, green, and blue—correspond to cone cells that are receptive to these colors in the eye. When these cone cells are stimulated in different combinations, we can perceive all the colors of the rainbow. (This mechanism of color perception developed in primates, possibly, it is thought, as a co-evolution between monkeys and trees with yellow- or orange-colored fruit.)

Harvey Quaytman, *Prussian Choir*, 1984, acrylic on canvas, 72.125 × 60 inches (183.2 × 152.4 cm.). Courtesy of McKee Gallery, New York.

Quaytman's use of shaped canvas creates an ambiguous center. We expect the painting to be a simple black square. The central area of white painting blends into the wall. The stark value difference between the black and white diminishes our ability to distinguish the shadows that reveal the real edges of this painting.

When we discuss color perception, we are concerned with additive color theory. Some basic aspects of color perception are:

- We see white when all three (red, green, and blue) types of cone cells are stimulated simultaneously. We see black when none of the cone cells is stimulated.
- Color is understood independently of the illumination of the setting. Painters call this "local color." Scientists call this "color constancy." For example, snow is initially labeled "white" in our consciousness, whether in noon sun or late evening shade.
- All human cultures make similar distinctions between "warm" and "cool" colors.
- Warm colors appear to advance relative to cool colors—so long as chroma (saturation) and value are held constant.
- A highly saturated color (that is, a color that is minimally diluted with white) appears to advance relative to a less saturated color. As such, if a figure-ground reading is desirable in the painting, it makes sense to color the "figure" in tones that are more highly saturated than the "ground."
- Positive and negative afterimages can result from cone cell stimulation. (This phenomenon is notably used in Op Art paintings.)
- Yellow appears brightest because the cone cells for red and green are much more sensitive than blue cone cells. Yellow wavelengths are midway along the spectrum between red and green

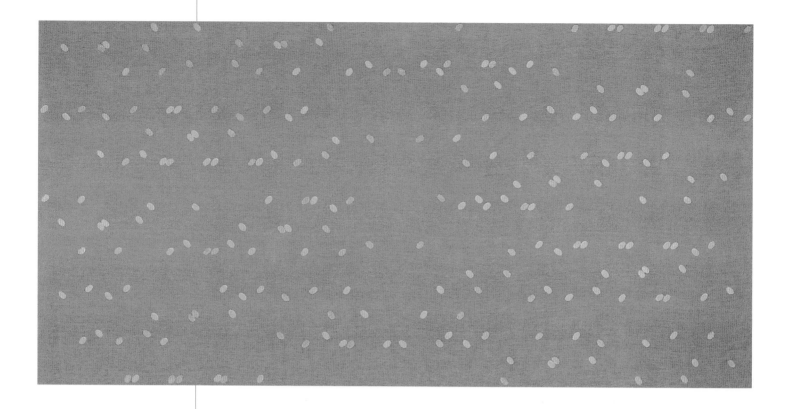

Larry Poons, *Han San Cadence*, 1963, acrylic on canvas, 72 × 14 inches (182.9 × 35.6 cm.). Courtesy of Jacobson Howard Gallery, New York and London, and the artist. Art © Larry Poons/Licensed by VAGA, New York, NY.

For Poons, color is to vision what rhythm is to music. In his 1960s dot paintings, he composed with color—using same-size dots of saturated hues to unify the allover field. Poons followed no pattern and had little interest in the dots' negative afterimages (this effect was an unintended "door prize"). The dots create an intuitively felt, flickering field of color "moments," whose rhythmic pulsing is akin to Mondrian's *Broadway Boogie-Woogie*.

wavelengths. As a result, yellow light easily triggers a reaction from cone cells. In addition, warm colors possess more value lightness overall. Yellow's lightness compared with red's is a ratio of 9 to 4.

■ Bluish-green and yellowish-orange hues are the easiest for us to differentiate. We have more trouble distinguishing greens as well as the violet to red hues.

PRIMARY COLORS As discussed in chapter 6 in connection with paints, the term *primary colors* is misleading. Physiologically, we could speak of the colors red, green, and blue as being fundamental because our cone cells respond to these colors. This means blue light is almost entirely detected by the cone cells receptive to the color blue, and so forth. Yellow is created in our minds by the stimulation of both green and red cone cells.

When we try to apply *primary colors* to mixing paints, the situation is vastly different. There is no single group of three paint colors that can be used to generate all the other visible colors. Anyone trying to mix a good purple knows this.

I am assuming, that colour is real. I am not assuming, however, that colours are real. . . . [M]y thesis is that they are the product of the lexical and grammatical structure of particular languages.

John Lyons, linguistics scholar

CULTURE AND VISION

Vision consists of a vast amount of mental organizing after the retina is stimulated. Even though the physiology of sight has not changed, our acceptance of abstract art can be seen as the product of an evolving visual sophistication. In other words, our culture has invented new ways of seeing painting.

This evolving visual language is apparent when we consider how Impressionist painting initially seemed ill formed to most audiences, whereas today the style is broadly accepted. A visual fashion, such as that which followed the discovery of a way to produce a synthetic dye in a previously

unavailable color called mauve, is unlike an evolutionary change; it's a blip on the screen. In order for there to be a significant advance in visual intelligence, a causal relationship must exist between one paradigm and the succeeding paradigm. Such an advance is a sea-change. So the Cubist "bending" of naturalistic space is a paradigm from which abstraction can logically and causally follow. Under the preceding logic, we would be surprised to have Jackson Pollock's work appear before Paul Cézanne's work. Abstract painting demonstrates the significant development of a new visual paradigm. We can experience the *absence of* subject matter as the *freedom from* subject matter. If we give up the security of recognizable forms, we become active participants in the art, since our own imagination is involved in finding meaning in the forms.

Stan Gregory, *Bird Whisper*, 2002, oil and tinted gesso on canvas, 51 × 51 inches (129.5 × 129.5 cm.). Courtesy of Sundaram Tagore Gallery, New York, and the artist.

Gregory reinvigorates the established features of painting. The challenge is to synthesize thoughts that have driven geometric abstraction for almost a century. Although directed toward the edge of the painting at various points, the drawing avoids actual exit from the picture plane. A sense of self-containment, balance, and even reflection is achieved. This edge-avoidance is reminiscent of Mondrian's "Ocean and Pier" series of paintings.

4

painting with oils

The only thing that is really difficult is to prove what one believes. So I am going on with my researches . . . and I have sworn to die painting. Paul Cézanne, artist

This chapter covers the basic materials needed to set up a studio for painting in oils. It touches on issues related to oil paints themselves: solvents, mediums, supports, support preparation, and safety issues. Painters experienced with oils may wish to skip this chapter. In chapter 5, we similarly discuss acrylic paint and its technical qualities and requirements.

IMPORTANCE OF STRUCTURAL SOUNDNESS

Oil paintings go through a long process of drying by polymerization and oxidation. Paint manufacturer Richard Frumess describes this process: "In the early stages, the oil turns from wet to sticky as it absorbs oxygen and moisture from the air, the paint film swells. . . . As the paint further oxidizes, it becomes touch dry, forming long molecular chains (or polymers). . . . The drying of an oil paint film starts at the top and works its way down. Very soon after the surface dries, the oil begins to shrink around the pigment particles."

Because of this complex drying process, oil painters have to be especially careful to ensure that their paintings are structurally stable or "sound." Fundamental to a painting's soundness is good adhesion between the upper and lower layers of oil paint and between the support surface and the oil paint. Without proper adhesion, the paint will crack or flake off altogether. Fortunately, there are ways to ensure that the paint adheres, and below are some rules of thumb for creating a durable oil painting.

- Start "lean" and add more "fat" as you build up layers of paint. In oil painting, "fat" refers both to oil paints and resin mediums; "lean" refers to solvents such as turpentine or mineral spirits and to wax mediums. As the painting is built up from the bottom layer on the painting's support, more fat (or less solvent) should be used in the general mix. Moreover, some pigments, such as phthalos, lamp black, and carbon black, act as high-oil substances.

- Start with thin layers of paint and work in progressively thicker layers. Lower paint layers, if slick, should be lightly sanded and wiped with solvent before another layer goes on.

- Apply slow-drying paint on top of fast-drying paint. Fast-drying pigments include umbers, neutral grays, cerulean blue, cobalt colors, flake white, sanguine earths, siennas, and viridian. Slower drying pigments include alizarin crimson, ivory black, mars colors, phthalos, rose madder, cadmium colors, chromium oxide green, jaune brillant, naples yellow, quinacridone magenta, ultramarine blue, warm pink, lamp black, and intense carbon black. See Pigment Properties on page 154 for a fuller list. It is preferable to allow time for the underlayer to dry before commencing another layer.

Thomas Nozkowski, *Untitled (842)*, 2003, oil on linen on panel, 22 × 28 inches (55.9 × 71.1 cm.).
Courtesy of Max Protech Gallery, New York, and the artist.

Nozkowski's paintings often take years to complete. A visual idea started will be put aside. Much later, after a long subconscious simmering, Nozkowski re-evaluates the painting in its entirety. The process that follows is more like excavation than alteration; it is wholesale, absolutely avoiding a tinkering mentality. Nozkowski applies subsequent layers of paint only after scraping out a good deal of the previous work. The support of the painting illustrated here is linen on panel, which stands up to the abuse of the scrape-downs. Along with a certain scale, this approach grew from Nozkowski's avoidance of "precious materials" and thus evolved from the lowly canvas board.

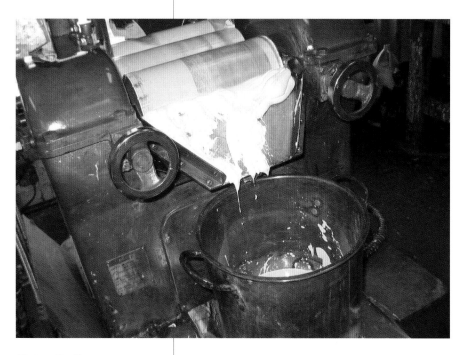

Three-roll mill.
Photo courtesy of R&F
Handmade Paints.

As oil paint dries, it transfers some of its vehicle to the underlying support. (When used in the context of painting, the word *vehicle* refers to substances that serve as carriers or binders for pigments.) A painting may flake off its undersurface if the top layer has less oil content than a previously painted layer. Also, the top layer will lose some amount of its luster over the time when oil is sinking into a lower level. A balance must be achieved between the "tooth" of the surface, the flexibility of the paint film, and the amount of oil in various layers of paint. To this end, I discuss oil on two grounds: acrylic ground and the traditional oil ground.

COLORS

For all paint systems, the basic formula is pigment + binder = paint. Oil paints consist of pigments that have been ground into an oil vehicle. Therefore, the overall quality of the paint is determined by the quality of the pigment, the oil, and the milling process used to combine the two. Store-bought paints have the advantage of paint manufacturers' knowledge and testing.

Some considerations in buying oil paint are:
- Pigments differ in their ability to absorb oil. Thus some colors can be considered "fatter" than other colors.
- Drying times for different colors vary widely.
- Transparency is a function of the pigment's

refractive index and particle size. The refractive index is a ratio of light-bending potential between the pigment particle and its binder. The higher the refractive index, the more opaque the pigment is. Inorganic pigments are generally more opaque than organic pigments.
- Different manufacturers use different oils to bind the pigments. Moreover, a high-quality paint has pigments that are finely and evenly ground. The milling process is consistent with the needs of the pigment-binder combination.
- Manufacturers use varying proportions of pigment to oil. These differences create paints that range from extremely "short" (stiff), to "long" (buttery), to paints that almost flow. When no fillers have been added to the paint, oil separation may occur; such separation does not mean the paint is poorly milled.
- The nature of the painting should play a role in decisions regarding the quality and price of the paint to be used. For example, expensive transparent colors, which are well suited to glazes, are wasted in thick-layered paint constructions.
- Paint "ages" in the tube in a beneficial way. The pigments have characteristic microscopic shapes and, over time, the oil vehicle continues to surround the pigment particles more completely, making the paint smoother and more gelatinous. As color maker Arthur Graham says, "Paint is a living thing." However, if any air is present in the tube, an irreversible thickening, called "livering," takes place; this makes the paint unusable.
- Incompatibility between lead (flake) white and sulfurous pigments (cadmiums and ultramarine) should not worry oil painters. The oil prevents chemical reactions from occurring.
- Only pigment charts that are hand-painted give true hues. Most charts show the mass tone (the top tone of an opaque application) and the undertone (the tint from a translucent application).
- Non-permanent, or "fugitive," colors will lose their strength over time when exposed to sunlight. The painter can often find lightfast measures on paint tubes or charts, especially if the labels conform to ASTM standards.
- Organic color in its most concentrated form is called a toner, and when used in lower paint layers it can be disastrous: Toners can bleed into subsequent paint layers. Artist-grade paints will not use such colorants, but they may still be found in some cheap, student-grade paints. A lake pigment—one made by dyeing an inert pigment, or lake base—is less likely to bleed.

If you have the time, temperament, and knowledge to properly mull pigments into oil, you can make paint in your own studio. Pigment Properties on page 154 gives a list of pigment characteristics for those wishing to make their own paint.

Oil sticks, a comparatively new form of oil paint, are composed of pigment bound with a small amount of oil and some wax. These sticks create rich and dense colored areas with a type of texturing difficult to achieve with brushed application.

SOLVENTS

Oil paints may be thinned, cleaned, and dissolved with mineral spirits and similar volatile organic solvents. All of these have dangers, as explained at the end of this chapter. There are alternatives to using solvents in the studio, including working with oil mediums exclusively. Temporary brush cleansing can be done with linseed oil and final cleaning can be achieved with soap and water. Another way to eliminate solvents in the studio is to use drying oils, such as linseed, poppyseed, and walnut oils, instead of resins as a medium, although this will probably slow down overall drying time when layering construction is used.

Solvents alone are not considered good mediums, because they impair the ability of the oil in the paint to create a good paint film. Unlike resins, the solvent simply evaporates. Sadly, works by Abstract Expressionist/Minimalist painter Ad Reinhardt were executed with a high percentage of solvent and too little oil in an effort to create an extremely matte surface. Today, Reinhardt's paintings that have been even slightly soiled present conservators with an almost impossible restoration problem.

Solvents *are* useful in early layers of paint and will speed drying. They may be used in moderation to decrease surface gloss, but if you forget the "fat over lean" rule, the paint will not be sound and could delaminate over time.

Turpentine is widely used because it disperses oil paint quickly. It is strong enough to dissolve the very hard damar resin crystals used in making damar varnish. Unfortunately, turpentine is toxic and is absorbed through the skin. An orange turpentine-like solvent that is strong enough to dissolve damar resin crystals is now on the market. Odorless mineral spirits are a slightly safer alternative to turpentine, but mineral spirits are not strong enough to dissolve natural resins, including damar resin.

> The three basic and equally important factors of a rational painting technique are the ground, the pigments and the binding media. Each is closely dependent on the other. Their composition and their harmonious relation to each other not only influence the future permanence of the work, but also—and this is of immediate interest to the artist—the textural effect that is of no small importance to the appearance of the whole.
>
> Kurt Wehlte, author of a classic text on paint techniques

MEDIUMS

A medium is mixed with oil paint to improve paint adhesion or to control drying time, surface reflectivity, or viscosity. Mediums, unlike solvents, remain on the painting, becoming part of the final paint film. They must therefore be added with special attention to the "fat over lean" rule. Mediums can be drying oils, resins, or gels.

Drying Oils
Drying oils add gloss and transparency and increase the flow of paint. Excessive use of drying oils in oil paint causes wrinkling during drying and is

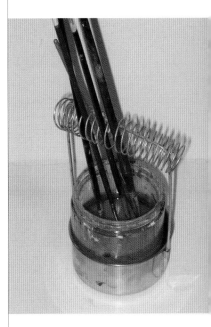

ABOVE Brushes suspended in oil for a solventless studio. To minimize solvent fumes, you can replace turpentine with safflower or linseed oil for cleaning brushes. At the end of a painting session, you can suspend your brushes and quickly leave the studio, rather than having to spend hours cleaning brushes. At the beginning of the next painting session, thoroughly wipe the old paint and excess oil off the brushes.

LEFT Inexpensive mixing tray. Artist Joanne Greenbaum applies color directly to the canvas with minimal modification of hue after the oil paint is diluted. Because of the low viscosity of the color mixture, a traditional palette would be unsuitable to hold the color. Greenbaum has found disposable aluminum trays ideal for diluting tube color and holding paints while she is working on a canvas.
Photo courtesy of Joanne Greenbaum.

David Row, *Tussle*, 2003, oil/alkyd on canvas and panel, 18 × 24 inches (45.7 × 61 cm.). Courtesy of Von Lintel Gallery, New York, and the artist.

David Row: "Scraping adds a kind of phenomenological aspect to the work, giving it an air of independence and presence. Alkyd is a synthetic oil and its main contribution to oil painting is that it dries quickly. Because of a large range of drying times, not all traditional oil colors can be painted under or over other colors. By using alkyd medium, or pigment ground in alkyd, in tandem with traditional oils, one can come very close to equalizing those drying times. This is significant, because it opens up a new range of color combinations to artists and changes the look and feel of contemporary oil painting."

more likely to lead to yellowing. Recommended drying oils include the following:

- **LINSEED OIL, COLD PRESSED AND WASHED** Creates a strong paint film with slight yellowing. It was used by Rembrandt with the simple addition of a solvent. A good linseed oil smells light and flowery. Linseed oil from northern climates is lighter in color than the oil produced from plants in warm climates. It is versatile enough for complex layered paint construction.
- **POPPYSEED OIL** Yellows very little and dries quite slowly. Poppyseed oil does not develop as strong a paint film as linseed or walnut oils and is best reserved for simple direct paint application. It has been used extensively to bind white pigments.
- **WALNUT OIL** Discolors minimally. The strength of its paint film lies between linseed and poppy oils. It was used as a pigment vehicle by da Vinci, Raphael, Veronese, and Tintoretto. One paint manufacturer asserts that walnut oil has a superior refractive index, giving the pigment greater visual presence.
- **SUN-THICKENED WALNUT OR LINSEED OIL** Oils that have been partially polymerized in oxygen. They impart an enamel-like surface with little

discoloration; improve flow, leveling, and transparency; and speed drying.
- **STAND OIL** Oil that has been heated and partly polymerized in a vacuum. It develops an enamel-like surface with little discoloration. Like sun-thickened oil, stand oil improves flow, leveling, and transparency. However, it does dry slowly. It is best reserved for top layers.

Mineral oil and some cooking oils will not oxidize and dry. Therefore, they should not be used in painting. Safflower oil is used by some paint manufacturers in place of linseed, but it is less flexible over time.

Resins

Natural resins such as damar, mastic, and copal introduce more refraction around pigment particles. This refraction results in vibrancy, transparency, and gloss in the finished painting. Resins dry by solvent evaporation. As such, they can dissolve again if exposed to a solvent during restoration or varnishing. Natural resins are hygroscopic, or prone to absorbing moisture from the atmosphere, and for this reason a cloudy "bloom" can develop within the resin layer.

Alkyd resins are the modern version of stand oil. Alkyds formulated for art materials create a relatively flexible paint film with very slight discoloration. Alkyd resins have been generally accepted as superior to traditional resins because they polymerize (rather than evaporate). After drying, alkyds are not resoluble. The quality of an alkyd resin varies depending on the oil from which it is derived.

Gels

If you want a deep glaze for your painting, consider using specially formulated mediums, or gels. Gel mediums can also be used to alter paint texture. When formulated with the addition of silica for impasto, gel mediums may be used to make thicker, buttery oil paints. Some alkyd gels impart transparency and gloss as well as body. Cold wax gels create a matte surface but should be kept to less than 30 percent wax to oil.

ALKYDS

Alkyd paints combine modern alkyd resin as a binder for the pigment with a small quantity of oil. Formulated to provide quick drying and transparency of color as compared to oil paint, they are, not surprisingly, compatible with oil paints. Unlike acrylic paint, alkyds retain their color whether wet or dry. Alkyd paints have similar handling properties to oil-bound paints and are considered to produce a more flexible film over the long term as compared with oil paint film.

APPLICATION TOOLS

Oil paint has certain inherent problems: It may yellow and become brittle, and it dries slower than most other paints. The overwhelming popularity of oil paint may be due to its ability to respond predictably to many types of application. Oil paint will hold an impression of the paint stroke yet can be laid down flat and stretched into blends of colors. In order to take full advantage of these effects, a painter needs to select the right tool for applying the paint to the surface.

Brushes

The length, shape, and flexibility of a brush's hair determine its best use. The most common hairs for art brushes are bristle (stiff), sable (soft), and synthetic (varied). Brushes used in oil painting are classed as rounds, flats, brights, filberts, and fans. Generally, these brush classes are the same as those for watercolor brushes, but the hair length on oil brushes is shorter and the handles are longer. Rounds are used for points or linear strokes. Flats and the slightly longer brights cover planes with clean edges. Filberts cover planes, but their oval shape leaves soft edges for less texture. Fans are used for textureless final blending. When selecting brushes, it is important to carefully consider the scale of your work and the degree of presence each stroke or gesture must command.

To extend the useable life of brushes with delicate sable hairs, try painting initial compositional layers with relatively robust bristle brushes. If you want a seamless oil paint blend, initial work can be done with a longer-length bristle and the final work-over with a sable fan to eliminate any brush marks—called a licked surface.

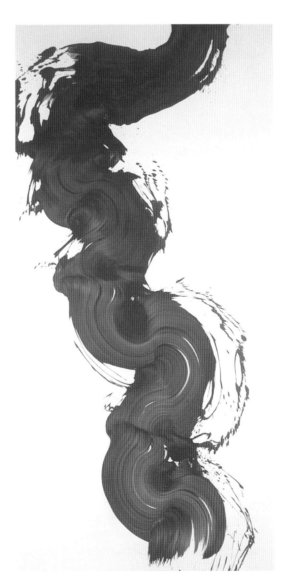

James Nares, *The Red Animal*, 2003, oil on linen, 108 × 53 inches (274.3 × 134.6 cm.). Courtesy of Paul Kasmin Gallery, New York, and the artist.

The large scale of these paintings represents an upper limit of human gesture and one-shot calligraphy. Nares creates with broom-like brushes. Using the strength of his entire body, Nares performs a single mesmerizing stroke of color. There is no looking back after the brush, soaked with color, dances across the linen.

Holding a bundle of brushes of similar handle length by the back of the handles keeps the bristles from touching each other.

Scraper tool, developed for precision in removing either dried or wet paint from a surface, is also useful in sgraffito (scratching).

Choosing brushes with handles of uniform length is a good idea, because when one is holding a fistful of loaded brushes it is easier to identify which brush has what color when all their tips are evenly aligned. When some brush tips are hidden because their handle lengths are shorter, it is difficult to find the brush you want.

Palette Knives and Other Tools

Palette knives are made for paint mixing, and using a knife to mix paint can greatly prolong the life of your brushes. Palette knives may also be used for textured applications of paint. For example, a knife with a broad blade may be used for applying traditional oil ground.

Another excellent tool for the oil painter is a paint scraper. This tool resembles a palette knife with a curved blade and pointed tip. Paint scrapers are designed to remove small pinpricks of wet color, dirt, or debris, but they can also be used to incise lines or other texture into a final layer of paint.

For finely detailed work, a mahlstick lets the painter zero in on an area of the canvas without the wrist or hand touching the support or disturbing the wet paint.

Process Painting Implements

Process painting refers to a number of non-traditional materials and processes for the application of paint to support. (*Process* is short for "materials and process.") In this category we find intense interest on the part of artists in experimenting with new materials and new application processes. Basic process painting equipment would allow for tossing, staining, or other non-brushed dispersion of pigments on a horizontally oriented support. Many of these techniques, while extensively used with acrylic paints, can be modified for oil paint or encaustic.

Some tools might be containers for pouring, spaying devices, blotting material, and a stable, flat working area for the support. A particular consideration for the oil painter is to be mindful of what implements can withstand exposure to solvents, if solvents are used in the studio.

SUPPORTS

Oil paints can be used on a variety of surfaces. The type of surface the artist chooses has aesthetic and technical consequences for the painting ultimately created. There is no single combination of support,

size, and ground that is completely trouble-free. After a century of drying (the length of time conservators allow for changes in the oil paint film to be fully completed), oil paint is a somewhat brittle substance, and the perfect support system for this medium remains elusive.

The adhesion between oil paint layers is mechanical—no chemical bonds occur. So the support's "tooth" is one of its most important qualities. All supports should be free of dust and be at least somewhat absorbent. Generally, artists face a choice between flexible (fabric) and rigid (panel) supports. Rigid supports are stable but get to be heavy in larger paintings.

Fabric Supports

All fabrics have inherent texture. This texture creates a surface sensuality, and fabric's long use as a support for oil painting creates a traditional imperative that many painters find hard to resist. On a technical level, the weave creates a texture, or tooth, that the paint can grip. Fabric is less stable than panels, however. Untreated, it is prone to expansion and contraction as humidity goes up and down. One solution to this problem for a large painting is to lightly fill the back space created by the stretchers with polyester batting, then secure a rigid material such as foam core as the "back wall" to keep the batting stable. This method also protects against contact damage from the back. Another (very expensive) solution is to stretch two layers of fabric—canvas followed by heavy-duty linen—with painting done on the topmost linen layer.

STRETCHED FABRIC Generally either cotton or linen canvas is stretched taut over wooden stretcher bars to create a painting surface. Linen is stronger than cotton and is less prone to expand and contract as humidity levels in the environment change. Linen is also relatively unforgiving in the initial stretching process. When stretching linen or cotton canvas, use a heavy-duty staple gun with copper or stainless steel staples and, for larger canvases, stretching pliers.

1 Make sure the grain of the weave runs parallel to the stretcher bars.
2 Start by stapling the canvas at the midpoint of one of the stretcher bars. Stretch the canvas, and then staple in the same position on the opposite stretcher bar.
3 Repeat on the remaining two sides of the stretcher.

4 Work from the center out to the corners, alternating sides.

5 Finish with corner tucks for a clean finish. (These are achieved by making "hospital corners," as when making a bed.)

UNSTRETCHED FABRIC When using stretched canvas, one can sometimes get unintended effects on the portions of the canvas that are in contact with the stretcher. When using the staining technique (see chapter 13), working on unstretched fabric is advisable to avoid stretcher bar marks. Similarly, the poured-paint technique (chapter 12) is poorly suited to being worked on stretched canvas. When a stretched canvas has a load of wet paint on its surface, the canvas will sag in the middle, and unwanted paint puddling may occur.

Unstretched fabric is often desirable in process painting to allow intentional puddling or flowing of the paint before it dries. Controlled flow is a notable technique pioneered by Morris Louis, who used Magna, a spirits-thinned acrylic solution paint.

Panel Supports

Wood panels were used by painters before stretched fabric. On the one hand, a panel can be smoothed to a fine, textureless surface that will accommodate very detailed brushwork and facilitate perfect blending without interference from underlying fabric texture. On the other hand, panels are generally quite heavy compared to stretched fabric. In other words, painting on panel exchanges the tooth of fabric for the overall stability of panel. Rigid supports are useful for erosion techniques, that is, squeegee-scraping wet paint or sanding away dried impasto.

The traditional panel support is still made of wood. Widely available plywood accepts paint with minimal warping. (Quarter-inch plywood with birch on both sides is a recommended plywood for painting.) Heavier than stretched fabric, a suitably primed and braced panel makes sense for smaller oil paintings. Panels are commercially available both with and without a bracing structure on the back side. A frame will brace a small finished painting.

Aluminum honeycomb panels are a lightweight, non-warping alternative with an inherently reflective surface. No ground or size is required on this kind of panel. The aluminum must be either covered with paint or varnished, however, as over time it will corrode if exposed to air. Aluminum panels, when hung, have a very low profile from the wall. This can create a sleek, modern presentation.

LEFT AND CENTER LEFT **Panels with masked areas on Gilbert Hsiao's work table.**

Photo courtesy of the artist.

BELOW **Panels with cutout by Vicky Perry. Linen glued to plywood panel has a circular portion sawn away to achieve sculptural possibilities not possible with stretched canvas. The lower left area is masked with duct tape in preparation for a geometric, hard-edge form.**

Photo courtesy of the artist.

from support to underpainting

In an oil painting, what you see is not all of what there is. Several layers lie below the oil paint itself. From the lowest layer up, here are the usual ones.

SUPPORT The material (for example, canvas, wood panel, canvas board) on which the painting is created.

SIZE A thin solution of glue applied to the support, especially to canvas, to make it less absorbent.

GROUND The prepared surface on which the first layers of paint are laid.

PRIMER A layer of neutral-toned paint sometimes applied to the ground before painting begins.

SEALING WASH A layer of neutral-toned paint sometimes applied to the ground before painting begins, to reduce absorbency of the ground.

These two layers are optional:

IMPRIMATURA A wash or glaze of thin color applied to the ground or primer that functions to tone down whiteness before painting begins.

UNDERPAINTING The process of painting or roughing-in a basic design with monochromatic or low-key color, prior to beginning the final painting.

Some artists work on paper or fabric adhered to a rigid panel, either before or after the painting is complete. Inexpensive canvas boards are useful for studies, but the gesso is often minimally applied and oil paints will lose luster as the paint layers dry. Additionally, the canvas boards often bend or warp over time. Masonite, with a stabilizing cradle on the back, can be prepared to make a sound support. An application of size and ground will make these panels suitable supports.

SIZES

Size is a glue-like substance that is brushed over a support to protect it from the rotting action of oil paint while also tightening the weave. Exposed canvas will deteriorate over the course of centuries (cotton more quickly than linen) and sizing reduces this potentiality.

Acrylic size is more stable than traditional glue size made of hide since it is not hygroscopic (will not reabsorb water in subsequent changes of humidity). It is believed that hide glue size contributes greatly to delamination problems, which become more likely as the scale of the work increases. Many painters still enjoy the way warm rabbit skin glue tightens their canvases, but they must live with subsequent changes in fabric tautness. Below are procedures for preparing both types of size.

Acrylic Size

- Apply a thin coat of clear acrylic medium evenly to a clean, slightly pre-dampened surface, brushing firmly to get the size deep into the weave. (For extra tightening and protection, you may choose to coat the back of the canvas first with a thin coat of clear acrylic medium.)
- When the size is dry, brush a second layer on the front. After the second layer of size is dry, visually inspect the canvas carefully; if it appears that some areas of fabric are not coated, go back and reapply medium to those areas.
- Allow at least a day, if not longer, for the size to dry fully. Do not rush this step, as proper drying is very important.
- Lightly sand the sized canvas. If you used a thin acrylic medium for your size, then you may subsequently apply acrylic gesso as a ground.

Rabbit Skin Glue Size

- Mix genuine rabbit skin (*not* hide or hoof) glue in a 1 to 10 ratio of glue granules to cool water.

- Soak the mixture for three hours, then heat in a double boiler until the granules have melted but before the mixture boils.
- Traditionally, the fabric is sized evenly on one side only. Apply one generous but not sloppy coat of quite warm rabbit skin glue with a wide brush, working the size into the weave.
- Be mindful that on large linen expanses, if the stretching is too tight, you may have to quickly loosen some tacks to prevent the tightening linen from deforming the stretcher bars. This phenomenon is peculiar to linen (and not cotton) canvas.
- Wait at least one day after applying the rabbit skin glue before applying an appropriate oil ground. One oil-ground formula is a mixture of titanium or lead oil ground (made from white oil paint) and just enough marble dust for increasing the tooth and absorbency.

Although some sources caution against following animal hide glue with acrylic gesso, we have found cases where no ill effects occur after such a sequence. Using rabbit skin glue to adhere a fabric to a panel, followed by acrylic ground, produces a stable support that is unlikely to respond significantly to atmospheric changes. However, in humid conditions, mold can attack rabbit skin glue. Acrylic emulsion is made with anti-fungal additives.

Wood panels must be primed before applying oil paint. A mixture of shellac and alcohol in a 1 to 1 ratio or wood sealer should be applied once and be followed by light sanding.

GROUNDS

A ground is applied to create a receptive surface and to ensure a reliable bond between paint and support. The ground must have a tooth; this diminishes the likelihood that the paint will flake off. The tooth will come from a combination of the weave (or grain) of the fabric, the ground material's film after a light sanding, and the molecular absorbency of the ground material itself. In addition to ensuring a bond between paint and support, the ground will soften the inherent texture of the support, be it fabric or wood.

Grounds for Flexible Supports

Because oil paint is inherently less flexible than alkyds or acrylic paint, there will always be the potential for flaking and cracking if an oil painting is on a flexible support, regardless of sizing or ground used. Paintings less than three feet square

are less likely to undergo flaking or cracking because the changes in fabric tautness over such small areas is minimal.

For oil paint on stretched fabric, the options are acrylic ground or traditional oil ground. One reason to prefer a traditional oil-based ground over one of acrylic is that the oil ground will behave more similarly to the subsequent layers of oil paint; both ground and paint will flex in a similar fashion, while an acrylic ground might be able to flex more than the brittle oil paints on top of it.

ACRYLIC GROUND Remove any oil, dust, or mold from the sized surface. Briskly brush on the acrylic gesso with a wide, stiff bristle brush, using counter strokes to even the surface depth. If a smooth surface is desired, after the initial application consider switching to a finer hair brush to diminish brush marks.

Sanding will knock down any texture. Be sure to vacuum or brush off the dust. This sanding eliminates the brushstrokes on the surface but leaves a fine, irregular tooth in the ground.

Reapply one or more coats of gesso as before. Let the surface dry for several days before applying oil paint. Note: It is very important to remember that acrylics dry in two stages. First, a skin forms and the surface feels dry to the touch. But more evaporation is required for the entire coat to stabilize. If oil paint is applied before this happens, it is possible that the oil paint will not adhere well to the acrylic ground. This is because oil paint cannot penetrate an insufficiently cured acrylic later and is a bigger issue on panel, where water cannot evaporate after the oils have been applied.

Allow at least two days after applying acrylic ground before commencing to paint with oils. Note: A final wipe of water or solvent removes acrylic additives that migrate to the surface during drying.

An optional step of applying a sealing wash will prevent colors from becoming dull. After the ground is fully dry, apply a light, even coat of thinned paint and alkyd medium over all the acrylic ground. Let it dry. (Do not follow with imprimatura.) This step reduces oil absorbency of the acrylic ground layer so that that oil paint layers will not lose too much oil to the ground during the drying process.

TRADITIONAL OIL GROUNDS Traditional oil ground can be purchased in formulas using lead white or titanium white pigment. After sizing, use a brush to apply a layer of ground that has been thinned to the consistency of whipped cream. Work the ground into the fabric's weave. Note: Sizing the fabric may be done with either a layer of rabbit skin glue or a layer of acrylic medium followed by acrylic ground. (The oil ground will not adhere to a slick acrylic size alone but will adhere to acrylic ground. Also, acrylic size alone will not prevent oil paint penetration into the fabric.)

Artist Melissa Meyer's studio paint table. For easy accessibility, Meyer groups her oil paints in cartons by hue. Almost all painters organize their paints by color—evidence of the psychological dominance of hue over value and chroma.

Photo courtesy of the artist.

After the oil ground is applied, smooth the surface with a palette knife. Canvas with a heavy, textured weave may require another coating.

Such an oil ground takes from one week to several weeks to dry and a few months to cure. This time-tested preparation results in a velvety, eggshell-like surface.

Grounds for Rigid Supports

Rigid panels may be primed with artist-grade acrylic ground made for painting with oils or acrylics. A mix of equal parts of rabbit skin glue, whiting, and zinc oxide makes a traditional panel primer formulated for oils. This primer is applied in several coats that are sanded between applications.

OIL PAINT OVER ACRYLIC UNDERPAINTING
Although oil over acrylic underpainting is widely used, I again caution that a slick, high-gloss acrylic surface will not absorb enough oil binder. Also, care must be taken that the underpainting is thoroughly dry, not just dry to the touch; days or weeks may be necessary to completely dry a thick application.

PROTECTING OIL PAINTINGS

The surface of the painting should be protected from environmental damage, and proper storage secured for it.

Varnishes

Varnish protects a work from ultraviolet light, dirt, and other contact damage. Varnishes unify a painting's surface, eliminating inconsistent gloss and matte regions. However, varnishing can destroy the beauty of surfaces where the pattern of matte to gloss is part of the aesthetic appeal. If the oil painting has not been developed so as to create a strong paint film, the solvent in the varnish (mineral spirits) will dissolve the surface of the painting when applied. A modern varnish that can be easily removed with mineral spirits is recommended.

Other Protections

Proper storage of the painting is essential. If a painting is fully dry it can be wrapped or boxed with archival material. Another way of partially protecting a work is framing, where aesthetically permissible. Humid environments can result in irreversible discoloration from mold attacking the support and sizing.

If the painting is taken off the stretcher bars and rolled, use a hollow tube at least 8 inches in diameter. Cover the roll with acid-free material. Then roll the fabric with the painted surface facing out.

SAFETY WITH OIL PAINTS

Ventilation is required to protect the artist from exposure to airborne solvents. Keep a fan—preferably one boxed into the window—running all the time. After you are finished working, remove all solvent-soaked rags from the studio. While using dry pigments, be sure to wear a mask and keep the area properly ventilated.

It is best to eliminate turpentine from your studio altogether. As a somewhat safer alternative, consider using artist-formulated mineral spirits. If you must use either turpentine or mineral spirits, keep their containers closed whenever they are not in use.

Whenever possible, wear gloves when handling any paint materials. Don't wait to wash. Washing your hands several hours after contact with a chemical leaves you with exposure to harmful chemicals.

Certain pigments are known to be dangerous to the body. These pigments include cadmiums, cobalts, cerulean, Indian yellow, Indian gold, vermillion, and titanium yellow, as well as any form of lead. Proper handling of lead (as in flake white), cadmiums, and cobalts is sufficient to avoid adverse effects. Do not sand paint that contains lead without a mask. To avoid exposure to lead, consider using titanium instead of flake white.

Last, but certainly not least, dispose of studio waste in a responsible manner, not down the drain.

American Society for Testing and Materials (ASTM)

The standards promulgated by the American Society for Testing and Materials (ASTM) greatly benefit the painter by ensuring pigment quality, disclosure in materials, labeling, and safety. Quality was once a guild-guarded secret. Today, science has produced a stream of light-fast, brilliant pigments. Today's student-grade paint is often better than an artists' grade paint sold forty years ago.

Artists are encouraged to read the labels on their materials and the associated materials safety data sheets, many of which can be found online. You can demand that paint manufacturers make their labels conform to ASTM standards, and communicate directly with manufacturers about existing products and artists' needs.

Melissa Meyer, *Love Me Tender*, 2001, oil on canvas, 70 × 80 inches (177.8 × 203.2 cm.).
Courtesy of Elizabeth Harris Gallery, New York, and the artist.

Meyer achieves coloristic effects similar to watercolor in these large-scale oil paintings. The artist uses a combination of solvent and a small amount of damar varnish to extend the oil paint to a transparent glaze. Meyer chooses oil paint over acrylic, having experimented with both. Since gesture is so important in these works, Meyer prefers the way that oil paints respond to her paint handling and brushwork.

5

painting with acrylics

Part of my thesis is that materials influence form.

Morris Louis, artist, to Leonard Bocour, paint manufacturer

Abstract art has nurtured a deeply physical stance and a fascination with materials and process. Acrylic paint opened up many new possibilities for paint handling and has deeply affected the course of contemporary abstract painting. As the tradition of easel and brush lost its pre-eminence, painters' intense focus on painting's materiality increased and acrylic paints came into their own. For one thing, they dry much faster than oil paints, and this makes them well suited to many of abstract painting's most favored techniques, including splattering, pouring, and transparent layering.

This chapter deals mainly with acrylic emulsion paints, that is, water-based acrylic paints. Acrylic solution paint is solvent-based and includes the Magna paint line used by Morris Louis as early as the late 1940s. Acrylic solution paint was important in the aesthetic development of abstract painting, allowing painters to break free of Cubism and traditional space, but it is little used today for technical reasons.

PAINTS

It can be said that acrylics offer the luminosity of watercolors with the textural and layering potential of oil paints. Although acrylic paints cannot accept as high a load of pigment as can oil paints, the acrylic binder's clarity and its ability to create thicker paint layers do allow extremely saturated hues to be easily achieved in acrylic paint.

In addition, acrylics enjoy some advantage over oils in terms of permanence. Acrylics remain flexible and do not discolor. They are suitable for large-scale paintings on flexible supports exactly because they resist delamination or flake-off. While oil paints enabled painters to produce textureless blending across a form, acrylics enable artists to produce a myriad of textures.

Acrylic paint is pigment suspended in an acrylic resin emulsion. When acrylics dry, the moisture in the paint evaporates or sinks into the support and the acrylic molecules coalesce, or polymerize. With the moisture gone, the paint shrinks and the paint's binder, originally a milky white, becomes almost clear. Once dry, acrylic paints cannot be dissolved.

The biggest drawback to working with acrylic colors is that the binder changes dramatically as it dries. As the binder goes from milky to clear, what you see while the paint is wet is *not* what you get when it is dry. Making test strips and letting them dry before starting a painting is a way to ensure that the final, dried colors are the ones you want in your painting. The downside of making test strips is that they are time-consuming to make and thus delay the start of the painting. If you choose to paint test strips, keeping a journal of paint mixes helps to fortify the routine.

Bearing in mind the speed with which acrylics dry, it is a good practice to mix a broad selection of colors in amounts larger than needed to complete the painting before beginning paint application. That way, they will be ready when needed.

Pre-mixed Paint

Initially, acrylic paints could only be purchased in pre-mixed pigment-binder formulas, in tubes or jars. Today pre-mixed colors are sold in many concentrations and viscosities.

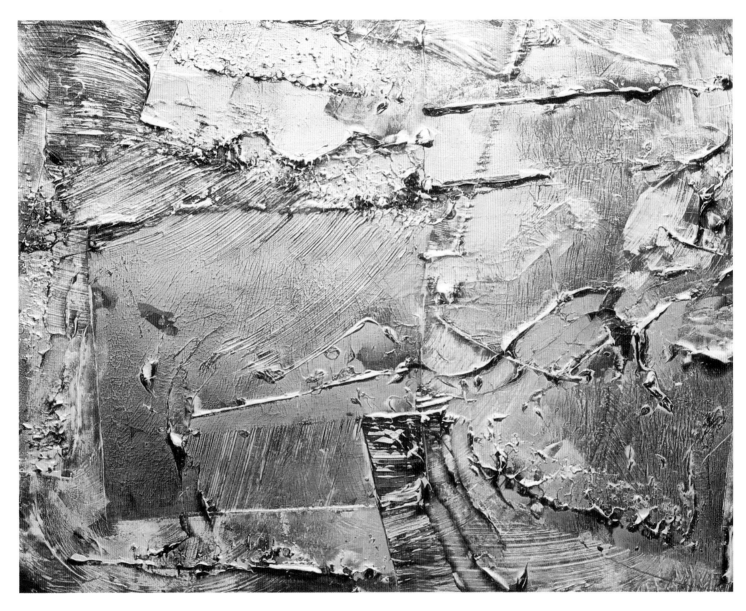

Walter Darby Bannard, *Luraville*, 1992, acrylic on canvas, 43 × 57 inches (109.2 × 144.8 cm.). Courtesy of the artist.

The "drawing" is accomplished directly with a squeegee. Bannard builds up ridges of paint and lets previous thin layers of translucent colors emerge between the ridges to establish a luminosity. Bannard has been at the forefront of investigating pictorial and textural possibilities for acrylic paints.

Test strips and journals kept by artist Walter Darby Bannard annotate decades of mixtures and give the artist a chance to duplicate previous color mixtures.

Photo courtesy of Walter Darby Bannard.

I had to grind away with a pestle and mortar for hours and hours, and that was a real problem because it was very difficult to get the pigment into the medium. But there was no alternative, there was no strong colours in the household emulsion paints then.

Bridget Riley, painter

Pre-mixed acrylic color has the advantage of being ready for immediate use. The paint manufacturer has already added disperse agents, defoamers, preservatives, and perhaps thickeners to the binding vehicle. These paints come in various strengths or pigment densities. A reputable color maker will manufacture acrylic paint using three-roll mills, as are used for making oil paints. Such a manufacturer will also ensure quality by selecting desirable artist-grade pigments; these high-quality pigments are milled singly rather than blended to form hybrid colors.

Studio-mixed Paint

Artists can also custom blend their own formulas by buying dispersed pigment separately from its vehicle. The variety of mediums and gels available today seems endless, giving the artist full control over a custom blend. Studio mixing is also especially advantageous when working with expensive pigments, such as cobalts and cadmiums, which might be more economical in powder or dispersion form. Acrylic medium is alkaline until it dries, so one must custom-mix alkali-sensitive pigments such as manganese violet, Prussian blue, and some forms of cobalt violet, and use this paint as soon as possible. (Note: there is a possibility that such a mixture may bleed up to a subsequent layer of acrylic.)

The disadvantage of studio mixing is the introduction of uncertainty. Studio mixing can create paint that is full of air bubbles. Paint with too high a pigment-to-binder ratio tends to adhere poorly to the painted surface. Finally, specific hues or textural blends may not be reproducible through studio mixing.

Safety in Handling and Mixing Acrylics

Ventilation is required to protect against exposure to airborne pigments and the ammonia from acrylics' chemistry. When using acrylic paints, be sure the space you are working in is well ventilated, and keep a fan running all the time. When handling dry pigments, always use a mask. If possible, wear gloves when handling any paint materials. Don't wait to wash. Certain pigments are known to be especially dangerous: cadmiums, cobalts, cerulean, vermillion, and any form of lead.

PIGMENTS

Many exciting new pigments are extending the range of possibilities available to the artist. Iridescent colors are created from mica flakes and exhibit a pearly quality. Interference pigments carry two colors, one seen in direct light and the other visible in indirect light. The effect of interference colors is more dramatic on a dark ground or with small amounts of darker color added. Fluorescent colors are not lightfast even after being varnished, but many artworks have used these colors with no noticeable degradation. Fluorescents are very transparent and best display their hues when applied on a light ground.

Two kinds of pigment—dispersed and dry—can be added to acrylic mediums.

Dispersed Pigments

Dispersed pigments are pigments that have been mixed into a water base, usually with the addition of surfactants—also called wetting agents or disperse agents. Unlike complete paints, these colors need the addition of a binding vehicle such as

acrylic medium. They are available through stores and catalogs. The variety of dispersed pigments available today is extensive and rivals the pigment choice for oil paints. Dispersed pigments save the painter from having to introduce water into sometimes-stubborn dry powders—a decided advantage. Also, dispersed pigments may be ground to a very fine particle size. The disadvantage, aside from health concerns associated with handling pigments, is that some larger-particled, inorganic colors settle over time into a cement-like solid and the "dispersion" becomes unusable or needs to be manually redispersed.

Dry Pigments

Using dry pigments, the powdered form of the color, the artist can be assured of the freshness and potency of the resulting paint colors. This said, it is important to keep in mind that there are health hazards associated with handling dry pigments. To protect against these hazards, commercial paint makers, clothed in head-to-toe protection and using a respirator, work with dry pigments in a sealed room. Artists should likewise use a respirator when handling pigments and work in a contained area to reduce the possibility that the dry color will contaminate the studio.

Lauren Olitski, *Angel Land*, 2004, acrylic on canvas, 40 × 48 inches (101.96 × 121.9 cm.). Courtesy of Donna Tribby Fine Art, Inc., Palm Beach, Florida, and the artist.

Olitski generally favors premixed colors. These are substantially transformed in her wet-in-wet working process, which is improvatory.

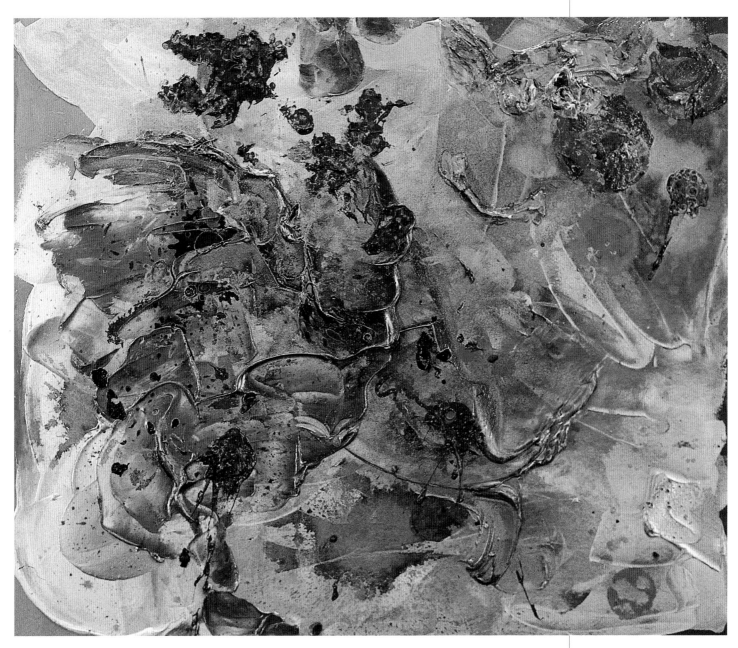

Paint shop walls, displaying a small portion of today's vast selection of pigments.
Photo courtesy of Guerra Paints and Pigments.

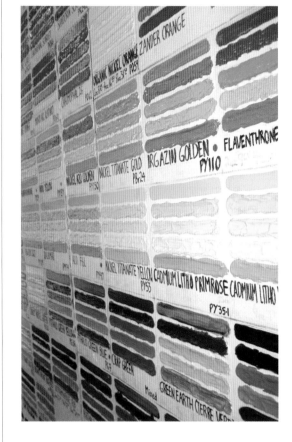

BELOW Dispersed pigment on shelves. As noted in discussing oil paint, most artists arrange their colors by hue.
Photo courtesy of Walter Darby Bannard.

HOW TO DISPERSE DRY PIGMENT The goal of dispersing pigment is to minimize open-air handling of dry pigment. When pigment has been dispersed, the result is a water-suspended pigment that is ready to be mixed into the acrylic binder. If you are starting with a dry, non-dispersed pigment, follow general safety procedures regarding ventilation and avoidance of airborne particles. Then:

- Select a suitably sized lidded container. If you are using several tablespoons of powdered pigment, an eight-ounce yogurt container will do. Create a small hole in the lid by slicing a V-shaped incision.

- When mixing pigments in the studio, a surfactant is required to break the surface tension between the dry pigment and the fluid receiving medium. Adding a drop or two of disperse agent (surfactant) to the bottom of the container greatly facilitates the pigment's acceptance of water.

- Gently deposit powdered pigment by the spoonful into the container. It is a good idea to have a can of water nearby in which to place the used spoon. Doing this reduces the likelihood that the spoon will shake loose powder into the air.

- Replace the lid.

- Spray or inject about the same amount of water as there is dry pigment into the container through the hole. You want enough water to join with the disperse agent in dampening and then surrounding all the enclosed powder.

- Cover the hole with your finger and shake the container. You need not be concerned with foaming at this point, since this dispersion procedure precedes the addition of medium and the dispersed color is so watery that bubbles rise easily to the surface and vanish.

- Carefully lift the lid to check that the powder is damp. If you didn't add enough water a cloud of dry pigment will rise up from the container when you open the lid. Be careful.

MEDIUMS, GELS, AND PASTES

A great variety of pre-mixed binders with a wide range of working properties are available to buy. The basic types of acrylic vehicles are mediums, gels, and pastes.

The most common binder is acrylic medium, which contains no pigment and dries almost clear. It is available in several thicknesses, leveling

characters, and reflective qualities. Generally, acrylic medium flows and levels in a range of consistency from that of milk to that of honey. Brands of medium vary in the amount of acrylic resin emulsified in the liquid, but the amount of resin runs generally from 40 to 65 percent. The more resin there is in a medium, the more viscous it is; that is, it forms a blob when poured out. Additionally, one may obtain special-purpose mediums that are harder, softer, or resist crazing.

Gels differ from mediums in that they are already thick enough to stand up and retain their applied shape. They are often sold in soft, regular, heavy, and high-solid varieties with the additional option of being gloss or matte. Gels retain the evidence of brushstrokes.

Pastes are high-viscosity gels with solids, such as marble dust, mixed in so that the material will retain its shape. Pastes are useful for creating sculptural effects. Because they have higher levels of solids in them, they generally do not dry clear.

MEDIUM CONDITIONERS

Medium conditioners and texturizing compounds that artists can use to customize their paints are available on the market. Keeping a journal can help a painter keep track of additives in paint formulas. Some of these additives are:

AMMONIA The non-suds variety of ammonia reduces lumps when added a few drops at a time.

ANTI-FOAM AGENTS Acrylic paint has a tendency to foam like soap. Because of this, one should avoid shaking or vigorously mixing acrylic paint. One or two drops of anti-foam agent per several ounces of paint may be added to retard the paint's foaming action.

DISPERSE AGENTS Disperse agents are surfactants that reduce surface tension. Generally, use one or two drops of disperse agent per several ounces of paint but use no more than 5 percent surfactant to total paint volume. Because one generally wants to avoid stirring air into paint, water dispersion agents may be added to ease the incorporation of certain stubborn materials, such as dry pigments. For stain techniques, pre-wetting the receiving support with water containing some disperse agent helps to create smooth stain effects.

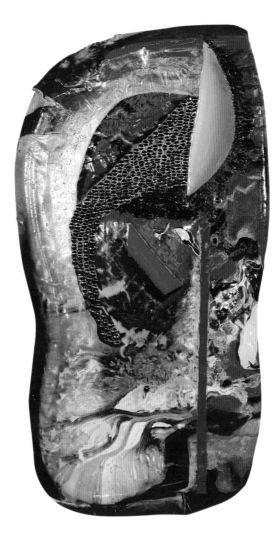

Graham Peacock, *Middle East*, 2003, acrylic on canvas, 54.75 × 29.5 inches (139.1 × 74.9 cm.). Courtesy of the artist. Private collection, Toronto, Canada.

Peacock's technique results from extensive, controlled crazing, which creates surprising color combinations. These are complemented by delicate textural collage effects, achieved by cutting and hand painting. According to Peacock: "My paintings start with pouring. . . . I have an interest in pushing the physicality of painting as far as is possible. . . . A pronounced physical surface has become both compositional anchor and expressive 'play' in my work. . . . In 1981–1982 I discovered how to make crazed fissures; separations in the paint which revealed one colour through another. This was a breakthrough which has remained the underpinning of my work."

RETARDER The quick drying of acrylic paint sometimes runs counter to artistic goals. In such cases, a retarder (propylene glycol) can be added to slow down the paint's rate of evaporation.

TEXTURIZERS A plethora of texturizing additives, from grit finer than sand to shredded rubber, is available. Texturizers vary in weight as well as grain size. The addition of large proportions of solids to a medium or gel may reduce the overall cohesiveness; a gel with more acrylic resin and less water may be required.

THICKENING AGENTS Acrylic paint may be created using a commercially prepared gel medium. Alternatively, a thickening agent can be stirred into a low-viscosity binder. When mixing a thickening agent into paint, painters should remember that it is generally advisable to avoid mixing in air bubbles.

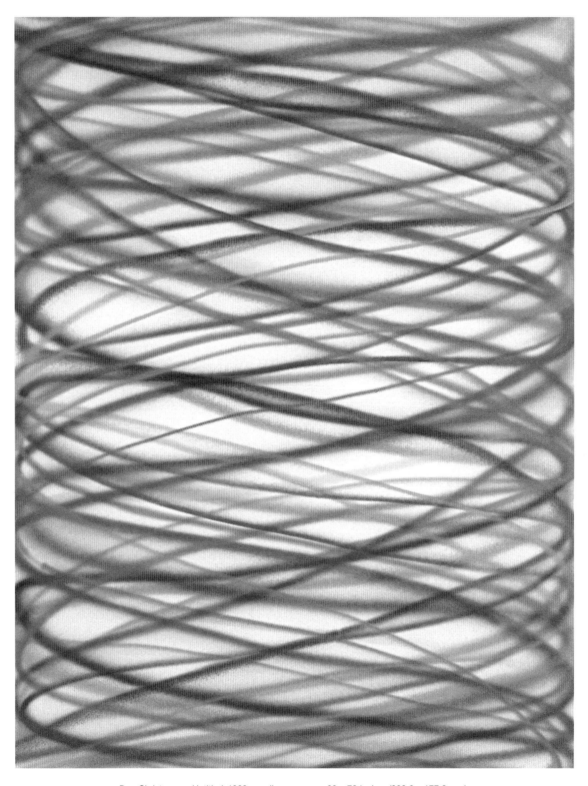

Dan Christensen, *Untitled*, 1968, acrylic on canvas, 90 × 70 inches (228.6 × 177.8 cm.).
Courtesy of the artist. Art © Dan Christensen/Licensed by VAGA, New York, NY.

Christensen's use of airbrush techniques to apply paint effectively reduces the sense of human touch. Although the painting is clearly comprised of "drawing," we can sense little gesture. The color seems disembodied and the painting feels self-created. Its large scale adds to a superhuman sense of the work.

BRUSHES AND OTHER APPLICATION TOOLS

Many implements can be used to apply acrylic paint to a support: brushes, bucket sprayers, and sponges. These tools must be promptly cleaned as dried acrylic paint cannot be removed. Some tools are disposable.

Brushes

As with oil paints, the range of brush types is large—from small, fine-haired sables to large, stiff bristle brushes and even housepaint brushes. Since, in general, acrylic paint is not as stiff as oil paint, softer-haired brushes are needed. For acrylic painting with brushes, it is helpful to first wet then dry the brush before putting it in paint. Doing so minimizes the possibility of accumulating dried paint in the ferrule of the brush, thereby extending its useful life.

Process Painting Implements

Unlikely items can be used to get color creatively from here to there. Basic process painting equipment includes cans for pouring, spray bottles, kitchen utensils (don't forget the turkey baster), and Rube Goldberg-inspired inventions (rubber gloves with holes in fingers, or cans with holes punched in the bottom).

SUPPORTS

As with oil painting, the choice of supports is between flexible (fabric) and rigid (panel) materials. Whether flexible or rigid, artists generally want a surface that is absorbent and has a tooth that will prevent delamination. Acrylic paint can be poured into designs on a slick surface, such as glass. After the paint has dried on such a surface, the painter may peel it off the glass and reattach it to a permanent support in a collage-like fashion. During application, the support orientation may be horizontal or vertical, depending on the process used.

Fabric

Refer to chapter 4 for a procedure for stretching fabric onto wooden stretcher bars. When using stretched canvas, be aware that the meeting points of stretcher and canvas may cause unintended effects. Particularly for staining work, unstretched fabric is a better support for avoiding stretcher-bar marks. Also, stretched canvas (lying flat with a load of wet paint on its surface) is going to sag in the middle and invite puddling in the center. (Intentional puddling or flowing of the wet paint is covered in chapter 12.) So, again, unstretched fabric on a flat surface will eliminate most unwanted wandering of wet paint.

Panel

The traditional painting support, the wood panel, accepts paint with minimal warping. It displays minute effects of paint handling or paint behavior and allows for extremely fine detail without interference from underlying fabric texture. One-quarter-inch birch plywood with birch on both sides is recommended. Panels are commercially available both with and without a bracing structure on the back side. A good frame will also act as a brace. Some artists work on paper or fabric that is—at some point—adhered to a rigid panel. Rigid supports are useful for erosion techniques—for example, squeegee-scraping of wet paint or sanding away dried impasto.

SIZING FLEXIBLE AND RIGID SUPPORTS

Acrylic paint will not rot fabric or wood in the way oil paint does. However, over the long haul, raw canvas is not archivally sound. It is recommended that, at a minimum, a thinned, clear application of acrylic medium be worked into the canvas. Artists can even use the stain technique after sizing the canvas with thinned application of acrylic medium and applying a commercially available absorbent ground. Rabbit skin glue is not a recommended primer for acrylic paints; it will expand in humid weather and create stress next to the stable acrylic layer.

If using quarter-inch birch panel, coat it first with a solution of 1 part shellac to 1 part alcohol to reduce absorbency.

GROUNDS

The acrylic gesso ground (flat white ground) is not strictly necessary for acrylic painting. Rather, it serves to create an even-tone background for subsequent work and slightly reduces the texture of a fabric support's weave. When the ground is white, later colors draw on the whiteness as a source of luminosity through transparent or translucent marks over the ground. When the ground is black,

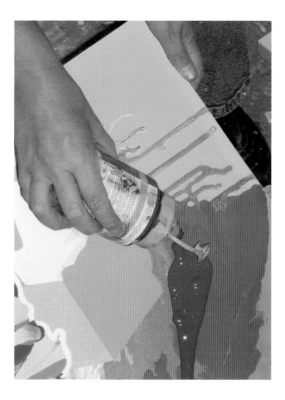

later colors must be somewhat opaque in order to be seen at all. Apply acrylic paints on top of an acrylic ground. Be careful not to buy primed canvas that has a traditional oil-ground preparation. To apply acrylic gesso ground to fabric or panel:

- Remove any oil, mold, or dust from the sized surface.
- Brush white acrylic ground on briskly, using counter-strokes to even the surface depth. If you want to diminish brush marks, finish off by using a fine-hair brush.
- It is very important to remember that acrylics dry in two stages. First, a skin forms. The surface feels dry to the touch, but the paint requires more time to thoroughly evaporate before the paint can stabilize.
- Sanding will knock down any texture. Be sure to vacuum or brush the dust off the surface to be painted.
- Reapply one or more coats of acrylic ground and repeat the steps outlined above.

PAINT MIXING

For thin opaque painting, it is easy to mix a suitable acrylic color—especially when using manufactured paint that you have worked with before. But for thick layers with semi-transparent passages, it becomes quite tricky to control the final result. As mentioned before, the drastic change in the acrylic medium from its milky wet state to its clear dry state makes predicting the final look of a studio mixture especially difficult.

The three-step method detailed below develops the color/transparency/viscosity combination, starting with dispersed pigments and some combination of clear mediums, flat white ground and additives.

STEP ONE. ADJUST HUE AND CHROMA.

The first concern is to create the hue you want. This is done by mixing what is called a "color broth." First, place a few drops of water in a container large enough to hold the quantity of paint you need. Next, add the various dispersed colors, drop by drop. The water in the container coaxes the colors to bleed together quickly. Gently but thoroughly stir to blend the hues. If necessary, add additional dispersed color to adjust the hue. A rough guide for how many drops of pigment to add is one drop per cup of final paint, but this rule of thumb is widely variable, as some pigments are inherently more potent color-carriers than others. The phthalo and quinacradone organic pigments, for instance, are intense and overwhelm most inorganic pigments. Also, darker tones are more potent than lighter ones; two or three drops of black in a whole cup of white make a middle gray. At this stage, you are making a "first cut" that is aimed at achieving the final desired hue. The color's value will be adjusted later.

STEP TWO. ADJUST PIGMENT STRENGTH.

At this point, add a spoonful or so of clear medium to see how the pigment combination "blooms." By shaking the medium gently into the color broth, one can get an idea of how richly pigmented the final mix will be. If the bloom is too weakly tinted, it may be necessary to add additional pigment at this stage. If the mixture appears too intense, pour some of the dispersed color mixture out and try adding in another small amount of clear medium. It is important to keep in mind how much medium will be used in the final mixture as well as the inherent lightening effect that the milky medium is having on the still-wet colors. This is most important and most difficult when trying to achieve translucent mixtures.

STEP THREE. LOAD THE MEDIUM.

Once you are satisfied with the hue and believe that it will exhibit the desired intensity when fully loaded with medium, you can add additional medium components. For painters using thick layers of paint, this is the point when acrylic paint's inherent qualities make it trickiest to work with. Not all the layers of pigments and other materials are visible. A wet acrylic paint layer displays a surface that is lighter and simpler than the dry layer, which will be darker and more complex when the veil of medium disappears. For most simple paints, a small amount of white acrylic ground added to the clear medium (one-third cup or less to a quart) will create a paint that is visually similar in both the wet and dried stages.

Opaque Mixtures

An opaque paint provides total coverage and obliterates any color beneath it. It might be desired as a strong hue for wet-in-wet mixes and pours. It can be thought of as "owning" the space it occupies on the picture plane. An opaque paint may be used as an initial tone, serving as a base upon which successive pours will lie. To create an opaque paint,

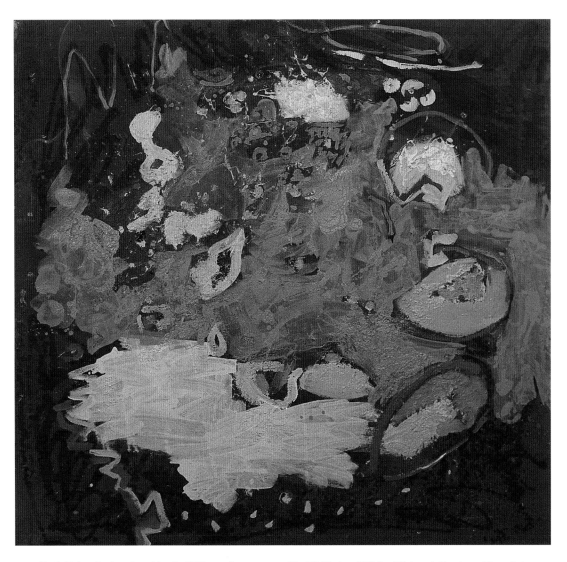

Paula DeLuccia, *Angels and Devils*, 2003, acrylic on canvas, 67 × 70.5 inches (170.2 × 179.1 cm.). Courtesy of the artist.

Scumble and opaque wet-in-wet applications give DeLuccia's painting a density and sense of struggle. The texture hidden beneath the topmost, opaque paint layer suggests secrets. DeLuccia tenaciously follows the improvisation to a point of openness. The closely valued yet chromatically divergent colors create a visually mysterious field.

a note on stirring

When making gravy, a cook adds the thickening agent slowly to ensure that the gravy is not lumpy. When an artist adds acrylic medium or emulsion to the color broth, this must also be done gradually, or the paint will not be of uniform consistency. Of course, the artist may want a paint of inconsistent thickness and can intentionally under-mix, achieving a now-thick-now-thin paint. Marble-like effects may result when one doesn't stir at all, perhaps only swirling the pigment and medium in the container several times.

If one does not fully mix all the pigments that are on the bottom of the container, there will be darker shades of paint coming out in the "dregs" of the pour.

To avoid adding air bubbles to the paint mixture, gently pour about a cup or two of medium down the inside of the color-holding container. An excellent stirring device is a medium-sized bristle brush that has been slightly moistened to remove the air between the hairs. Bubbles aren't technically unsound but may run counter to the aesthetic goal. Upon drying, they may be so numerous as to create a pock-marked, spongy surface that will pick up dust. Large bubbles may be created intentionally that reinforce the direction of flowing paint in glaze-like mixtures.

artists mostly rely on flat white acrylic ground added to the color broth, but it is possible to use a very heavy load of powdered pigment in place of the white acrylic ground. In either case, a good portion of clear acrylic medium should be added to create a flexible film. The basic recipe is:

1 to 3 cups white acrylic ground to 1 gallon mixed paint (the amount of ground depends on how much lightening of value is acceptable)
or
1 to 4 cups powdered pigment plus ½ tablespoon white acrylic ground to 1 gallon mixed paint

While some darkening of opaque paint occurs during drying, test samples are recommended but not as crucial, since the visual result of an opaque paint is not a complex of many layers.

Glaze Mixtures

Glaze paint is used to alter a layer of color(s) while retaining almost all of the other visual information. Only the subtlest compositional details will be erased by the application of a glaze. Glaze will intensify a color that is its close neighbor in the spectrum and diminish chroma in a complementary color. The final value of a color is a function of the relative pigment-to-medium ratio and the thickness of the glaze application. To create a clear glaze of color, the task is simply one of adding sufficient gloss acrylic medium.

Judging the final effect of a glaze is difficult and counter-intuitive, especially if the glaze layer is somewhat thick. When wet, the glaze is a "pastel" version of its final color, due to the milky-when-wet nature of acrylic emulsion. Remember, glazes always darken upon drying.

It is extremely important to take pigment character into consideration when mixing a glaze. Some pigments have high staining power. Mixing a cup of 50 percent resin medium with one drop of phthalocyanine blue will develop a very rich glaze. Numerous drops of Prussian blue (iron blue PB27) would be needed to achieve the same richness of tone. This is an example of how keeping a journal of mixes becomes helpful.

Translucent Mixtures

Translucent paint is useful for diffusing the underlying composition while leaving some of the lower layer visible. Using this technique, one can achieve the illusion of "veils," or the milky fog so often found in encaustic works. Like a glaze, a translucent layer can lower the original intensity of a color. Translucent paints' effects depend on the amount of diffusing solids; the contrast of colors in top and underlying layers; and the thickness of the poured or brushed-on layer. Diffusing solids such as powders, silica/matte medium, and flat white ground can be used in making a translucent paint. Also, darker-valued colors tend to increase the effective coverage of such a layer. A general recipe for a translucent paint, based on a 50 percent resin medium, would be:

½ to 1 tablespoon of white acrylic ground to 1 gallon of mixed paint
or
2 to 4 cups of silica matte medium to 1 gallon of mixed paint
or
2 to 4 tablespoons of powdered opaque pigment to 1 gallon of mixed paint (this amount varies depending on pigment: Inorganic pigments are generally the most opaque; organic pigments would add color but be generally transparent)

The actual steps in mixing a translucent paint are simple. Develop a color broth, add the diffusers (gesso, silica, or powders), and finally load up the acrylic medium. It's possible to combine any of the above diffusing ingredients.

The coverage of a translucent overcoat is difficult to predict, due to the number of factors that

Test paintings are more detailed than test strips. This series of mini-paintings demonstrates the effect of glazes.
Courtesy of Walter Darby Bannard.

impact its opacity. The thickness of the acrylic medium (the ratio of acrylic resin to water in its formulation) is of critical importance. Consistency and routine pay off here. The artist is strongly advised to test the degree of translucence by test-drying a sample drop or puddling onto the appropriate base color.

PROTECTING THE ACRYLIC PAINTING

Varnish is the primary means of protection for acrylic paintings. The tackiness of the acrylic paint film makes the painting likely to pick up environmental dirt. Be aware that any varnish can destroy the fragile beauty of many surfaces where the effect of matte to gloss is part of the aesthetic appeal. Also remember that any varnish, but especially a matte varnish, is going to diminish the immediacy of whatever surface texture has been attained.

Three reasons to consider varnishing an acrylic painting are:

- To protect a work from ultraviolet light. Some pigments are fugitive (alizarin crimson and fluorescents especially) and are not permanent when exposed to sun.
- To protect from dirt and other contact damage. Matte surfaces are especially prone to absorbing environmental elements.
- To unify a painting's surface by eliminating inconsistent gloss and matte regions.

Acrylics remain somewhat porous after drying. A finished work should get an "isolation coat" of water-thinned soft gloss gel. This is followed by a mineral-spirits-based varnish with ultraviolet light protection.

STORING AND WRAPPING ACRYLIC PAINTINGS

Storage of paintings is often a problem but less so for acrylic paintings, which do not have an inherent brittle paint film, than for oils. Vertically stack or wrap acrylic paintings, allowing for some flow of air.

The long-term tackiness of the acrylic paint film creates a potential storage hazard. When wrapping an acrylic work, be mindful that the porous plastic surface of the painting may stick to plastic or absorbent papers. Any texture on packing material that comes into direct contact will imprint the painting's surface, so be sure to "float" all wrapping off the surface of the painting. For quick temporary wrapping, parchment paper is a low-wax wrapping feasible for smaller paintings. Glassine works for large paintings.

Unstretching a work and rolling it around a large tube may be done if carefully executed. Make sure the back of the painting won't soil the front surface, by rolling it with a layer of parchment or glassine. Rolling is not recommended for higher gloss, tacky paintings.

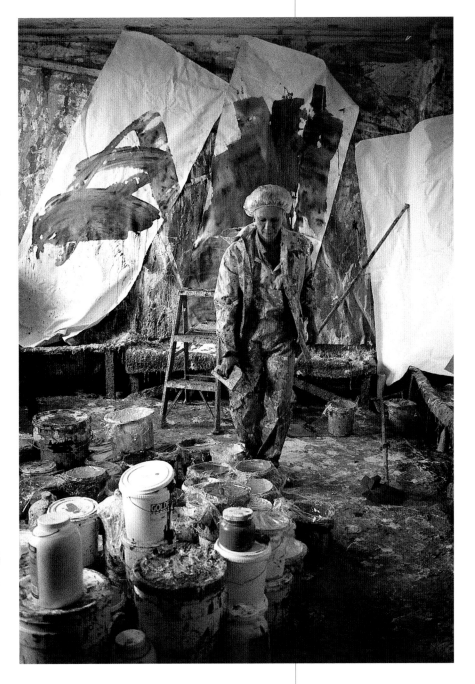

Safely attired in protective gear, painter Francine Tint works in the studio, employing a process that has paint flying in every direction.

Photo © J. F. Smith.

6

color

In terms of range of form possibilities, abstract art is no match for older art . . . at the same time, abstract art is free of those restrictions on color that older art perforce imposed. . . . Color gradually came to have the upper hand. . . . It is not a question of just covering canvases with wonderful pigments, but of making pure color pictorial. **Kenworth W. Moffett, art historian**

The first topic many painters talk about when describing their endeavor is color—that color is a primary concern. Color is present in all art, but in abstract painting, color takes on additional importance. It can be said that color is the subject matter of much abstract painting. Indeed, abstraction owns the style labeled Color Field painting.

After Minimalism's monochrome paintings, color seemed to decrease in importance. New materials, textural innovations, conceptual, and performance aspects, as well as a stronger sense of narrative received a share of focus. However, color continues to be one of abstraction's most potent idea-carriers.

EARLY COLOR THEORIES

Artists have either invented or adopted theories in an attempt to tame the dizzying complexity of color. Some theories try to identify primary colors and harmonious color schemes. Other theories expand the meaning of color to correspond with musical tones, psychological states, or levels of spiritual purity. While some of these theories are still widely accepted today, they are far from exhaustive in scope. For example, color theories that stress the role of "primary colors" are vulnerable on a number of points.

- The distinctions "primary" and "secondary" are of limited value. In nature, all wavelengths are created equal.
- Human vision is a complex mixture of evolutionary compromise, and retinas do not respond to all wavelengths equally well.
- Pigment character overrides the usefulness of many theories, even scientifically sound ones. We must be mindful from the start that a big divide exists between light waves and actual light-reflecting substances.

From Aristotle through Goethe, color theories need to be approached with skepticism. For example, Wassily Kandinsky's mystical writings described violet as red withdrawn from humanity by blue. Mondrian, too, seemed to struggle with philosophic doctrine:

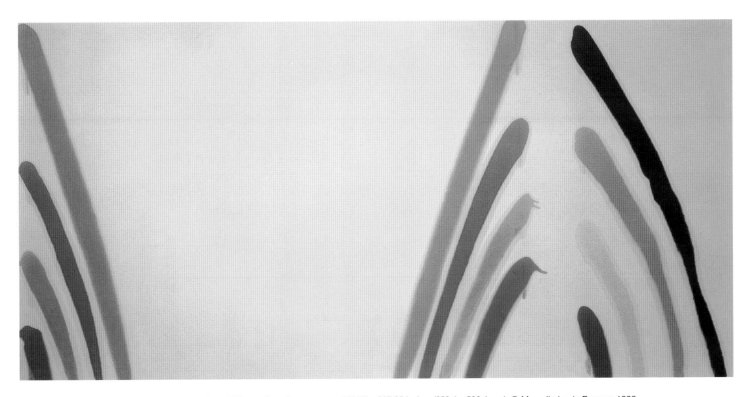

Morris Louis, *Delta Upsilon*, 1960, acrylic resin on canvas, 101.75 × 207.25 inches (258.4 × 526.4 cm.). © Marcella Louis Brenner 1993. The Estate of Morris Louis is represented exclusively by Diane Upright Fine Arts, LLC. Courtesy of Paul Kasmin Gallery, New York.

Louis was captivated by color to the extent that it could become alive in his presence. As Louis's personal intervention with the colored paint diminished, the artist let himself become passive and the paint took on the autonomy of a sentient being. The color displays its transparency, its ability to stain and soak and spread. The color responds to gravity and we almost see the paint flowing before our eyes. The downward force tears out the insides of the paint and we understand it has pigments that separate from one another. Almost as different aspects of a complex personality, the colors will mingle and argue their position with each other.

Gene Davis, *Black Balloon*, 1964, Magna on canvas, 93.5 × 171.5 inches (237.5 × 435.6 cm.). Courtesy of Charles Cowles Gallery, Inc., New York, and the Smithsonian American Art Museum, Washington, DC.

Says Davis: "I seldom think about color. You might say I take it for granted. Color theories are boring to me, I'm afraid. In fact, sometimes I simply use the color I have the most of and then trust to my instincts to get out of trouble. I never plan my color more than five stripes ahead and I often change my mind before I reach the third stripe. I like to think that I am somewhat like a jazz musician who does not read music and plays by ear. I paint by eye."

It is now that red emerges in his work as a colour in its own right. In Theosophy red was seen as earth-bound and sensual. Mondrian was not, or was no longer, concerned with colour symbolism, but in his letters he makes clear that he always regarded red as the most physical and least spiritual of the three primary colours. This belief cost him a great effort in reaffirming red's identity. Henceforth his blues are invariably tied to the blacks, while yellows are married to the whites and pale greys, while the reds assert only their own presence.

John Golding, historian

It is not fruitful to be too harsh on painters caught up in concepts, for often excellent work emerges through dogmatic theoretical underpinnings. It may be best to view color theories as diaries or personal attempts to integrate the artist's love of the medium with other cognitive spheres. As personal props, theories may "work"; extended to a more general application, they lose relevance.

Gene Davis . . . felt [stripes] provided a "simple matrix to hold the color and do not distract the eye too much with formal adventures." Like [Kenneth] Noland, he distrusted what he saw as Albers' system building, arguing that the painting must grow empirically under the painter's eye and hand.

John Gage, historian

Sometimes, a color theory may make sense in terms of normal perception but not in relation to aesthetic contemplation. For example, consider the notions that high-contrast colors are jarring and that closely related tones are soothing. A painting composed completely of close tones of black, for example, Frank Stella's *Marriage of Reason and Squalor* (see page 151) does not seem soothing. In this case, we experience high contrast in the placement of the black painting against a wall that is typically white. Add to this phenomenon the cultural prohibitions against monochrome paintings when black paintings were made in the 1960s and our Western association of black with death. The result is a powerful, demanding work.

I think there is a naïve and widespread misunderstanding about theories of colour. Take the colour circle . . . it is a purely theoretical concept existing in the mind but not in our actual experience. Nobody can ever paint it out correctly . . . you get involved with pigment-and all the scientific purity is lost. . . . [There is] an immense range of variables which govern your vision.

Bridget Riley, artist

COLOR SCIENCE

Facts about color embrace the physics of light, the physiology of human perception, and the chemistry of paint.

Light has different wavelengths of energy. Our eyes have three kinds of cone cells sensitive to either blue, green, or red wavelengths. Refracted through a prism, light makes a spectrum of colors along a band of wavelengths. The reason we conceptualize a color *wheel* instead of just a color *line* is that humans perform retinal and mental blending of light waves. This explains why purple and red seem similar to us—even though they are at opposite ends of the wavelength spectrum.

Sir Thomas Newton added significantly to our understanding of the science of color:

The most revolutionary aspect of Newton's work was his demonstration that the different hues of the spectrum are caused by a fundamental attribute of light he called "refrangibility." He found that each spectral color has a unique and unchanging angle of refraction when light is passed through a prism, and that pure spectral "orange" or "violet" light are just as primitive or basic as "red" or "green" light because none of these spectral hues can be broken down into any other color. However, they could be "mixed" in any combination to make other colors, including all the dull colors of nature and colors (such as red violet) not found in the spectrum, and Newton even showed that three or sometimes just two spectral hues could mix to make a "white" light. These and other findings led

Newton to reject both the ancient Greek theory that colors arise from mixtures of light and dark, and the contemporary painter's theory that there were just three "primary" colors—red, yellow and blue.

Bruce MacEvoy, authority on watercolor

Newton also discovered that the color magenta, while it is found in nature, does not exist in the spectrum. This led Newton to correctly assume that some color-mixing takes place in human perception.

THE THREE DIMENSIONS OF COLOR

Color embodies the three dimensions of value, hue, and chroma. If we see blue we need to know further, "Is it bright and intense or grayed-out? Is it paled with an addition of yellow or darkened to navy blue?" It takes some effort to appreciate the importance of both value and chroma, since hue is a culturally dominant attribute of color. In our language, "color" is more often used to refer to hue and almost never to describe value or intensity.

Joanne Greenbaum's work-in-progress, a 2004 oil painting on canvas. Photo courtesy of the artist.

Greenbaum applies glazes of oil paint. The combined hue of the ultramarine blue and geranium lake produce a clear blue-purple. The numbers on the painting will be left in; Greenbaum paints them during the process of building up her layers of forms in order to "expose the process," an impulse that is in line with her unpretentious brush handling.

Bill Komoski, *4/3/04*, 2004, acrylic on canvas, 68 × 56.75 inches (172.7 × 144.1 cm.). Courtesy of Feature, Inc., New York, and the artist.

The restricted palette feels unrestricted because of the strong manipulation of value across the surface, which creates a forceful sense of light. Komoski explains: "The many elements in the painting present a range of materiality/ immateriality. The softness is about creating a silvery light, a distinctly different sort of focus from the other elements in the painting. . . . I'd like to provide an experience that allows the viewer an opportunity to look at something that feels like thought: unfocused, concentrated, dreamy, analytic, dyslexic, humorous thought."

Pat Lipsky, *Bourges*, 2000, alkyd, oil, and acrylic on canvas, 64.5 × 75.5 inches (163.8 × 191.8 cm.). Courtesy of Elizabeth Harris Gallery, New York, and the artist.

Context conditions our perception of color. In *Bourges*, Lipsky drenches our senses with alternative values and saturations of closely aligned hues. Each hue, seen in another setting, might evoke sky. But in this painting, the overwhelming focus is an analysis of blueness with regard to a rhythmic composition. Reference to nature is eliminated almost completely in favor of an intellectual, optical exploration.

Value

Value, or luminosity, is the degree of light or dark a color possesses. In a biological sense, value discernment is actually a more fundamental visual process than is hue discernment. Texture, edge-detection, light source, and fullness of form are cues delivered by value discernment. A high-key color is light in value; an example of a high-key color is cadmium yellow. A low-key color is dark, such as ultramarine blue. The highest-key color is white and the lowest-key color is black. Any two colors, when mixed, create a value somewhere between the two unmixed values. When mixing, darker pigments can quickly overpower lighter ones, so proportions must be adjusted with this in mind.

Attention to luminosity can give a painting a "sense of light" without seeming to depict natural space or perspective. When we want to avoid a naturalistically coherent reading of solid mass in an abstract work, we have to pay close attention to the handling of value and avoid shading and consistent light source.

Painters sometimes train their sensitivity to value by making monochromatic compositions with a limited black, white, and gray palette. Such a composition, used as an underpainting for subsequent transparent glazes of hue, is called a "grisaille." Surprisingly, this exercise mimics human perception, in which separate optic channels carry information about value and hue to the mind.

Hue

Hue is the wavelength of a color. Since we never see a single wavelength of color in isolation, the color we perceive has character based on its context or surroundings.

Remember that color models that identify "primary" and "secondary" colors are disputable. Instead of seeking out primary colors, we can shift our focus to developing a restricted set of paint colors that will generate most other colors. A workable and versatile set of three "primaries" is yellow (hansa yellow), magenta (quinacradone rose), and cyan (phthalocyanine cyan). To these three we may add the "secondary" colors—ultramarine blue, cadmium red orange, and phthalocyanine green YS. The additional hues allow for more intense mixtures.

By definition, two complementary colors should mix to a truly neutral gray. While lights from a spectrum can easily be so paired, paints are less cooperative. In fact, one pigment may have more than one complementary pigment, and it is especially difficult to find complements for yellows.

Creating personal color-mixing experiments from a self-selected group of pigments is a good exercise to deepen familiarity with colors and pigments. Many painters find themselves in situations where they will not mix colors, whether for aesthetic or technical reasons. (Mixing requires a type of tasteful finesse which may be antithetical to their approach. And working fast under the time pressure of an improvisational approach doesn't allow an artist to stop and mix.) Using paint straight from the tube or can means that a large collection of colors will probably be required. The paints' pigments contribute so much idiosyncratic behavior that a good color chart with mass tone and undertone greatly aids the painter.

Chroma

The third and last quality of color is chroma. Also referred to as "intensity," chroma is the degree to which a color is "grayed" or "muddied." Adding gray to an intense hue decreases its intensity. When chroma is adjusted in accordance with the brightness

of the hue, it is called "saturation," and refers to the richness of a hue as compared to a gray of the same brightness. Generally, today's commercially available pigments offer more intense color for the warmer hues as compared with what is available for the cooler hues.

It can be difficult to distinguish between the meanings of value and chroma. An easy way to remember this is to think of value as the measure of a color's light, while chroma is the measure of the hue's purity.

RELATIVE COLOR

All three color attributes—value, hue, and chroma—attain their character in context. Physiologically, our eyes dilate to accommodate varying light levels (tonal variations), and the stores of enzymes in our cone cells are depleted when we fix on a particular color (giving rise to negative afterimages). The eye must make these adjustments quickly as we look from one color-form to another. Thus, each color is affected by its surroundings.

Layers of tones create an electric tension. Colors found in pharmaceutical manufacturing, surely among the most "artificial," are Finklea's inspiration: "Broad slabs of highly saturated pigment contrasted chromatically with equally saturated masses of color. . . . One viewer concluded that I had stacked two painted forms upon one another. In other smaller works the colors seemed to slide apart and disconnect from one another. It was optically difficult to connect two colors together in most of the work."

Color Contrast

A group of colors, or color scheme, will contain contrasts. These contrasts set up expectations. If, for example, the majority of the picture plane is covered in closely related hues, one area of great chromatic shift will be jarring. In this way, expectations condition our satisfaction with color.

We often speak of colors' relative "temperature" as being "warm" or "cool." Lightness is also a function of its surroundings; as the pupil adjusts to ambient light, our sense of what is "white" and what is "black" can shift dramatically. Hue intensity is also determined by context. Consider the how deeply green a grassy, rain-soaked field seems to be; next compare a single blade of that grass to green from a paint tube.

Color Harmony

Color harmony is a confusing concept in painting. The color scheme will represent some part of the visible spectrum. If by harmony we mean a pleasing combination, then it is unlikely that any agreement can be found as to what types of color schemes fall within this range.

Suppose that we averaged the hues in an entire painting surface by mentally condensing its color scheme to a single color. Such a composite color note could be called a "color gestalt." Although we are ignoring, for the moment, variety and location of colors, this composite color note gives a sense of the painting's identity with respect to the concept of harmony.

"Harmony" has, at times, been equated with "balance." As such, a balanced color scheme should draw hues from all along the spectrum, balancing warm and cool and thus ultimately blending to a color gestalt of gray. As the well-known color theorist Johannes Itten wrote, "Harmony in our visual apparatus, then, would signify a psychophysical state of equilibrium in which dissimilation and assimilation of optic substance are equal. Neutral gray produces this state."

This said, it does not follow that we should strive for a balanced spectrum in all painting. The unbalanced, off-center color gestalt is an important factor in developing a painting's mood. Expressive color schemes, in Itten's view, are possible.

Bruce MacEvoy, Artist's Color Wheel, last revised 2/02/2003. © 2004 Bruce MacEvoy, http://www.handprint.com/ HP/WCL/wheel.html. Courtesy of Bruce MacEvoy.

"My [MacEvoy's] artist's color wheel starts with the masstone color locations of the 90 most commonly used watercolor pigments. . . . The pigments were measured as slightly diluted watercolors applied to white watercolor paper rather than the normal oil/acrylic painter's method of mixing with titanium white. [Oil binder tint] shifts the hue, generally toward yellow, and for some pigments such as the phthalos this shift can be large."

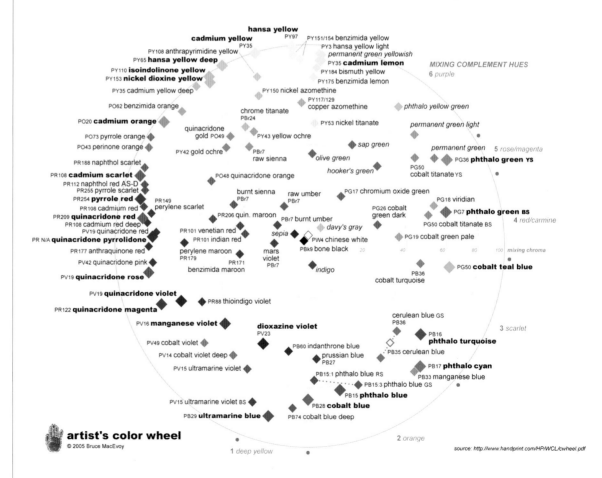

If our color schemes are to be useful rather than always "harmonious," we can be more objective in considering what color gestalt we need as well as how much contrast and variety the color scheme should contain.

PIGMENTS

While value, hue, and chroma can be described in isolation, in practice we meet all three aspects combined in the form of commercially available pigments. Modern color makers have produced some of the highest quality paints ever available. Moreover, the number of commercially available pigments has mushroomed over recent decades, the effect of which is clearly evident in the relatively theatrical color schemes in some contemporary artwork. Aside from the intensity of phthalocyanines, we have fluorescents, iridescents, and metallics in both oil and acrylic formulations.

Notable pigment qualities are:

LIGHTFASTNESS This is how well a pigment resists fading when exposed to sunlight.

TRANSPARENCY Transparency is a function of the refractive index of both the pigment's and the binder's molecules. Pigment particle size is also a factor in transparency. Therefore, obtaining the pure form of the pigment for any purpose is important, as is the quality of the milling process. Lead (flake) is the most translucent white, and it becomes more so as it ages. Titanium is the most opaque white. When mixing, opacity can quickly overpower transparency.

TINTING STRENGTH Tinting strength is the degree of color change when a color is mixed with a different color. The tinting strength of phthalocyanine blue is forty times that of ultramarine blue. Warm colors are almost entirely synthetic organic pigments with a high tinting strength.

OIL ABSORPTION Oil is not absorbed by individual pigment particles. Rather, this term refers to how much oil is needed to effectively surround and suspend particles. Smaller particles need more oil than larger particles.

INORGANIC AND ORGANIC BASIS Inorganic pigments are minerals and generally have larger particle size. In a very liquid dispersion they will settle first. Organic pigments are plant or modern synthesized pigments. Being smaller, these particles are often more transparent and have a higher tinting strength.

DRYING SHIFTS Changes in hue take place in both oil and acrylic binders, but as discussed in chapter 5, this phenomenon is most problematic in acrylic paints.

BINDER The vehicle in which the pigment is suspended will affect the optical hue of the paint.

CULTURAL CONDITIONING AND COLOR PERCEPTION

Just as colors get retinal conditioning from their surrounding colors, cultural conditioning also at least partially determines our mental processing of colors. Cultural messages come from our personal life experiences, the market, cultural, and educational

Joanne Mattera, *Uttar 248 (Madrugada)*, 2004, encaustic on four panels, 48 × 67 inches (121.9 × 170.2 cm.). Courtesy of the artist.

"I've called the series Uttar," says Mattera, "because I wanted a word that referred to India. . . . Uttar Pradesh is the name of a province in India in which Agra, site of the Taj Mahal, and the ancient, holy city of Varanasi are located. Besides, it sounds similar to the English word 'utter' . . . as in 'to give expression,' and as in 'total and unconditional,' which is essentially what I'm feeling about this work."

institutions. We should expect the various influences to sometimes contradict each other. A color-form may have a mixed set of messages. Color schizophrenia happens all the time, when a color seems forbidden by one mental influence and welcomed by another.

Traditions of Color

A culture invests colors with specific connotations. For example, within the Chinese Tai Chi tradition, the color of enlightenment is violet, yet within the Christian church violet is used to represent penitence. In some cultures the identification of color with concept may be very rigid, while elsewhere we find loose or varied correspondence of color to concept. Regional color myths create a culture-specific palette wherein some hues are more popular and widely used than others. Use of a particular palette or color scheme may conjure up the flavor

of that region or culture in viewers already familiar with that culture. It would be a mistake, though, to overreach the correlation between a specific tradition and colors in an artwork.

> I have laid most emphasis on the instability of colour-perceptions because it should give pause to those many ethnographers and semioticians who have been tempted to speak confidently of colour-meanings and preferences in many cultures.
>
> *John Gage, historian*

Economics of Color

The monetary price of a pigment gives it cultural value. For example, blue pigments were scarce until the early eighteenth century, when Prussian blue was chemically synthesized. Scarcity led painters to

reserve blue for the most sacred subjects, such as the dress of the Madonna.

Color schemes mutate over time due to pigment innovation. The number of modern synthetic pigments has affected current painting practices. The invention of aniline dyes produced a fad for purple in Victorian times. We saw the incorporation of fluorescent colors in paintings during the 1970s.

Color and the Mass Media

Media research makes these pronouncements about color's emotional connotations:

Lime green and avocado induce nausea.

Orange is disliked in the United States but well liked in the Netherlands.

Yellow combined with black is interpreted as a warning and also connotes power.

Blue is the most likeable color. It is cool, cold, dark, soft, the color of life, masculine, and feminine.

While perhaps strangely true in a commercial setting, these statements are less relevant to perceptions of paintings. Consider the casual attention of looking at a package compared to the intense focus of evaluating a painting. Color schemes in an art setting carry art-historical connotations. For example, the three colors red, blue, and yellow bring to mind work by Mondrian, Barnet Newman, and others. As such, this triad carries an emblematic charge. Pastels may evoke associations with Impressionist paintings. Saturated tones and Day-Glo colors are linked to our conceptions of Pop or Neo-Geo aesthetics. The expectations, which are the context of looking at art, are vastly different from those tied to our experience of the marketplace.

> In some . . . cultures, moreover, a disdain for colour has been seem as a mark of refinement and distinction . . . yet [the] experimental psychology of van Gogh's time [showed] that a love of strong, saturated 'primary' colours was not the preserve of primitives and children, but was also common among educated European adults.
>
> *John Gage, historian*

However, we might be surprised at how insidious the influence of mass culture is. To think we can fully disengage art (with a capital *A*) from the sphere of commerce and media-drenched popular culture is self-deception. We should expect that commercial culture persuades artistic color sense, and vice versa.

Consider how the stylistic innovations of Warhol, Bridget Riley, and Mondrian found their way into mass markets. There is a two-way interaction between innovation in painting and popular culture. Before we look at a painting, we are already culturally conditioned. This said, we also can expect a painting to have an effect on culture. The painting offers its expression, and we, the viewers, approach it with a heightened sense of awareness and a desire to be challenged. A painting is an active synthesizer, and perhaps a leading indicator, of contemporary thought. Art is meaningful when it crystallizes connections between disparate parts of our lives.

The expressive power of a color is conditioned by so many variables that we have to rely on our visual intuition when judging each application. The problem with intuition is that it is unverifiable. The best approach is to temper intuition with critical looking and experience.

Lori Ortiz, *Reflectors II*, 1989, oil on canvas, 20 × 20 inches (50.8 × 50.8 cm.). Courtesy of the artist.

Ortiz makes an amazingly severe painting break into representation of our near-universal automobile culture. This referencing is accomplished through color.

7
form

Form is all we have to help us cope with fundamentally chaotic facts and assaults. Formulating something is a great start. I trust form, trust my feeling or capacity to find the right form for something. Even if that is only by being well organized. That too is form.

Gerhard Richter, artist

We can conceptualize form and color and texture as separate entities. They are, however, nearly inseparable in our *experience* of an artwork. This chapter describes considerations of pictorial form, or the shapes and marks that we perceive as being separate from other visual units on the picture plane. (Chapter 9, "Composition," treats compositional concerns and the actual, physical form or shape of the painting.) For the purpose of considering the broad subject of form, distinctions between linear and painterly forms, as well as those between gestural, biomorphic, and geometric forms, are useful categories.

FORM AND COLOR

Over a period of time, the emphasis in abstract painting shifts back and forth between form and color. When Color Field painting was ascendant, form was less in the spotlight. However, even when color dominated, form continued to engage many painters as they grappled with the permission Pollock had given them to lay down marks. If a brush was not the only way to transport paint to the canvas, laying down marks became a wide-open area of experimentation. As the introduction of new pigments affected painters' choices of colors from the 1950s onward, so did the introduction of acrylic paint alter the expectations and "rules" of paint application.

Painting has many problems, but the foremost is the synchronized development of both form and color. Both developments are aesthetically identical in their relation to the picture plane.

Hans Hofmann, painter and teacher

POINT, LINE, AND PLANE

When an artist places a mark on a blank surface, the mark destroys a pre-existing unity. Paradoxically, if the artist makes a series of marks, depending on their arrangement the marks may create a new unity.

Early in the history of abstract painting, Wassily Kandinsky described the basic pictorial marks as being the point, the line, and the plane. This is a reasonable taxonomy, although we can see that, in the real world, all of these marks are planes. (Pure points have no dimensions, and lines have only length and no width.) As we think about these categories, we should not presume that these forms sit like blobs on a picture plane. That is a simplistic conception of what marks on the canvas really do.

Joanne Greenbaum, *Renovation Project*, 2003, oil and flashe on canvas, 78 × 78 inches (198.1 × 198.1 cm.).
Courtesy of D'Amelio Terras Gallery, New York, and the artist.

The layering of basic shapes proceeds slowly, building up a floating spaceship-like structure of forms. A classic foreground/background atmosphere supports a sensibility of humor.

Monique Prieto, *Descent*, 2003, acrylic on canvas, 72 × 84 inches (182.9 × 213.4 cm.).
Courtesy of Cheim & Read, New York, and the artist.

In this painting, Prieto has two classes of forms. The pale blue on the upper left is in a class by itself. The other forms are grouped as a similar type, since they are all verticals and all "stand" on the lower edge, which reads as a horizon. "My drawings are done almost always on the computer," Prieto reports, "so I work from an 8¹⁄₂ by 11-inch inkjet printout. The color range of the technology never quite meets my expectations but the printout functions well as a reminder. I choose the form I will paint first and mix that color in its own pot. I will sometimes use a combination of previously mixed colors and unmixed colors to create a new color, but I never re-use a previously mixed color . . . without some adjustment."

For example:

- We may not be dealing with classic forms on a background. Many paintings subvert the figure-ground reading of shapes; this phenomenon is discussed in chapter 10, "Pictorial Space."
- The edges of some marks will be so blended that their contours may be invisible. In such cases, they exist almost as a "force field" with an indistinct visual pull.
- Aleatoric or mediated application of shapes without using a brush (pouring, staining, screening through templates, and collage are examples) stretches the traditional conception of what a mark on canvas can be.

If we look at basic drawing units across cultures and across history, we see repeated use of what might be called ur-symbols, or fundamental shapes. These fundamental shapes have universal qualities that at least partially transcend culture. Perhaps the mind has an innate geometric sense.

> Abstraction—of any kind, geometric and gestural—is a pursuit of the source of geometry, an attempt to delve the place from which it comes. And that source, that essence of the geometric, constitutes the profound mystery, for we know nothing else of its kind. It is neither a fact—for it cannot be localized in a world of facts, any more than gravity can be—nor is it an idea.
>
> *Sol LeWitt, artist*

As discussed in chapter 6, "Color," hue and value are understood relative to their surroundings. Context also plays a large part in the way we perceive marks on a painted surface. For example, a short brushstroke might be perceived as a line if it is situated among relatively smaller marks; the same brushstroke may be read as a point if it surrounded by much longer brushstrokes. So, we can see that the mind categorizes both colors and forms.

Point

As the most primal mark or form, a point has one fundamental characteristic: location. We conceptualize a point as a form with no direction and with nominal weight and mass. It represents a location or a presence but doesn't imply any character to that location. While a point has a relatively indistinct

character, it represents an action, a break from the background of the picture plane. Within painting, it has color and size, and it can convey some sense of its application, be it gestural or mechanical.

> The point digs itself into the plane and asserts itself for all time. Thus it presents the briefest constant, innermost assertion: short, fixed and quickly created.
>
> *Wassily Kandinsky, artist*

Line

A line, unlike a point, has at least two characteristics in addition to location: length and shape. Lines may be understood as one of two things:

AN EDGE OR CONTOUR A line has the potential for being a contour, especially when the two endpoints reach the edge of the canvas or reach the edge of some other planar shape.

A SOLID OBJECT This is when a line is really a plane. If a line doesn't feel like a contour, it feels like a path.

We cannot conceive of a line as being both of these things at the same time. But a painting can lead to a shifting indeterminacy between these two readings of the form. Barnett Newman's "zips" shift between two readings, perhaps appearing to be an opening space at one moment and the next moment giving the impression of being a division between two larger planes.

Lines are the basis for drawing. In turn, linear brushwork in paintings enables qualities that mass-like planes cannot manifest. For instance, a line can be rendered in such a way as to suggest speed and direction. A series of converging lines reinforce direction and appear to move faster. Lines in opposition that cross-hatch space appear slower and suggest balancing rather than unbridled speed. In addition, the meeting points of overlapping lines are locations of higher visual weight.

The associations of curved versus straight lines vary depending on the type of application. Within a geometric scheme, a relatively straight line feels fastest and seems uninfluenced by other forces; a geometric curved line gives the sense of having been acted upon. However, a gestural straight line suggests speed and also tension—or at least rigidity. A curved gestural stroke has less tension but more freedom.

Pat Passlof, *All Done*, 1998, oil on linen, 75 × 65 inches (190.5 × 165.1 cm.). Courtesy of Elizabeth Harris Gallery, New York, and the artist.

The artist's consideration of the touch and the questioning borders result in a linearity that wavers as it moves from the lower right to upper left. She says, "What happens on canvas escapes the mind: the viewer responds with some sense, quite possibly a sense developed thousands of years ago and hardly changed."

Whereas the straight line is a complete negation of the plane, the curved line carries within it a seed of the plane.

Wassily Kandinsky

This distinction acknowledges the possibility that the curve may "contain" some portion of the picture plane, as a cup holds water. A line can be open or closed; it can end on itself, as a ring, without becoming a plane.

I construct lines and color combinations on a flat surface, in order to express general beauty with the utmost awareness. . . . I want to come as close as possible to the truth and abstract everything from that, until I reach the foundation (still just an external foundation!) of things. . . . I believe it is possible that, through horizontal and vertical lines constructed with awareness, but not with calculation, led by high intuition, and brought to harmony and rhythm, these basic forms of beauty, supplemented if necessary by other direct lines or curves, can become a work of art, as strong as it is true.

Piet Mondrian, in a letter from January 1914

Lines can be applied to the painted surface in a variety of ways. If a brush is used, the brush size, shape, and degree of hair stiffness largely determine the character of the line. A line may be rendered with a single stroke, or gone over numerous times. Alternatively, lines may be dripped, squeegeed, sprayed, or etched.

The line's orientation on the picture plane also matters. The general path of the line may be diagonal, vertical, or horizontal; each of these orientations can carry associations of figure or landscape when other elements reinforce this suggestion. A diagonal line is perceived as more dynamic than a horizontal or vertical line. Lines can be grouped to suggest receding pictorial space. Intersecting lines create nets or grids.

One of the best teachers I ever had looked at a painting of mine and said, you are drawing lines when you should be making them. Lines are things— and they should be built, lived and thought through. Lines are just another kind of shape on the paper.

Thomas Nozkowski, artist

Plane

A plane is the most visible shape on a painting's surface. A plane has least three characteristics: location, size, and shape. The combination of size and shape allows a plane to have mass and to "own territory" on the picture plane. Because a plane has mass, it can be rendered in more ways than lines or points can. Its complexity is its great power, and with this power comes large pictorial responsibility. Some of planes' capacities and qualities:

1 Within a single mass, color can be shaded or graduated, suggesting solidity or concave space.

2 Shape implies that the form will be primarily horizontal, vertical, or diagonal. Each orientation lends associations and creates directional force.

3 Symmetrical shapes, such as circles or squares, imply stability.

4 The contour of the plane can vary from hard-edged to gradually blended.

5 The way a plane's contour changes can also impart a sense of direction.

A painter must negotiate the sharing of territory between a plane shape within the picture plane and the picture plane itself. Again, the issue of pictorial space is involved, for even a flat, planar shape can be made to float optically at some depth in front of or behind the picture plane. As discussed in chapter 9, "Composition," the location of forms on the picture plane evokes specific readings or understandings of the form.

A plane can be open or closed, as can a line. Some ways to defy the sense of solidity in a shape and make it "open" are to:

1 Render the plane translucently, so that it may be perceived as a veil.

2 "Puncture" the plane with "holes" or other forms with the same color and texture as the background.

3 Scrape through the plane to reveal a texture of broken color beneath it.

CONTOUR: LINEAR AND PAINTERLY

More than a century ago, the German art historian Heinrich Wölfflin proposed that all paintings could be categorized as either "linear" or "painterly." This distinction lies in qualities of a form's contour or outline—how the edge of a form is distinguished from another form. Linear forms are clearly, strongly defined; painterly forms are loosely defined and may seem to merge into an overall mesh of paint.

Richard Pousette-Dart, *Ramapo Night*, 1962, oil on linen, 80 × 116 inches (203.2 × 294.6 cm.). Courtesy of the estate of Richard Pousette-Dart.

With patient repetition, Pousette-Dart accumulated myriad drops of color over a vast surface. Often using the paint tube directly, Pousette-Dart's pointillism develops into a shimmering sense of evening. The indistinct contour of the light form and the consistent texture across the picture plane diminish a clear differentiation between foreground and background.

James Nares, *Somewhere in the Desert*, 2003, oil on linen, 108 × 96.5 inches (274.3 × 245.1 cm.). Courtesy of Paul Kasmin Gallery, New York, and the artist.

The effect of Nares's scaled-up gesture overwhelms the viewer as if in the presence of something larger than life. While the gesture carries inferent expression, the repetition of broad gesture invokes an analytical sensibility—almost a "trial and error" experiment—and brings to mind a post-painterly cool retreat from overt expressionism.

complex marks are generally of a gestural nature, followed by a "biomorphic" category, and then, at the extreme end of regularity, highly geometric forms. These three categories can cross-pollinate, as they do, for example, in a gestural geometric shape.

Gestural Marks

In Abstract Expressionist painting, the gestural application of paint makes the artist's human presence highly tangible. Implicit in gesture is motion. For instance, a large bristle brush heavily loaded with paint may be worked wet-in-wet to communicate the performance of the brush stroke, often with a sense of speed or pressure to abet the sense of the painter's energy. Painterly gesture has transmuted substantially over the decades since the heyday of Abstract Expressionism to include calligraphic marks, scribbles that resemble handwriting, and remnants from computer-mouse doodles.

Biomorphic Forms

Biomorphic shapes—sometimes referred to as "organic"—tend to read as a symbols for nature or some natural object. Such marks have greater complexity, and therefore distinctiveness, than geometric shapes, but don't necessarily refer to the hand of the painter in the way gestural shapes do. Biomorphic forms achieve detachment from human physicality but not from human psychology, as these forms are often used to express surreal or dream-like figures.

> The violently colored, near-surrealistic paintings Kandinsky executed . . . incorporate unspecifically "biomorphic" imagery suggestive of the physical world. . . . [H]e utterly renounced pictorial representation in favor of "anti-logical" abstraction, convinced by his encounter with [the composer] Schoenberg that his art could somehow, like music, be thereby liberated from the realm of the material.
>
> *Terry Treachout, author*

The widespread use of oil paint in the Renaissance and afterward encouraged artists to explore "painterly" expression.

> [O]il paint introduced an opposition between the linear and the painterly. . . . The linear stressed clear contours and strong design; the painterly, "fullness of effect."
>
> *Terry Fenton, artist and scholar*

Detailed and sharply contoured areas draw the viewer's gaze. Hard-edge definition also lends itself to more detached, less gestural effects.

SIMPLICITY OF SHAPE

The forms all marks take in a painting can have varying degrees of complexity. The degree of simplicity is found in a form's shape, color, and texture. The most

Geometric Forms

The inherent abstractness of geometry induces a different approach: platonic detachment from human physicality and psychology. These forms can readily generate seriality and symmetry, which are sometimes accomplished by using templates.

Form independent of relatedness carries little meaning. It is building material without a blueprint. It awaits the creative process of composition, the blueprint, to acquire that meaning.

Barbara Takenaga, *Robusto*,
2003, acrylic on wood panel,
42 × 36 inches (106.7 × 91.4 cm.).
Private collection,
Courtesy of McKenzie Fine Art,
New York, and the artist.
Photo © 2003 D. James Dee.

An intricate cosmos of forms is knitted by Takenaga across the smooth panel surface. Varying pressure on the soft-haired brush tip creates lines whose widths expand, lending a sense of warped space. The biomorphic reference to nature is tied to an understanding of the ubiquitous geometry found in the natural world.

Steve Karlik, *Untitled (28)*, 2003,
oil and acrylic on wood panel,
18 × 24 inches (45.7 × 61 cm.).
Courtesy of Pentimenti Gallery,
Philadelphia, and the artist.

The artist comments: "Instead of overly romanticizing painting, I look at painting as an equation to solve, wherein each solution a more difficult equation arises. I approach my work through the Literalist emphasis on surface and unified field, carefully emphasizing the illusionism often associated with pre-Pollock Modernist Abstraction. My surfaces are detached, a sound-free ambiance devoid of personal expression."

8

texture

I really have come to the conclusion that what makes painting pleasurable—how we read it (that it tends to stay around and remain reasonably popular)—is that it's the one visual art experience that combines an image and a reading of texture at the same time. I think what a great painting is is a painting that we both read haptically, texturally—that we get a pleasure out of our material reading of it, like a van Gogh—and we also equally enjoy the image.

Peter Halley, artist

Thanks to our binocular vision, we are able to perceive different textures and depths of paint. By moving about in front of a painting, we can consciously experience its textural "presence." (Thus, viewing the work in person is critical to a full appreciation of it, as photographs often cannot convey the surface quality.)

The rewards of paying increased attention to texture when painting is that we can transmit sensory information at an almost unconscious level. Just as scent has a powerful potential to stir our emotions directly, so texture can reach us on an unguarded frequency, calling up distant memories that resonate with great force.

Texture can be separated into two categories: "literal" texture and "pictorial" texture. This chapter concerns itself with literal texture—the painted surface that catches light and casts shadows.

Pictorial texture, such as pointillism, is achieved by the richness of paint strokes (the marking) and is discussed later in terms of composition.

Paint texture can run from very thin and watery to mud-like impasto. Newer paint additives, such as metals and iridescents, leave a smooth surface yet create an optical "texture" through their reflective or refractive qualities. Reflectivity (the degree of glossy or matte on a surface) and paint granularity (the graininess of the paint itself) are also treated in this chapter.

In order to control texture, it is essential to match the paints to the receiving surface. If the texture is the result of thinly mixed and thinly applied paint, the surface of the support will largely determine the painting's final feeling. If a thick impasto is used, the surface material must be able to support the paint load applied to it.

Stanley Boxer, *Reaphoar*, 1984, acrylic on canvas, 30 × 30 inches (76.2 × 76.2 cm.). Collection of Laura Winchester.
Courtesy of Frances Aronson Fine Art, Atlanta, GA. Art © Estate of Stanley Boxer Licensed by VAGA, New York, NY.

Gestural and incident-ridden, Boxer's built-up, thick oil paint creates organic abstractions reminiscent of geological forces. "[Boxer] felt no sentimentality or attachment to the paint or the materials. He simply used whatever was required to get the job done," observed Boxer's widow, artist Joyce Weinstein. Boxer's utilitarian stance led him to incorporate sand, pebbles, wood chips, sawdust, seeds, fish tank pebbles, and glitter. Although his results were anything but traditional, Boxer prepared his support in a traditional manner, using rabbit skin glue. The glue was usually followed by a ground layer, then the oil paint. The textural agents were incorporated into the paint, sometimes before application, sometimes after.

TOP Pat Adams, *Until*, 2000, oil, grit, shell, enamel, and isobutyl methacrylate on linen, 48 × 114 inches (121.9 × 289.6 cm.). Courtesy of Zabriskie Gallery, New York, and the artist.

Adams believes in painting "ur-images," works whose primal meanings convey non-verbal experience. She is sensitive to the micro-shape of textural grain to predict larger pictorial shapes—the formative potential she calls the "morphological run," the premise of which is that the distinct grain of a texturizing substance prepares the viewer, at a subliminal level, for macro-level forms. For example, broken eggshells suggest a straight-edged, geometric shape.

BOTTOM David Miller, *Sedona Sunrise*, 2003, oil on canvas, 60 × 60 inches (152.4 × 152.4 cm.). Courtesy of the artist.

Miller achieves multiple effects with a modest build-up of texture. Through repeated layers of thinned washes, veils of color allow previous layers to be present only as texture. Scumbling lets some under-layer peek through. A range of reflectivity in the drawing from matte to semi-gloss provides further visual density. While some of the drawing is by brush, Miller also uses a pen-like dispenser of oil paint that gives certain areas an intimate scrawled effect, reminiscent of doodles or graffiti.

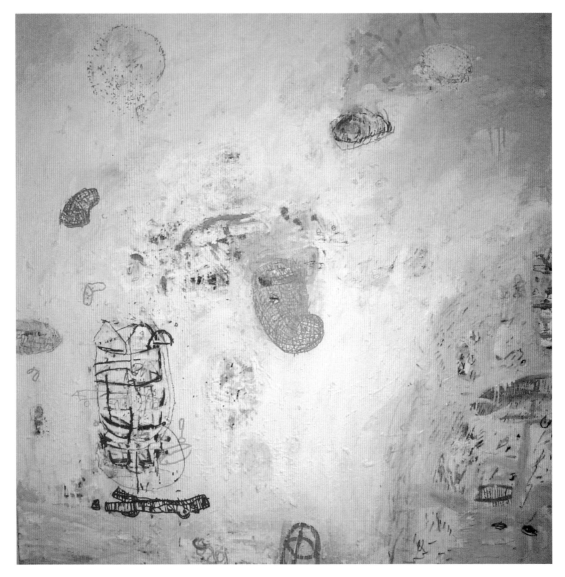

THIN PAINT TEXTURE

Textureless painting can seem dull compared to other effects. But plain, flat paint may be desirable in conveying a sense of mechanical restraint by limiting the degree of gesture expressed in the paint. Thin application allows the painter to let other aspects of the art dominate the viewer's attention. With thin applications of paint, the character of the support is largely retained in the final work. Therefore the fabric chosen as well as the absorbency and reflectivity are critical. Thinned paint applied in numerous glazes over a textured region will diminish or eliminate the underlying texture.

For oil paint, thin application is the most desirable. This is because thin paint layers create less opportunity for the paint film to crack or to move counter to the movement of the underlying support. Thin-layered canvases are also more easily removed from stretchers than thick-layered paintings.

Paint straight from the tube, be it oil or acrylic, will hold the texture of a brush stroke. A moderately thin application of paint can be made virtually textureless either by physically leveling the paint (brushing back and forth with counter-strokes) or by diluting the color to a low viscosity that self-levels. (One of the attractions of house paint to the abstract painters of the mid-twentieth century was its self-leveling quality—so different from artists' oil paints.)

If you dilute paint, you must be careful to retain enough binder to hold the pigment to the support once dry. (Test a dilute mixture by rubbing a dried sample to see how much color comes off with physical contact.) Thinning solvents are used to make extremely dilute washes of oil paint. You should limit your exposure to them and always wear a respirator. To achieve a thin wash of acrylic paint, add water or very thin medium to the color mixture.

When paint is extremely thinned, heavy pigment particles can separate from the binder. The pigments may then nestle into the ridges of the underlying support, accentuating the surface texture of the support, This effect, if desired, can be manipulated by using different fabrics as supports.

Thinned paint, both oil and acrylic, tends to dry to a matte finish. This can be modified after drying by the use of gloss varnishes.

THICK PAINT TEXTURE

Comfortable in many thicknesses, acrylics allow adventuresome applications of paint. Conversely, layers and layers of dense oil colors, especially on fabric supports, ultimately become a brittle mass that may crack or delaminate. Typically, a thick mixture should be applied to a dry surface in order for it to retain its character. Thick acrylic paint applied to a wet surface will generate a "halo" of color around the thick application of paint. Paint thickeners can be chemical agents or physical bulk-builders.

Paint Granularity

We normally think of texture in terms of the physical surface left from the application tool: brushstrokes, trowel ridges, or palette knife slash marks. A secondary texture comes from the texture of the paint itself. Suggestive of earth, textured paint has a substance and weightiness that asks to be touched. To make it granular, texturizers are mixed into the binder or flung on top of a pool of wet binder to become an underlayer for further painting. Available in different shapes and grain sizes, glass beads and shredded rubber may be purchased from art or craft suppliers. Sand is another commonly used texturizer. Some artists have used less stable substances such sawdust, coffee grounds, and tobacco that would seem to have long-term risks, including making cleaning very perilous. Keep in mind that unless the granular material is used modestly, oil paint may not be the best binder for this sort of effect.

Accentuating Thickness

For passages of heavy impasto, whether oil or acrylic, many techniques can be used to accentuate the build-up.

- Sanding or grinding the top layer when the paint is dry creates an effect that mimics erosion. Buried layers of color get revealed.
- Spraying or airbrushing color from an angle accentuates the experience of depth.
- Brushing or rubbing a glaze into crevices on the surface can emphasize surface texture.
- Lightly touching paint to the top "peaks" of the texture with an advancing color will heighten the painting's textural dimension.

ways to thicken acrylic and oil paints

FOR ACRYLIC PAINT

Use purchased pre-thickened colors. Mediums with a relatively high proportion of acrylic resin solids (over 50 percent) will not run or self-level. You may add a thickening agent to an acrylic mixture. Or mix a few drops of thickening agent per cup of color and stir quickly. Alternatively, you can add solids such as silica, clay, and sawdust.

To recover from mistakes, remove layers before they dry. It is possible to sand down dried paint, but it is not easy. Once impasto is dry, it is generally best to accept the dense surface it creates.

FOR OIL PAINT

Mix tube paint with commercially available gels, even if adding non-paint texturizers. Cold wax mediums can also thicken oil colors. Aluminum stearate may be added a drop at a time to linseed oil and then to oil paint. Clay and alabaster plaster fillers bulk up without adding additional granularity to oil paint.

Oil paint can be lifted off while wet and the support cleaned. If the impasto has dried, carefully scrape with a palette knife and then sand the support.

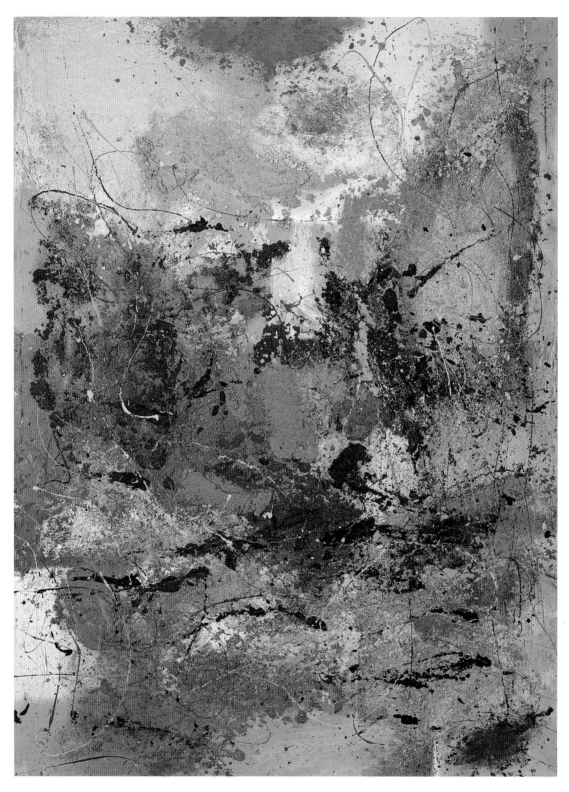

Richard Timperio, *Sandpainting 5*, 1995, acrylic with grit on canvas, 96 × 72 inches (243.8 × 182.9 cm.).
Courtesy of Sideshow Gallery, Brooklyn, and the artist.

Timperio generates a fiery chaos whose natural language is improvisation. The surface runs a range from stain to thick paint daubs to accumulations of sand-like grit. He augments the physical texture—which casts shadows to break up the color areas—with dribbles and lacy skeins of flung paint that splatters to form another type of visual sparkle.

INCISED SURFACE

Sgraffito is a decorative technique whereby the artist cuts, etches, or incises a surface's top layer, creating a low relief. The sgraffito technique can be used to add texture to the painted surface, and the resulting lines are usually much thinner than could be painted with a brush. Incised lines can lend a delicate, sometimes mechanical, sensibility.

Working on panel is suggested so that the support will not be damaged by the vigorous removal of upper layers. Acrylic itself is quite tough—especially in gloss formulation. Before application, acrylic paint can be "conditioned" (lowering the percentage of tough resin) by mixing in silica, chalk dust, or other soft material—or by beating air bubbles into the paint to make it foamy and spongy. Oil paint accepts cuts readily since it doesn't fully dry for a year or more.

After any "deepening" of the surface, one can highlight the cuts with a toned glaze which will accumulate in deeper-toned ridges at the incised points to create a "drawing" from the incisions.

IMPRESSED TEXTURE

Texture can be pressed onto a wet paint layer. Impressions may be peeled off quickly or left to dry in place.

■ On viscous wet paint, lay down waxed paper and press firmly into the layer of wet paint; this "imprint" will create a stucco-like surface when the waxed paper is lifted off.

Caio Fonseca, *Pietrasanta Painting CO3.23*, 2003, mixed media on canvas, 28 × 38 inches (71.1 × 96.5 cm.). Courtesy of Paul Kasmin Gallery, New York, and the artist.

The artist has incised delicate lines and dots into the surface to contrast with large flat areas. The texture of the incision is emphasized by a slight glaze that accumulates in to a deeper surface, an alternate form of drawing.

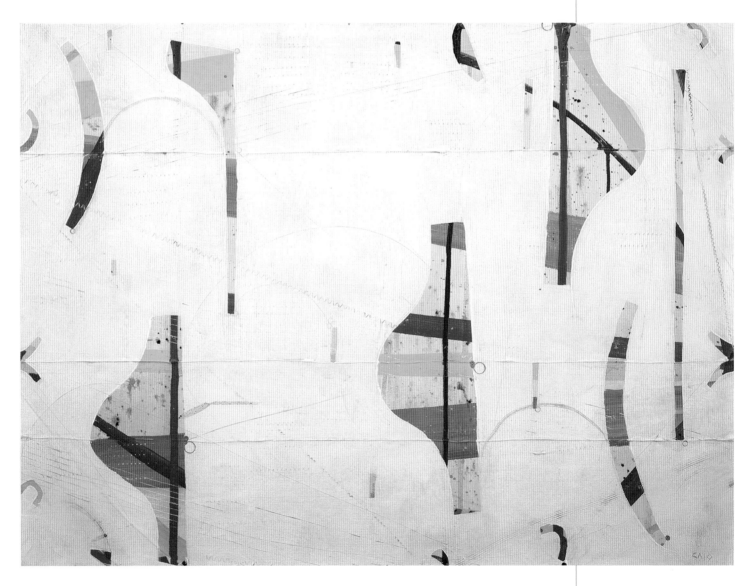

GLOSS

LIGHT WAVES IN SYNC
SURFACE FILM SMOOTH
PIGMENT PARTICLES

SEMI-GLOSS

LIGHT WAVES SLIGHTLY SCATTERED
SURFACE FILM SLIGHTLY IRREGULAR
PIGMENT PARTICLES

FLAT (MATTE)

LIGHT WAVES SCATTERED
SURFACE FILM VERY IRREGULAR
PIGMENT PARTICLES

RIGHT Vicky Perry, *Crust/Canyon* (detail), 1987, acrylic on canvas, 18 × 24 inches (45.7 × 61 cm.).

This example of reflective effects and impression-produced texture was developed while the thick acrylic was still wet by impressing it with crumpled aluminum foil. When the acrylic dried, the foil was removed. The surface was brushed with acrylic medium and then dusted with metallic powders. The metallic reflectivity accentuates the underlying texture.

- To create a crinkled texture, a moisture-resistant covering (such as heavy-duty aluminum foil, waxed paper, or cling wrap) can be applied to the wet acrylic paint, then massaged into it and allowed to dry in place before peeling it off. (It's helpful to first spray a non-stick coating on the covering to aid in removal.)
- To accentuate this or any texture, follow up with a thin wash of color.

REFLECTIVITY

A painting's texture is also defined by how glossy or matte the surface is. This dimension of the artwork is often subtle and unphotographable. High gloss evokes the sense of fresh paint or wetness and brilliance and is achieved with slick paint films. Acrylic medium is inherently glossy. Adding a resinous medium to oil paints will enhance these paints' glossiness. Gloss effects can also be achieved using glaze techniques and metallic pigments. (Dust metallic pigments over a wet paint film, as acrylic medium can tarnish them if they are mixed in.) For highest reflectivity, burnish these pigments after the paint is dry.

The velvety finish of a matte surface has a sensuous quality that seems aged and encourages tactile interaction. Because matte surfaces have "tooth," they are easily dirtied. Matte can be introduced to oil or acrylic mediums with a higher load of large pigment particles (generally the inorganics) or with substances such as silica that "punctuate" the paint film to make the surface uneven. For oil paints, adding cold wax medium can increase the matte quality.

NAP

A nap surface reads differently depending on the viewing angle, as velvet does. Its effects are due to a highly regular surface modulation and irregular lighting conditions.

One method to create nap is with comb-like ridges. These can be incised into thick wet paint with pre-patterned trowels. A way to achieve texture-less nap is to use interference colors, the kind of pigment that presents two complementary colors according to the lighting angle. These are available in oil and acrylic formulations as well as in powder form. Another method to produce nap-like effect is to cover the surface with glass beads that catch and reflect light at different angles. While small glass beads are generally used to introduce a sandy texture, larger size beads are flung over a fairly thin coat of wet acrylic or glue to create a field of light-catching elements, similar to crushed velvet or fur.

Peter Halley, *Gold Prison*, 2004, acrylic, metallic acrylic, and Roll-a-Tex® on canvas, 47 × 44 inches (119.4 × 111.8 cm.).
Courtesy of Mary Boone Gallery, New York, and the artist.

Areas of stucco are played against clinically clean flatness to create subtle textural effects, allowing about the only hint of sensuality these austere references to motel-room ceilings of suburban walls have. "To me it's a little like how we perceive architecture," Halley says, "You might not actually go up and touch the concrete. But I think the brain still perceives it as texture. That's how I hope my paintings work. That's what I get when I look at de Kooning as well. I like looking at them really close up and experiencing the surface. But there is a divide between painterly work, which is also a record of the artist's performance, and work like mine . . . in which painterly texture is absent and intended to be absent. But you can still have tactility without the presence of the artist's hand. . . . But when a painting is mechanically made, I don't think it's any less sensuous—especially in our society when so many things that we value as sensual are technologically made."

9 composition

The willing beholder responds to the artist's suggestion because he enjoys the transformation that occurs in front of [his] eyes. It was in this enjoyment that a new function of art emerged gradually and all but unnoticed during [the emergence of Impressionism]. The artist gives the beholder increasingly "more to do," he draws him into the magic circle of creation and allows him to experience something of the thrill of "making" which had once been the privilege of the artist.

Ernst Gombrich, art historian

The painting process is the coevolution of color, form, and texture on the picture plane. As the locus of connection between these three formal components, composition is the place where ideas and doctrine—a predetermined plan or perhaps impractical concept—need to give way to the visual. It is a hard truth that only attention to visual facts can save a painting from being an ornament.

Composition refers broadly to the visual field's "architecture"—the relationships among intrinsically simple visual units. This chapter includes considerations of:

- scale and size
- physical shape of the support
- appearance, location, and density of marks
- visual weight and direction of forms
- visual speed
- rhythm.

Moreover, the responses to choices we make as artists are culturally conditioned. For example, responses to left- or right-side placement of forms on the picture plane may depend on observers' direction of scan when reading their own language. If the scan sweeps in the opposite direction from that of the artist's sensibilities, the "reading" of the image will be different. Another example: Scale is an element that has changed over the past century as larger-scaled works have become the norm. This cultural force works especially potently on the art-literate viewer.

Harvey Quaytman, *Sodalit*, 1998, acrylic on canvas, 33.75 × 33.64 inches (85.7 × 85.4 cm.). Courtesy of McKee Gallery, New York.

Quaytman's work investigates the primary effect of intersection. The shape becomes radically unrectangular and we can hardly speak of a picture plane. The picture is linear expression. There is no way to view the painting without considering the wall on which it resides. Art critic and curator Lilly Wei wrote of the artist: "Quaytman began working at a time when painting had already been declared dead. Nonetheless, determined to squeeze new possibilities out of European and American nonobjective art, he refused to turn abstract syntax into signs and theory. He operated on the principle of 'what if': what if he placed a line here instead of there, repositioned a plane, intensified the color?"

Pat Lipsky, *And Louder Sing*', 2003, pigments and oil on canvas, 66 × 94. 25 inches (167.6 × 239.4 cm.). Courtesy of Elizabeth Harris Gallery, New York, and the artist.

The color-forms that make up the composition share a basic tall, rectangular shape, creating unity, even seriality that leads to rhythmic sensations of color change. The forms exert their character most actively in the mid-height region, where one scans a series of meeting places between upper- and lower-level shapes. This creates a sense of pushing or movement.

SCALE

Scale refers to the painting's size relative to the viewer. Power relationships develop between object and viewer based on scale. Works that are larger than the viewer tend subconsciously to evoke authority. In viewing a large painting, we must stand back from the work in order to see it all. Doing this makes some of the surface effects unreadable. When we get closer to inspect the surface, the painting engulfs us. Smaller-scale works develop intimacy as we get closer to them. Sometimes we have to get so close as to practically step through the plane, like Alice at the looking glass. The size relationship between painting as object and viewer is captured in painter Ad Reinhardt's description of his Black Square paintings of 1963: "as high as a main, as wide as a man's outstretched arms (*not large, not small, sizeless*)."

PHYSICAL SHAPE

The support, whether stretched canvas or panel, represents the arena within which optical considerations operate relative to the surrounding wall and room. It is also, in a sense, a sculpture. The overall shape of a painting's support may be termed its "literal shape," on which we artists compose the elements and marks—the pictorial forms.

The primacy of literal over depicted shape It is as though depicted shape has become less and less capable of venturing on its own, of pursuing its own ends . . . unable to make itself felt as shape except by acknowledging that dependence [on literal shape].

Michael Fried, art historian

Obviously, shape impacts design decisions. Horizontal rectangles suggest landscapes and may have restful associations. Vertical rectangles connote the human figure and appear more active. A single painting may be composed of more than one painted surface (diptychs, triptychs, and the like). Organic shapes may be cut from panel material and covered with fabric for other compositional challenges. The final shape can even be determined by cropping after the paint application.

Stretcher Bar Thickness
The depth of the space from the wall to the picture plane surface is usually determined by the thickness of the stretcher bars. A painter may deviate from the standard depth for aesthetic reasons.

[Frank] Stella began to increase the size of his box and stripe pictures. He stretched the cotton duck over 1 × 3s which he butt-ended together. This method, used for reasons of economy, produced an approximately 3-inch-deep stretcher that set the picture more clearly off from the wall. Stella soon found this deep stretcher to his taste aesthetically . . . given the flatness of his paintings . . . the deep stretchers. . . [says Stella] "lifted the pictures off the wall surface so they didn't fade into it as much."

William Rubin,
curator and art historian

Thomas Nozkowski, *Untitled (7-135)*, 1999, oil on linen on panel, 16 × 20 inches (40.6 × 50.8 cm.).
Courtesy of Max Protech Gallery, New York, and the artist.

All artists go by a small set of rules, specific points of self-limitation. For Nozkowski, scale is such a limit, and that makes all the other pictorial decisions interesting. His commitment to supporting a personal art is reflected in the "domestic size" of his paintings, which can live within the ordinary setting of everyday lives. This scale diverges from public, largely corporate interests. In Nozkowski's work, the convergence of intimate scale and, often, a centered "figure" suggests a direct dialogue of an intimate or discreetly personal nature.

some considerations of scale

We must recognize that human gestures cannot scale up or down infinitely. For example, a chorus of broad, intertwining splatters needs large-scale areas to develop mass.

The chemistry of paint materials does not really change just because scale changes. One must use appropriate materials for each size of work. Small textural effects, such as glass beads added to create a nap effect, are best appreciated in small- to medium-size paintings.

The kinds of studio tools required for large-scale work may be appropriated from industry: for example, commercial paint-mixing machines or mixer attachments for high-speed drills.

As the overall weight increases, support mechanics become more complex. For collage or thick paint on large expanses of stretched canvas, rigid backing may be required to prevent sagging.

Peter Halley, Multiple canvas panels of work in progress, 2004, acrylic and Roll-A-Tex® on canvas. Photo courtesy of the artist.

Halley's works incorporate multiple panels. These panels will later be assembled according to the study on the wall. Each panel is constructed of stretched canvas on three-inch stretcher bars. Halley: "I was really trying to find materials that in and of themselves would make a painting that was more intense than a normal painting—a kind of hyper-realized painting—a painting with contemporary impact that could compete with modern-day spectacles in architecture or a shopping mall or movies or whatever. Somehow I came up with a little more than three inches as a depth away from the wall where the painting would have its autonomy. Its separateness away from the wall plane would be empha-sized. It has its own autonomous space. When the canvas is thinner, I find it becomes too contiguous with the wall. I think Stella really happened on to something and it just seemed like a good solution."

MARKS ON THE PICTURE PLANE

The blank canvas is transformed by the intentional mark of the paint. Marks can be characterized by appearance, location, and quantity. Further, we differentiate areas of a painting by changes in shape, texture, glossiness, size, and color.

Appearance

Just as scale conditions the force of the entire painting, the *size* of a mark dictates the way it is read. The effect of size propels a shape, from repre-senting a pebble to a planet. A form's edge—its *contour*—can range from hard edges to indistinct, feathered blends. Value and color are used to define marks on the picture plane. Typical foreground/ background marking can be subverted, as when a wash can leave pockets of negative space; these unpainted areas can seem to be marks.

Location/Orientation

The location of marks/forms is central to compo-sition. Generalities about location and orientation, both cultural and physiological, are worth respecting.

UPPER OR LOWER ZONES Location at the top of the pictorial field is associated with "more," or ideal. Lower, or bottom, is associated with "lesser," or down to earth.

Another aspect of composition is the viewer's subconscious "perception" of gravity. This sublim-inal sense of weight conditions how artists place forms at the top or bottom edges of a painting. The sense of falling down is especially strong for viewers whose system of writing runs from top to bottom.

The liquid nature of thinned paints explicitly demonstrates the effects of gravity, evaporation, and gestural force. For example, a bold splatter will appear to be falling or rising depending on which edge of the painting is the top edge.

If, in a visual composition, some of the constituent elements are placed in the upper part, and other different elements in the lower part of the picture space or the page, then what has been placed on the top is presented as the ideal, what has been placed at the bottom as the real. For something to be ideal means that it is presented as the idealized or generalized essence of the informa-tion, hence also as its, ostensibly, most salient part. The Real is then opposed to this in that it presents more specific information (e.g. details), more "down-to-earth" information (e.g. photographs as documentary evidence, or maps or charts), or more practical information (e.g. practical consequences, direc-tions for actions).

Gunther Kress and Theo van Leeuwen, linguists and communications theorists

LEFT OR RIGHT SIDE For left-to-right readers, the left side is the "given," the accepted and the right side holds the "new." Many Asian languages are read right to left. Thus, viewers who read in these languages tend to scan a work of art from right to left. Conversely, audiences schooled in Western languages generally scan from left to right. The importance of this dynamic is that the composi-tion can mean different things in different cultures. We should not assume that all viewers will respond to the same side as evoking the estab-lished and the opposite side to suggest the newly formed.

MORE LOCATION EITHER/ORS Generalities about location also include the following:

- Central or peripheral. Western art has a tradition of avoiding a single, central focal point in favor of a more complex balance of visual weight. Certainly the painting by Darren Waterston (opposite) is an example of this strategy.
- Clustered or dispersed. Our human process of seeing groups close things together. A cluster of marks creates a denser pictorial texture and achieves greater visual weight.

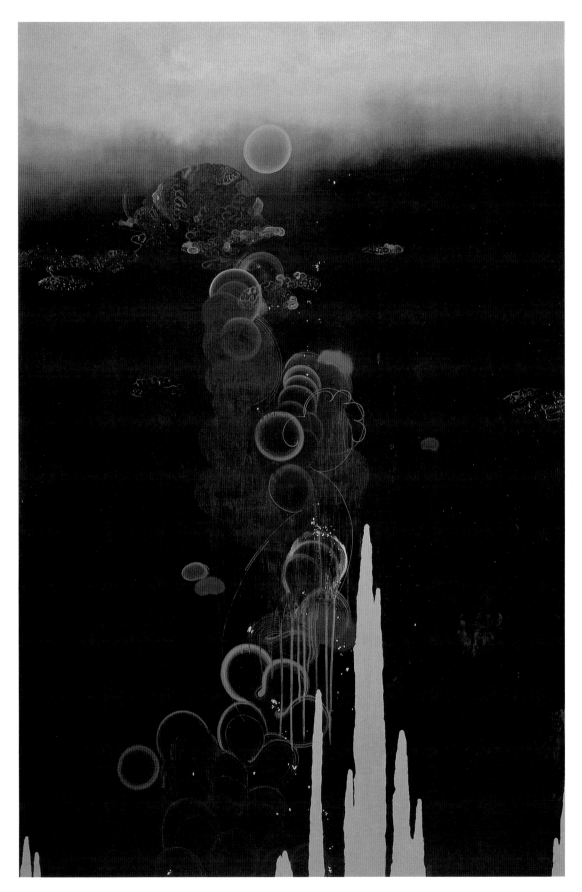

Darren Waterston, *Black Lobe*, 2003, oil on wood panel, 72 × 48 inches (182.9 × 121.9 cm.). Courtesy of Charles Cowles Gallery, Inc., New York, and the artist.

The evocation of a surreal landscape with a lower form, which appears to rise up through an atmospheric mist, is precisely due to the placement of forms reflecting the remembered effects of gravity.

Stephen Greene, *Moreau's Garden 7*, 1994, oil on canvas, 12 × 12 inches (30.5 × 30.5 cm.). Courtesy of Ruth Bachofner Gallery Santa Monica, CA, and the estate of the artist.

A slower speed of gestalt formation is understandable with Stephen Greene's unique marks, which display a dazzling range of methods. Eschewing a single style of marking, this small canvas takes huge leaps across the possibilities available to abstraction. Every inch of the surface offers a deep-felt surprise.

■ Systematic or irrational. Marks can be serial and predictable, seemingly referring to orderliness in their obvious clarity of design. Random placement—a complex, sometimes convoluted laying down of marks—can be used to simulate randomness.

Quantity of Marks

Once you have made a mark, you have established a point of interest on your painting. There is a range of interest points possible, from the economy of monochrome painting's highly reductive marking to the mind-numbing complexity of Pattern and Decoration works.

The individual mark has a presence similar to an actor in a play. The number of marks evokes a range of players. We feel an intimate dialogue with a single form, while several marks establish a more "public" feeling. When taken to a further extreme, an aesthetic of accumulation takes hold. Some effects can only be achieved through the accumulation of a critical mass of marks.

VISUAL WEIGHT AND DIRECTION

Areas that attract attention have greater "visual weight." These areas or marks might be focal points, whose emphasis can be used to balance the weight of other areas in the composition

Early twentieth-century abstraction stressed compositions with asymmetrical focal points. This design preference derived from mainstream Western European traditions. Areas of visual weight led the viewer's eye in certain directions to create a dynamic balance. This "dynamic balance" approach to composition contrasts with the all-over composition seen in mid-twentieth-century abstraction like Pollock's nets of paint. Such paintings disperse visual weight evenly across the entire picture plane.

> [Pollock and De Kooning's] ability to bring a weighted flatness, a dimensionally coherent presence to the new surface of painting, the cotton duck field, combined with the ability to spread that symmetrical coherence across and into that same field with a convincing pictorial tension, made them unique.
>
> *Frank Stella, painter*

Other dynamics of visual weight and direction include these conditions:

■ Painted marks that lend themselves to being perceived as a "figure" will be visually "heavier" than areas that appear to be "ground" or background. At the subconscious level of perception, the eyes selectively search for edges and figure-ground combinations.

■ If shapes appear to overlap other shapes, the shape or mark understood as closest to the viewer will demand more attention.

■ Clustering marks creates a sense of density or weight, while less-marked areas evoke airiness.

■ Areas of contrast have more visual weight than areas of minimal contrast.

■ Intensely colored marks will attract attention and seem closer to the viewer than less saturated marks.

■ Direction of scan can be controlled somewhat by the painter. The grouping rules mentioned in chapter 3 suggest that proximity of marks can create a path that the eye will follow, connecting the closely space marks.

■ Direction can be evoked by shapes stretched out of symmetry (for example, compare an oval to a circle).

- Edge character affects directional reading of a mark. A softer edge or softer portion of an edge suggests motion.

VISUAL SPEED

We know that artworks require varying amounts of time to be seen by the mind before we begin to form an appreciation of—or fully absorb—the work's conceptual merits. The initial visual impact of a painting is its gestalt, a concept introduced in chapter 3. In gestalt terms, the parts must take meaning from their relation to one another within the context of the larger composition. Abstract painting is not comprehended instantaneously. We make a mental map that condenses and categorizes the visual incidents. Later, we begin to analyze whether the painter chose wisely in the placement of these incidents. Some paintings will have a slower speed of gestalt formation than will other paintings. Overall variableness of marks in the painting affect our speed in understanding it. Marks display degrees of unity or contrast in terms of appearance, location, and quantity.

An all-over color field with indistinct regions of close tonal variation offers a relatively quick gestalt. Another form of quickly read composition is serial or repeated imagery. (A quick-to-form gestalt does not imply that the painting is uninteresting, however.)

Eric Freeman, *Untitled*, 2003, oil on linen, 72 × 72 inches, (182.9 × 182.9 cm.). Courtesy of Mary Boone Gallery, New York, and the artist.

Freeman's large, softly blended paintings glow with subtle hue and value changes. Scale and color intensity develop a grandeur that is reinforced by lack of pictorial incident. Yet Freeman has said, "I like to use historical references, but I don't really want that many external influences. I want my work to be self-contained, from my own head."

Visual speed is one of the more difficult aspects to control, especially when using action-oriented painting methods. For example, it is very difficult to predict the degree of pigment separation in dilute, flowing washes. One's intention to be sublimely subtle may result in being simply boring. Conversely, some magnificent gestural calligraphy might be lost forever under a layer of over-worked color correction.

> The experience of looking at and perceiving an "empty" or "colorless" surface usually progresses through boredom. The spectator may find the work dull, then impossibly dull; then, surprisingly, he breaks out on the other side of boredom into an area that can be called contemplation or simple esthetic enjoyment.
>
> *Lucy R. Lippard, art historian*

RHYTHM

A visual motif that unites all or some of the picture plane will create a rhythm. Rhythmic feel may range from almost chaotic through alternating, to regular, progressive, and flowing. Rhythm is built from consistency across a series of marks. Whether size is similar and shape varies or vice-versa, the marks relate as a group because of their similarity. The differences within the group establish the rhythmic effect. Repetition located along some horizontal alignment has an almost musical sense of time for viewers whose written language moves horizontally. Similar marks that get progressively smaller suggest receding distance. Repetition located along a vertical alignment reinforces the sense of gravity.

Gilbert Hsiao, *Read*, 1997, acrylic on canvas, 37 × 37 inches (94 × 94 cm.). Courtesy of the artist.

The all-over dispersion of the pattern creates flatness or frontality. In a sense, we feel a barrier of marks behind which lurks some atmosphere. Hsaio uses a systematic, serialized composition that is not totally symmetrical. Some forms subvert the main color progression to raise the question of autonomy or free will.

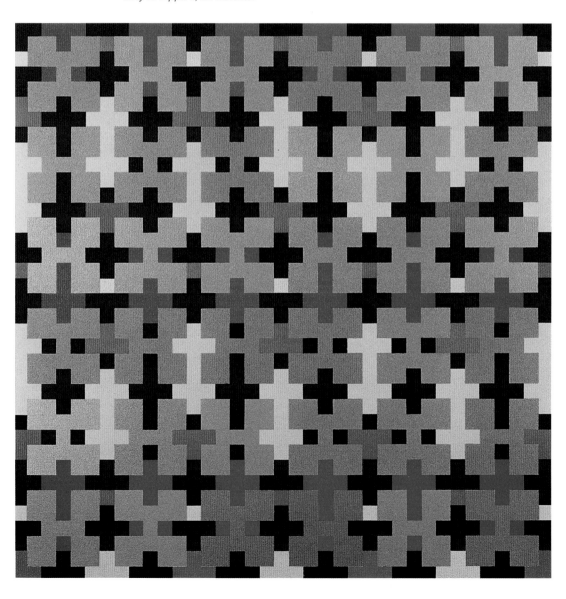

Symmetry

Symmetry is the specialized rhythm of identical marks across a central axis, and order in composition flows from degrees of symmetry. Our visual apparatus is conditioned; a symmetrical axis of attention creates a sense of order. The axis might be a single line, resulting in bilateral symmetry so common in nature. When bilateral symmetry is vertically aligned, the standing figure is evoked. Radial symmetry is present when the repetition is along a number of axis lines.

Symmetry also operates with respect to the edges of the painting. A diagonal line evokes tension or dynamism when painted on a standard rectangular canvas. If, however, a square canvas is oriented at 45 degrees to the floor, the tension of diagonals (now parallel to canvas edges) is greatly reduced.

Optically, asymmetry asks, "Why?" This is not the whole story, however. In Western art, symmetry has been eclipsed in favor of more dramatically asymmetrical compositions for a long time. Therefore, the all-over compositions of Op Art and of Color Field paintings have a startling frontality to which viewers were—or are—unaccustomed.

EDGE

Visually, we focus on the center of the painting more than the edges. However, because a painting is an object with artist-determined dimensions, the edges are extremely important. This fact is the sculptural aspect of the painting and underscores its objectness. A dichotomy exists between a composition with a framing edge and a composition with a "slice of life" arrangement of marks that travel off the edge. An edge can also be active in the sense of some "magnetic" push or pull on the pictorial marks.

Framing Edge

Early Cubist paintings and many of Pollock's drip canvases share an avoidance of the edge. The indeterminate location of marks relative to the edge results in a weightless, floating atmosphere. There is also an illusion of movement created by marks floating within the picture plane.

Because the marks seem to reside in an idealized universe separate from our own, we do not get a definite sense of scale. The marks seem to be seen through a lens—either microscopic or telescopic; we don't know which. We have to consider how to keep the entire surface, especially the corners, important or energized when such a composition is employed.

Active Edge

Some compositions are so marked that the painting's edges seem to be acting on the pictorial shapes. The interaction between picture plane forms and edge is charged to the point where we get the sense that the edges are exerting a magnetic effect on the forms. Such forces are felt in Pollock's works, where the paint arcs back to the center. Imagine a hockey game whose limits are bound by high walls past which nothing escapes. Such a painting has a strongly active edge.

Slice of Life

In this format, marks, especially lines, appear to travel off the edge. We feel the picture plane represents a cropped portion of reality, as a camera selects only one rectangle of the entire view. Because slice-of-life tells us the scale of the forms, the relationships of marks are more concretely sensed. Engagement of compositional marks with

Monique Prieto, *Reflection*, 2003, acrylic on canvas, 96 × 84 inches (243.8 × 213.4 cm.). Courtesy of ACME, Los Angeles, and the artist.

Prieto consistently uses a framing edge composition. Because her forms never exit the picture plane, we sense that the painting is a self-contained universe. The narrative of the work is idealized and at one remove from our own world. This increases the sense that the composition has symbolic import. Eschewing painterly brush handling furthers this impression.

"My paintings are all about the edge and how the image sits inside the container," says Davie. "They push, pull, distort, contort to fit inside the edge. They don't avoid the edge in as much as they respond directly to it as if the image is squashed inside the canvas."

the painting's edge creates a lock or tautness. The entire composition is grounded wherever the marking touches the edge.

A composition whose marks are locked into lower edges with no such locking in the upper edges will give a naturalistic sense of landscape's ground and sky. Morris Louis used the encounter with the edge to anchor his "Unfurled" series, of which *Delta Upsilon* (page 55) is an example.

CROPPED COMPOSITION

A support may be cut to another size or shape after the paint application stage to satisfy compositional demands. This technique is often accomplished when the painting process takes place on unstretched canvas. Cropping gives more options for selecting the successful areas of improvatory work. If the painting is on a panel, the painting can be cropped into a shape other than the standard rectangle.

ANTI-COMPOSITION

Compositional "design" can carry a negative connotation within the realm of artistic production. Design carries the sense that something is being "sold." Coincident with such a suspicion is the notion that design may be too logical. With

All compositional approaches, even the more seemingly methodical approaches, contain a good deal of chance. Calame uses the forms of chance spills traced from marks found on city streets. She arranges the tracings on the support, meticulously transfers the outline and decides on colors for each shape. What appears wild and fluid in fact once was so, but Calame has mediated the fluidity with a deliberate re-examination of the spills. How many great paintings, created with seemingly deliberate methods, progressed haplessly to finally surprise their creators?

tasteful design, there is the distinct danger that excessive "understandability" will limit the expressiveness of the work. Today, designed beauty, unity, and harmony are conservative elements, and we tend to cite a type of beauty that flows from nostalgia for "good taste" as being less inventive.

To circumvent the incessant ordering of the human mind, an aleatoric, or made-by-chance, approach distances control of the painting process. Surrealism highlighted the value of allowing our subconscious decisions to govern design. Art is not pure accident—there is no art without decisions—but we may decide to find art by making certain accidents visible. Arnold Schoenberg exchanged ideas with Kandinsky on this topic:

I am sure that our work has much in common—and indeed in the most important respects: in what you call the "unlogical" and I call the "elimination of the conscious will in art." . . . Every formal procedure which aspires to traditional effects is not completely free from conscious motivation. But art belongs to the unconscious! One must express oneself! Express oneself directly! Not one's taste, or one's upbringing, or one's intelligence, knowledge or skill. Not all these acquired characteristics, but that which is inborn, instinctive.

Arnold Schoenberg, composer

10

pictorial space

The new illusionism both subsumes and dissolves the picture surface—opening it . . . from the rear—while simultaneously preserving its integrity.

Michael Fried, art historian

Pictorial space is the sense of a spatial dimension we feel when we view a painting's formal elements. This is distinct from literal space—how far we stand from the painting, how far from the floor the painting is hung. Pictorial space emerges from cues on the picture plane. The sense of space, like the sense of light, is a subtle element in painting. This sense takes time to reveal itself. More challenging, even, than finding space, is creating space—deliberately and with conscious control. Just as we create a sense of light through manipulation of values, we control space through composition. The possibilities of investigating spatial problems in abstract art are enormous.

Different experiences of space result from viewing a painting.

THREE-DIMENSIONAL Linear or scientific perspective, invented in the Renaissance, generates an illusion of natural space, depth that stretches away to a distance from the viewer. Abstract paintings may display something like natural space.

FLAT Abstract paintings can exhibit almost no sense of depth. For example, Mondrian wanted to eliminate illusionary space and emphasize the concrete flatness of the picture plane, and he did.

OPTICAL This type of space in abstract paintings is ambiguous and contradictory, oscillating between flat and deep pictorial vistas.

CONCEPTUAL A conceptual space investigates the distance between what is seen and what is known. Abstract painting can present conceptual space that is at a calculated remove from natural space.

THREE-DIMENSIONAL SPACE

Traditional space creates a figure-ground understanding of the marks on the picture plane. Early Surrealist abstraction—an example being works by Joan Miró—maintains a somewhat traditional naturalistic spatial sense. There are figures or solid-appearing objects, and there are backgrounds or settings for these objects. The presence of gravity permeates such works.

The term *figure* when referring to a mass of pictorial interest, often close to the viewer, is also referred to as positive space. Ground or background are considered less solid or less interesting and can be referred to as negative space. Like many pairings, the supposedly weaker, less important element of the pair is crucial to the vitality of the stronger element.

Bill Komoski, *4/12/04*, 2004, acrylic on canvas, 59.75 × 78 inches (151.8 × 198.1 cm.).
Courtesy of Feature, Inc., New York, and the artist.

Renaissance linear perspective space, which speeds to the distance away from the viewer, and modernism's optical illusion, which does not involve the viewer's body in space, are two of several methods for creating an illusion of depth. By contrast, Komoski succeeds in bringing the painting's space forward to envelop the viewer. The artist has so interwoven the drawing that the viewer feels virtually within the mesh of various lights. Of his work, the artist says, "There's always been a spatial component and often an illusion of light, but this is for sure the deepest I've gone into the presentation of volume in a long time. . . . Introducing an illusion of three-dimensional form into the painting provides one more strong element to mix into the stew."

Kenneth Noland, *Mysteries: Hum*, 2002, acrylic on canvas, 60 × 60 inches, (152.4 × 152.4 cm.).
Courtesy of Ameringer/Yohe and the artist. Art © Kenneth Noland/Licensed by VAGA, New York, NY

Noland's circle series of paintings were sometimes referred to as "targets." The overall square shape of the painting creates a dual presence, that of a weaker component—the corners of the canvas—and the stronger circles. If the circles were painted on a round-shaped canvas, with literal shape resonating pictorial shape, the painting would not achieve the tension that this artwork possesses. Here, the circle expresses its circleness more pronouncedly by residing within the square. Noland did paint circles on a circular canvas, but the rings seem, in that configuration, to be simply lines parallel to the edges.

Without depicting natural forms, a painter can suggest three-dimensional space by:

- painting forms with strong contours so there seems to be a separation between figure and ground
- suggesting depth by overlapping forms
- adjusting size of forms to suggest receding space
- shading forms to suggest solidity
- using a single light source when shading or casting "shadows"
- decreasing intensity of color and tonal contrast to suggest distance (atmospheric perspective).

Idealistic thinking led painters in the early twentieth century to turn away from illusionistic space. However, there is no rule that abstraction should strive to evoke a flat space.

FLAT SPACE

The de Stijl and Suprematist painters advocated that artwork be two-dimensional, period. For them, paintings should not seem to have any space other than flatness.

This may be an impossible goal. Even a painting that is ostensibly "flat" will evoke an illusion of space if it is composed of at least one mark. Our visual apparatus is designed to automatically detect forms and space. Even a monochrome painting will have some surface inflection induced by variety in ambient lighting and thus will suggest space.

In defense of flatness as a working goal, a modern abstract work can present itself conceptually as being a flat object—that is, it can be "decoded" as flat. An abundance of cues can point to the painting's surface as a two-dimensional space. The viewer will "know" intellectually that the painting is flat even while some unconscious contradiction—a flirtation with a sense of illusory space—floats below the surface.

Flatness is promoted by:

- avoiding the typical methods of suggesting volume, such as shading and single light source
- contradicting any composition that fosters a figure-ground reading of shapes, such as overlapping forms, atmospheric color and value changes, or diminution of sizes
- employing minimal texture or build up of paint layers
- creating extremely slick surfaces

- using shapes and colors that are associated with flat objects, for example, blackboards, flags, signs, targets, or the printed page
- reinforcing the painting's status as a flat object undermines the expectation of space. Shaped (non-rectangular) canvases present themselves as almost flat-faced sculptures.

While the remarkable chromatic harmonies of [Kenneth Noland's] early Circles demanded (and rewarded) close attention, they were easy to read. Their symmetrical, declaratively frontal, deadpan imagery was readily apprehended, and their rigorously close-valued color structure kept their subtly varied rings in a single plane.

Karen Wilkin,
art historian and critic

OPTICAL SPACE

Optical space is a sense of openness that can be traveled only with our eyes. In the mid-twentieth century, abstract painters in New York continued to challenge natural perspective, not by insisting that a painting be flat, but rather by allowing painted space to be pliable. Plasticity in space is exemplified by Abstract Expressionist Hans Hofmann's admonition to lay down colors and shapes that visually push and pull. For him, space could be as freely conjured, as color was free from form. Modernism advanced the coexistence of flat canvas with an illusion of purely optical space.

The result is ambiguous space—is it flat or is it full of distance? Optical space is a shifting, even shimmering, sense of space. In fact, during the mid-twentieth century, modernists considered some of the devices of Renaissance perspective acceptable even though they shunned other devices:

The creation of an illusion of space, even deep space, was once more acceptable so long as it was not accomplished by the separation of planes, shading, or linear perspective, all of which came to be thought of as too easy, too heavy-handed.

William V. Dunning,
artist and scholar

Some of the devices painters use to create space concentrate on formal qualities of vision and include:

- differences in color "temperature" without other cues to perspective
- minimal drawing, or the sense of "hand," so that the end result appears to be "disembodied color"
- extreme differences in scale or large expanses of a single tone accompanied by much smaller areas, making visual judgments between the regions difficult and unnatural
- extreme textural buildup, forcing the physical objectness and literal space of the canvas to compete with the purely retinal spatial cues of color and value.

Optical space can conjure physical feelings and emotional feelings. Because we are presenting a space that defies normal limits, our sense of gravity is often subverted and the viewer may even experience dizziness or weightlessness.

> [The abstract picture seems] to offer a narrower, more physical, and less imaginative kind of experience than the illusionist picture…[and] also appears to do without the nouns and transitive verbs, as it were, of the language of painting.
>
> *Clement Greenberg, art critic*

CONCEPTUAL SPACE

As suggested in the above discussion of two-dimensional space, our intellect can override innate visual processing. Conceptual understanding can hammer home the idea that the painting is flat. Similarly, through intellect, a painting can be about spaces we cannot see. An abstract work can present traces of another space and ask us to extrapolate from the painting through concepts to the originating space. Implicit is the request that we employ our reasoning abilities at least as much as our purely retinal processing. While Frank Stella said, "What you see is what you see," with conceptual space, we see what Jean-François Lyotard means by, "Let us be witnesses to the unpresentable."

For example, Ingrid Calame traces spills and splashes from around the world. These tracings are joined in "constellations" of flatly painted forms. While Pollock gave us a drip, in Calame's work, we get tracings of a drip. The artist's chosen methodology, a predetermined system of action, distances us from the painting's gestalt. Knowledge about the performance of creating the work is integral to fully seeing the work. Confronted with such a painting, we are asked to look and imagine at the same time.

David Reed, *#473*, 2001, oil and alkyd on canvas, 36 × 168 inches (91.4 × 426.7 cm.). Courtesy of Max Protech Gallery, New York, and the artist. Private collecton.

An all-over structure of pictorial incidents (both gestural and geometric) creates an experience of extension—the picture extrapolates past its literal edges. The large scale of the work challenges our ability to see it in its entirety, and often we seem to see movement at the edge of our peripheral vision. This work challenges us to enter into a new optical space where distinctions between background and foreground shift.

Ingrid Calame, *lpk!*, 2003, enamel on aluminum, 24 × 24 inches (61 × 61 cm.). Courtesy of James Cohan Gallery. New York, and the artist.

Calame elaborates: "The stains are evidence of a parade of public activities, and they are a visual incident in the incomprehensibly large field of the world (I imagine the surface of the world as one continuous whole surface of sidewalks and grass and streets and mountains, etc.) which I could not possibly document in its entirety in one-to-one scale."

Peter Halley, *Two Cells, Horizontal Prison*, 2004, acrylic, Roll-A-Tex®/canvas 63 × 42 inches (160 × 106.7 cm.). Courtesy of Mary Boone Gallery, New York, and the artist.

"I'd like to think," says Halley, "that a less artsy, more conceptual art that uses Pop materials is more glamorous. I might try to make the case that it's also more elegant if you think of elegance as doing more with less. It used strategies of representation and syntax that were more sophisticated."

Another example is Peter Halley's paintings, which aim to use geometry to portray large social spaces. The iconography is of cells and conduits as points of concentrated power and connections between cells. Halley's geometry evinces the tangible material of civilization, neither sublime nor simply object-presence.

What is the point of involving these mental constructs rather than purely retinal sight? Vision requires both the eye and the mind. Perhaps, during the recent history of abstraction, the mental portion of visual processing has been diminished. Since abstraction had sublimated reference to the natural world, there was little opportunity for intellectual analysis of subject matter or for symbolism. A conceptual space adjusts the point of balance, suggesting that the retinal is not necessarily the whole story. In a sense, representation and subject matter return.

> [W]e can no longer see only a visual object, or only a physical world or even only a single imagined world. We see gaps and absences, through which various expressive hints begin to enter. . . . Once these openings arise, the entire image vacillates between the perceptual and the conceptual.
>
> *Charles Altieri, scholar and literary theorist*

Bridget Riley, *Turquoise and Others*, 2004, oil on linen, 45 7/8 × 107 7/8 (180 × 424.7 cm.).
© the artist. Private collection.

Riley remarks thoughtfully, "In general, my paintings are multifocal. You can't call it unfocused space, but not being fixed to a single focus is very much of our time. It's something that seems to have come about in the last hundred years or so. Focusing isn't just an optical activity, it is also a mental one. I think this lack of a center has something to do with the loss of certainties that Christianity had to offer. . . .When that sort of belief disappeared, things became uncertain and open to interpretation. We can no longer hope as the Renaissance did that 'man is the measure of all things'. . . . I think that an artist today has to totally accept this lack, has to start from a 'placelessness' virtually as a point of departure."

11

brush and easel paint construction

Paint bears physical record to the expressions of the human hand. It conforms to the trail of the brush being driven by impulses of the psyche. In no other art medium is creation more permanently and intimately bound to the movements of the human body.

Jonathan Lasker, artist

The "construction" of a painting refers to the ways paint is laid down—from the foundation of the support up through layers of color. Traditional painting involved easels, brushes, oil paints, and canvas or panel. Abstract painting grew from traditional representational painting and so shared the same technical methods.

Using a brush to apply paint to a panel or canvas may seem a simple task until you try it for the first time. (It is important to remember that paint is a substance with weight and depth.) Construction will range from thick to thin, gloss to matte, complete or minimal. Just as we might want to use color to define an area, we can consider application method as a way of defining an area. Having a large repertoire of brush techniques is empowering. While no single painting may need more than a few techniques, the freedom to choose from a number of strategies creates a potential to use the most expressive method at any particular moment.

HAND

The word *hand* has a specialized meaning within the context of oil painting; here it describes the evidence within the painted surface of the touch of the brush, the paint load, and the gestures that created a painting. "Hand" is a way for an artist to leave a signature and is a subtler, broader term than *gesture*.

Some painters eschew the sense of touch in their work. In stain painting, for example, we sense a detachment or elimination of hand, with the aesthetic implication of a decrease in the human creator's presence.

Making Contact

Qualities that define touch, or hand, are the type of tool used to apply color and the speed, pressure, and motion behind the paint-loaded tool.

Karin Davie, *Pushed, Pulled, Depleted & Duplicated #14*, 2003, oil on canvas, 60 × 48 inches (152.4 × 121.9 cm.).
Courtesy of Mary Boone Gallery, New York, and the artist.

"My work," says Davie, "takes on the physical appearance of speed through the gesture. This is a direct result of the process. In the last series of work titled 'Pushed, Pulled, Depleted & Duplicated' I wanted the gesture to communicate my physical activity so that the viewer's body becomes engaged—a corporal reality is exchanged. They are made wet on wet so that the gesture is not restricted in any way. I need this to exist in order to get the quality of line and image I want. The bleeding of one color into another is intended. It sets up an opticality and a very tight interwoven image."

Francine Tint, *Pompeii*, 2003, acrylic on canvas, 16 × 20 inches (40.6 × 50.8 cm.),
Courtesy of the artist.

Speed of execution engenders beautiful chaos. The work proceeds as an improvisation and will be subject to cropping for composition. Critic Margaret Sheffield describes Tint's work as "both visceral and cerebral . . . explosively energetic and pensive." Tint's paintings are executed on a wall, often utilizing long-handled brushes or rollers to allow the artist to assess progress from an appropriate distance. The gesture is full-body exertion rather than wrist-driven.

TOOL CHARACTER Paint is most commonly applied with a brush. Brushes can convey a broad range of moods. Soft-haired ones tend to disguise the separate hairs and give a smooth layer of paint. Stiff-haired brushes leave evidence of the individual hairs in the paint stroke. The striations associated with painting with a stiff-haired brush give a more complexly textured shape with a capacity to generate shadows and catch highlights. Striations also reveal the direction and movement of the brush.

Flat-surfaced application tools, such as palette knives, spatulas, and squeegees can apply paint without the surface striations caused by bristles. As always, the tool reacts with the paint's consistency. Stiff paint worked with painting knives can be used to create different sculptural effects that evoke a crispness and even brittle qualities. Conversely, highly liquid paints can be spread with broad spatulas, for example in the work of David Reed (page 108). Here the free-flowing paint is restless and energetic.

SPEED Often confused with pressure, speed affects the control over thinned paints. Greater speed can create sprays, drips, or splatters from the paint stroke. A slower application will reduce the number of such incidents. Relatively thick paint is less likely to drip or splatter, even at relatively fast speeds. In such situations, speed only affects how well decision-making can keep up with brushwork.

PRESSURE Pressure of a brushstroke can vary from light and questioning to heavy and definite. Light pressure can generate a skimming of paint over the surface. On a textureless surface, such a mark will be clean and graceful. Over a deeply textured surface, light pressure results in broken color that preserves visibility of lower paint layers in spots (especially when using thick paint). Intense pressure makes a solid, opaque mark. This calls for using bristle-haired brushes. Under heavy pressure, the metal ferrule that holds the hairs can force a channel through the center of the stroke.

MOTION The painter moves the arm and/or wrist while holding the brush at some angle relative to the canvas. Angle is important because it establishes the interaction between the metal ferrule, the hair tips, and the surface being painted. The motion of the brushstroke on the surface can be:

Jonathan Lasker, *Crisp Feelings*, 1999, oil on canvas board, 11 × 14 inches (27.9 × 35.6 cm.). Courtesy of Sperone Westwater, New York, and the artist.

Reminiscent of van Gogh's touch, the warm-toned bars are forcibly stroked to create a ridged outline. Lasker: "There's a good deal of pressure. I'm very careful to go back and forth to build up the edges of the stroke to enhance the identity of the stroke as a thing." The construction of the painting, the steps from base layer to top layer, is completely apparent—an extravagant display of pure oil paint. The emphatic brushstrokes are contrasted with calm, linear painting over them.

Melissa Meyer, *By Myself*, 2003, oil on canvas, 22 × 22 inches (55.9 × 55.9 cm.).
Private collection. Courtesy of Elizabeth Harris Gallery, New York, and the artist.

The thinness of the paint allows a speed of gesture not possible with thick paint. The lack of texture from brush hairs creates an impersonal power that contrasts with the sweeping gesture—in a sense cooling down the human presence. It cannot be overemphasized that the "rheology" (character of flow) of a dilute oil paint differs from flow exhibited by a dilute acrylic paint.

- dragged, with the ferrule in the lead. This is an intuitively natural motion.
- pushed, with the ferrule behind the hair tips. This motion is counter-intuitive and can be very damaging to the brush, as it results in a brutal, deranged spread of paint-soaked bristles.
- brushed back and forth
- dragged sideways at an extreme angle. Doing this will allow the metal ferrule to actually scrape the surface.

THIN LAYERS OF PAINT

A thinned oil or acrylic paint is akin to watercolor, especially when working on a white ground. Very thin paints will display pigment separation when using inorganic pigments or powders. Low-viscosity paint will dribble down the canvas if working in the standard upright orientation on the wall or easel.

Borrowing some watercolorists' strategies and principles for control of thinned oils or acrylics makes sense.
- Work with the canvas in a horizontal orientation.
- Have some absorbent materials on hand and fix mistakes by mopping off thin paint before it dries.
- For extra control, mask surfaces with tapes or liquid masks before applying paint.
- Erasing a dried acrylic paint by physical abrasion has limited potential, especially when staining pigments have been used.
- For oil paint, re-wetting with solvent easily picks up paint. Very little removal of dried paint is possible if alkyd resin is in the paint.

Imprimatura, the first layer of ground-toning color which eliminates the stark whiteness of the ground, can be allowed to show through in the finished work as a middle ground. This middle ground can be supplemented with a combination of lighter and darker marks to stretch the spectrum of values on the canvas.

THICK LAYERS OF PAINT

Compared to the seeming ethereality of thin paint, thick layers of paint evoke a sense of physicality. Without resorting to collage to build up thickness, we recommend acrylic paints for paint layers more than a quarter of an inch thick for work on canvas.

Acrylic gels and pastes contain resin solids and other inert solids. Acrylic medium, which is almost

transparent, gives this paint system characteristics of light surrounding pigment (similar to watercolor) while allowing deep build-up of paint textures.

If you must use oil paint for applications more than a quarter-inch thick, alkyd-based gels or mediums should be incorporated. Or work on rigid supports. Alkyd resins, whether in liquid or gel form, introduce greater overall flexibility to oil painting. Natural damar and copal resins will produce a dangerously brittle structure in thick applications. Remember: If oil is painted over a slick, closed acrylic surface, or if the acrylic layers are not thoroughly dry, delamination can occur.

Jim Bohary, *Drummer*, 2002, oil on canvas, 24 × 18 inches (61 × 45.7 cm.). Courtesy of Elizabeth Harris Gallery, New York, and the artist.

Bohary takes years to build dense masses of oil-painted intuitions. A layer of wet-in-wet paint handling rests for some weeks or months, after which Bohary begins to emphasize areas to draw out a composition.

DIRECT PAINTING METHOD

Paint application is either direct or indirect. Direct painting is straightforward application. The top layer of brushstroke comprises the final visual effect. Indirect painting consists of planned layers of paint, and the final visual effect is a composite of glazes or broken colors.

Wet-in-Wet and Alla Prima

A direct method of painting into other wet paint, and the most common, is called wet-in-wet. This method does not require the planning that indirect painting does. *Alla prima* refers to painting that is completed in a single sitting. (Slow-drying paints can be worked wet-in-wet over several sittings for as long as the paint film stays open.) Direct wet-in-wet painting reduces the need to worry about the fat-over-lean rule for oil paints because the painting will not be comprised of distinct layers.

If we want new paint to blend with a pre-existing paint layer, wetting or dampening the surface will eliminate surface tension. Traditional painters used to "rub-in" or brush a light coat of oil or medium onto a dried canvas to make the surface more accepting of the new paint.

The many types of effects we get from wet-in-wet include:

- shaded or semi-blended forms
- virtually invisible blends
- gestural brushstrokes displaying chance blending of adjacent strokes

flat, solid forms. (Note: It is hard to prevent blending of edges of two distinct regions when both are wet.)

Wet on Dry

Painting over dry paint is the other direct method of paint application. The new top paint is opaque and fully obliterates the color below, although it may leave traces of texture.

INDIRECT PAINTING METHOD

Indirect painting means that the final visual result is a combination of numerous layers of paint. Careful planning is needed as many, if not all, of the underpainted marks will show through.

Scumble

An opaque or semi-transparent paint may be brushed vigorously over a dry layer, revealing portions of the bottom color. With this technique, a residue of the underpainting comes through.

The scumbling technique takes practice and familiarity with pigments to control.

Glazing

A glaze is a translucent paint applied on top of previously painted areas. It is often a mixture of a small quantity of pigment with a substantial amount of resinous medium. The proportion of tube paint to resin medium varies depending on the pigment's intensity or staining power and the pigment's innate transparency.

Test glazes before painting or consult pigment charts for guidance. A place to start is a 1 to 3 ratio of paint to medium. A glaze is usually glossy, but matte medium or an addition of cold wax medium may be used to cut a shiny effect. Glazing generally:

- results in a sense of passive human presence because the methodology is not apparent to the viewer
- may be used for color correction
- creates special surface interest as matte/gloss areas may be interspersed.

Rae Mahaffey, *Concentric*, 2003, oil on wood panel, 18 × 36 inches (45.7 × 91.4 cm.). Courtesy of the artist.

The intellectual challenge of planning indirect layers couples nicely with geometric forms. Mahaffey counters this indulgence in logic and control by allowing the sensuous wood grain of the panel to be clearly evident below several glazes. A thin alkyd medium is used.

David Reed, *#4482*, 2001–2002, oil and alkyd on canvas, 99 × 55 inches (251.5 × 139.7 cm.). Courtesy of Max Protech Gallery, New York, and the artist.

Reed's method of preserving a sense of light surrounding color is reminiscent of watercolor effects. Buoyant gestures are evidenced in transparent glazes of oil and alkyd paint on smooth acrylic ground. (Most paintings, despite their complex "read," have only two layers of paint.) Reed will sometimes sand a section of paint back down to the thirty-layers-deep ground. This is a method of recovery from excessive paint—from darkening or over-painting—and gives Reed a degree of freedom that is unavailable to watercolor painters. In this way, Reed retains the all-over sensation of light around color.

Scraping or Scratching

A wet paint layer can be wiped off, leaving residue on the underpainting. Dried paint needs physical abrasion, such as sanding, to be removed. The erosive gesture of scraping off paint gives a sense of force and struggle. (Chapter 14 offers an extended discussion of these techniques.)

Sgraffito, the technique of etching a painted surface with a stick-like tool creates, in effect, a negative drawing. More extensive scraping of dry paint requires great attentiveness to the ground's ability to withstand such re-working. If removal of dried paint is routine, one should consider using rigid panels as the support.

HARD-EDGE TECHNIQUE

Hard-edge painting insists that forms be unambiguously defined. Usually, painters working in this style use a mask or template to restrict where paint is deposited.

Hand Painting

It is possible to make hard edges by hand. Bridget Riley, for one, insists on hand control:

> "In fact, [masking tape] has never been used [by me] as it leaves an unsightly ridge on the edge of the band and creates a mechanical effect."

Painting hard edges by hand requires practice and patience as well as attention to paint viscosity, brush character and angle, and the always-changing load of paint on the brush as it is dragged along.

Templates or Masks

If the requirement is for a larger-scale form and an extremely regular edge (such as a straight edge or a pure, geometric curve), some masking technique probably will be helpful. Follow these practices:

1 Before applying the template, make sure the support is dry and as smooth as possible.

Kevin Finklea, *Shift-A, Fluphenazine*, 2003, acrylic on MDF, 8 × 10 inches (20.3 × 25.4 cm.). Courtesy of Pentimenti Gallery, Philadelphia, and the artist.

Finklea uses no masks or tape but handles the straight edges of each painted form with the same care that is lavished on crafting the immaculate support he uses. Yet Finklea maintains: "Just about everything I paint is an approximation. A constant response to my work is its perfection. I assure you that nothing I paint is perfect. I can't imagine a perfect painting being made by anything less than a machine. I believe that work . . . is far more interesting for its failures. . . . The small imperfections and variegations made by my hand make a surface far more interesting than anything I've seen made by machine."

Peter Halley, Masked work in progress, 2004, Acrylic and Roll-A-Tex® on canvas. Photo courtesy of the artist.

Halley's works include bars with straight edges built up using dozens of coats of paint masked with tape. Between every four brushed layers, the tape must be peeled off and re-applied. Otherwise, layers of color would prevent the tape from coming off cleanly. When the tape is laid down, Halley applies a single coat of clear gel to seal the edge and prevent bleeding beneath the tape. In the works shown here, some portion of the composition has been developed and covered with masking tape. Halley applies the Roll-A-Tex® formula, usually several layers deep, which will later be overpainted with the appropriate color.

2 Templates are generally made from masking tape. In order to get the cleanest line possible, there are a number of things to take into consideration.

First, the kind of tape you use is important. Tapes with elasticity, such as electrical tape, make it more difficult to achieve a perfectly straight line. Very tacky or sticky tapes may pull off layers of paint when removed. Lower-tack blue drafting tapes are quite useful. Conditioning the tape to reduce the tack can be done by first adhering it to, and then removing it from, a clean surface prior to use.

3 It is possible to create irregular or curved templates. By overlaying many criss-crossing layers of tape on a temporary panel, you can create a tape-plane larger than the desired hard-edge curve. Use a razor or knife to score through the tape-plane. The template is now ready to be placed on the painting surface. Note: You have two templates now, the desired curve and its inverse.

4 A problem often encountered in masking techniques is that the paint will bleed under the tape, resulting in a jagged edge. A way to avoid this is to seal the tape edge; after the template is correctly placed, apply a thin, even line of clear gel along the mask edge; applying by hand is best since the fingers sense how surface texture is being filled.

5 Depending on the kind of paint used and its resulting skin, more than one layer of paint can sometimes be applied before peeling off the tape.

6 After the unmasked region is worked and dry, carefully peel off the template. The angle and speed of the pull will vary, depending on how thick and how elastic the top layer of paint is.

7 Sometimes it is necessary to break the paint film to lift it. Use a small, sharp tool, such as a straight edge razor, being careful not to cut the support.

It is important to keep in mind that a painting may be over-worked, with the result being that the work feels uncertain. You would do well to develop a special form of discrimination that can either warn you when you would be best served by putting down the brush or identify what areas are over-done and can be scraped down and reworked—or maybe discarded. Often, if the artwork is put away, we can find a way to use it at a much later date.

[A painting is finished w]hen it stops questioning me. . . . Sometimes I don't know what to do with it. . . . I check it out, recheck it for days or weeks. Sometimes there is more to do on it.

Joan Mitchell, artist

Thomas Nozkowski, *Untitled (8-50)*, 2003, oil on linen on panel, 22 × 28 inches (55.9 × 71.1 cm.).
Courtesy of Max Protech Gallery, New York, and the artist.

Nozkowski's paintings often take years to work to completion. A visual idea will be started, then put aside. Later, when it is dry, the composition will be considered in its entirety. The reworking that follows will be wholesale, absolutely avoiding a tinkering mentality. The subsequent layers of work may proceed from scraping clean a good deal of previous work. (The support is linen on panel which can accommodate the series of scrape-downs that may occur.) Along with a certain scale, the practice grew from an avoidance of "precious materials" and thus evolved from the canvas board surface.

12

poured paint

By 1950, at the height of his powers, there is nothing old left in Pollock's art, except maybe art, which is pretty remarkable. By way of comparison, when Picasso made *Les Demoiselles d'Avignon*, he initially thought it might be a bad painting; when Pollock finished *Lucifer*, he had to ask Lee Krasner, his wife, "Is this a painting?" *Jerry Saltz, art critic*

Pouring color onto the canvas is the first of three "process painting" techniques this book treats. Staining (chapter 13) and layering (chapter 14) are two other process painting modalities artists use to create paint without brushes. A very strong focus of such paintings is the intimate relationship between specific materials and specific processes. With its devoted focus on art materials and techniques, process painting is an almost predictable descendant of the "art for art's sake" ethos.

POLLOCK AND POST-POLLOCK

Jackson Pollock's first drip paintings appeared around 1947. Today, the drip is often "read" as a quote from Pollock. His innovation was so bold that it was difficult for other artists to see this as an opening. Rather, it was considered an aberration.

Pollock's very radicalness made it hard for other painters to see possibilities in his work—possibilities in getting around or beyond him. He was too personal because his solution seemed so indissolubly linked with his technique of dripping and staining. There seemed no way to continue without merely imitating him.

Kenworth W. Moffett, art historian

Both anecdotal and film evidence point to Pollock's developing a complex, decision-ridden process. Specific paints were favored over others for their liquidity and color density. The dripped or splattered incident may appear in isolation as a simple calligraphic composition. When developed into the dense mesh, as in Pollock's late 1940s work, we see the marvelous effect of making line a sculptural entity.

Jackson Pollock, *Number 1, 1950 (Lavender Mist)*, 1950, oil, enamel, and aluminum on canvas, 87 × 118 inches (221 × 299.7 cm.).
© 2004 The Pollock-Krasner Foundation/Artists Rights Society (ARS), New York.
Collection of the National Gallery of Art, (Ailsa Mellon Bruce Fund).

"Well, [without using brushes] I'm able to be more free and to have greater freedom and move about the canvas with greater ease. . . . With experience it seems to be possible to control the flow of the paint, to a great extent, and . . . I don't use the accident—'cause I deny the accident."

Morris Louis, *Seal*, 1959, acrylic resin on canvas, 100.5 × 140.5 inches (255.3 × 356.9 cm.).
© Marcella Louis Brenner 1993. The Estate of Morris Louis is represented exclusively by
Diane Upright Fine Arts, LLC. Courtesy of Paul Kasmin Gallery, New York.

The color forms express the interaction of gravity and liquids in an almost idealized way. By allowing the paint to flow, perhaps guiding the wetness and channeling the movement, a gestureless work of untouched beauty results. No brush was ever found in Morris Louis's studio.

The very uncontrolled nature of the "drawing" led directly to another important new compositional paradigm: the "all-over picture." But as Clement Greenberg cautioned, the all-over compositions might appear to be no more than wallpaper; a danger exists in uncritical focus on process and materials.

> [Pollock] was an edge conscious artist. And he would define the edges of his compositions with masking tape, even when working on the floor. But the carefully calculated movement of the skeins of paint extending off a picture's edges and back onto the canvas creates a sense of constant flux.
>
> *John Golding, art historian*

SURFACE FOR POURED PAINT

Regardless of the thickness of the final paint film, the support needs to fortify the artistic vision. The surface on which paint will land may be panel or canvas, stretched or loose, lying flat or positioned vertically.

Rigid or Flexible
Both fabric and panel can be used as supports for poured paint. Panels and fabric both allow for tilting before the paint has dried. Once a poured painting is finished, it must be placed somewhere safe and allowed to dry undisturbed.

Some techniques are suitable only for a very specific support, as each one takes poured paint differently.

Some conditions for working on unstretched fabric include the following:
- Work on a substrate that is flat and stable. If fabric is placed on flooring, eliminate ridges from floorboards. Carpet covered with a taut, stretched drop cloth is a good substrate.
- Unintentional puddling is not a problem.
- Intentional puddling or flowing of the wet paint can be created by lifting and folding the fabric.

When using stretched fabric, bear these things in mind:
- If a stretched canvas is lying horizontally, the weight of a load of wet paint is going to force a sag in the middle. This creates one big central puddle. To prevent this, a temporary panel may be slipped directly under the fabric to support it.

Jane Callister, *The Expanded Sticker Project*, 2003, installation including acrylic on self-adhesive vinyl, 94 × 94 inches, (238.8 × 238.8 cm.). Courtesy of Southfirst Art, Brooklyn, NY, and the artist.

Callister has released poured paint from the convention of the stretched canvas support. The spills are on self-adhesive material that is placed directly in walls to create an installation. Of *The Expanded Sticker Project*, Callister comments that she "employed various mediums to reconcile and analyze paintings' relationship to its broader material context . . . this project stretches the definition of painting and blurs the distinctions between sculpture and installation practices. . . . [I]n pure painting I am forced to work within its perimeters and recognize its inherent properties. By stepping outside of painting practice every now and then I am able to see it from an external position. . . . I have become clearer about the range of applications available in paint . . . rather than simply making an inventory of painting possibilities or a postmodern pastiche of art historical quotes."

- Places where the stretcher bars meet the canvas may have visible bleeding of paint onto stretcher bar.
- Weighty puddles of paint may push canvas in contact with the underlying crossbars, creating impressions at the meeting points. Again, a temporary support under the fabric prevents this.

Panels differ from fabric substrate these ways:
- After the poured paint is dry, extremely abrasive erasure of portions of the paint is possible.
- The substrate will not interfere with the poured paint on the panel.
- A panel must possess sufficient absorbency to grab the paint. However, some painters will pour onto a slick, mirror-like surface then peel off the dried paint film and affix this to canvas or other surface.
- Unintentional puddling is not a problem.

Orientation during the Pouring Process
In process painting, the receiving support will probably be lying flat in relation to gravity—usually on the floor or table. It's important to have quick access to every part of the surface. The on-floor position allows for good visibility over the entire composition, whereas a table might allow one to see fine detail. (Exemplary works of pouring on a vertically positioned surface are Morris Louis's "Veils" and Larry Poon's "Cascade" series of paintings.)

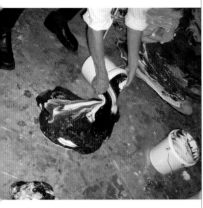

The shape of the pouring is the shape of the painting, a paint-thing with no predetermined composition. Neal controls the color mix in the bucket, with an initial small amount of white to retain a sense of light. She then adds modest bits of dispersed colors that are barely stirred into the depths of the medium. Neal's hands-off approach creates a freshness expressive of the natural interaction of liquids and gravity. A large percentage of her artistic decision-making comes from editing—deciding which final works pass the eye test and which do not.

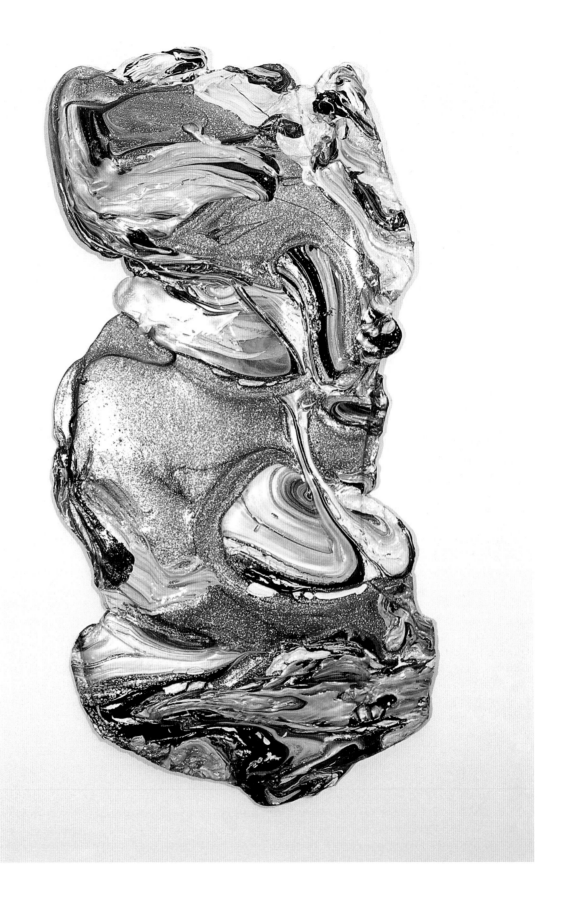

Plan realistically for what can be accomplished by one pair of hands. With help available in the studio, a number of techniques are opened up. For example, pouring a "braid" of three interweaving streams of color is impossible for one person. Likewise, larger-scaled work will often require additional hands to execute post-pour movements of the support.

Non-Flat Pouring Surface

We can intentionally create creased or raised areas of fabric before pouring. When we do pour, gravity creates pools of color in the lowest regions. The fabric support will probably be unstretched. Morris Louis partially stretched canvas to make the "Veils" series; the bottom edge was unstretched.

Dry or Wet Surface

Consider whether or not the receiving surface is dry. An initial color or ground may be already applied; we may pour more paint before this initial layer is dry. If the surface holds watery puddles, subsequent colors (unless the thrown paint is extremely stiff) will disperse into the puddles and will loose its shape as it disperses.

Sprinkling opaque paint over a dry undercoat up to the point of almost obliterating the first color, creates a web of top color with visual energy similar to pointillism. This is reminiscent of Pollock's densest dripped regions.

Tossing colors onto a thoroughly dry base affords the best chance of portraying the motion of the throw. But this may make the topmost color seem severed from the rest of the painting, the underlying work. Or it may have the effect of being planned.

From a practical point of view, a dry base allows ample time to mix up and test subsequent colors; there's no race against the clock to prepare paint before the base dries. Also, a dry base affords total recovery from a bad splatter. If the gesture just doesn't work, the artist simply sponges or scrapes off the failed gesture, lets the surface dry, and tries to throw again.

Finally, there is the mid-position, where the receiving surface is just wet enough to "clamp" onto a splatter but undercoat and topcoat retain their respective identities. In this case, the various layers of paint are truly integrated—settling together as they dry. This unified effect is heightened when the viscosity of both paint layers is similar.

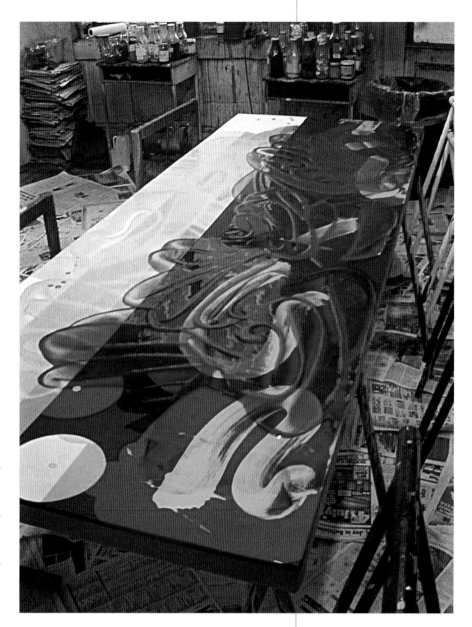

David Reed, #504 (in progress), 2002–2003, oil and alkyd on linen, 102 × 36 inches, (259.1 × 91.4 cm.). Mondstudio Collection. Courtesy of the artist.

Reed has spent decades developing a precise practice to make paintings that look as if they grew spontaneously. Yet preparatory sketches reveal that his is a meticulously planned effort. Although Reed does not pour, his painting practice requires a horizontally positioned surface. From the preparation of the ground to brush marks and layers of transparent paint, the paintings are often worked on horizontally, flat out on saw horses. To view the entire painting while the paint is still wet and modifications are possible, Reed sometimes stands on a ladder.

Lauren Olitski, *Speak Up*, 2002, acrylic on canvas, 40 × 30 inches (101.6 × 76.2 cm.). Courtesy of Donna Tribby Fine Art, Inc., West Palm Beach, Florida, and the artist.

Olitski combines techniques of pouring onto wet surfaces and also pouring onto fully dry surfaces. The painting usually is begun with a stain to establish a tonal atmosphere. Collage elements, such as dried paint, are integrated in some pours.

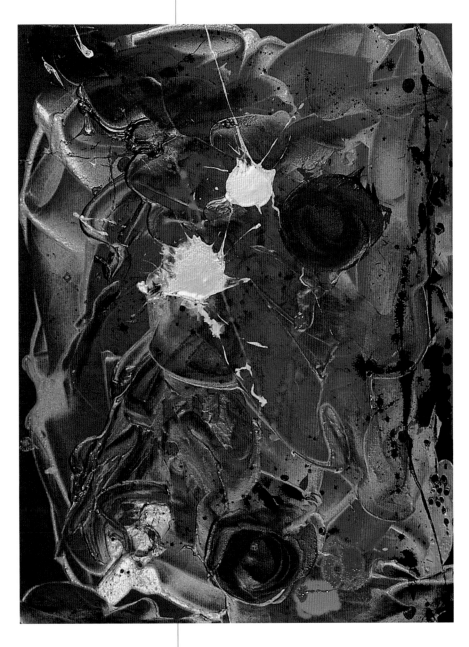

POURED PAINT PREPARATION

Gravity operates to model the paint on the support, and for that reason we generally use low-viscosity mixtures or self-leveling mediums. Poured paint is rarely very stiff paint.

Acrylic Paint for Pouring

Brushless painting is deeply reliant on acrylic paints and mediums, partly because of their quicker drying time and partly because poured paint is frequently put down in quite thick layers. Their less toxic chemistry is an advantage for such paint handling. A quarter-inch-thick coat of oil paint releases a good amount of solvent over a long period of time, and many studios are not set up to deal with ventilation that would be needed if pouring oil paint .

Oil Paint for Pouring

Pollock did not live to see the introduction of acrylic artist paints. His work resulted from using thinned oils, house paints and other alkyd-based colors. Today an artist can get results similar to Pollock's by mixing an oil color with an alkyd resin medium in about a 1 to 1 ratio, followed by adding solvent to reach the desired viscosity. As discussed earlier, the higher the ratio of solvent to oil or alkyd, the more matte the dried paint.

House Paint for Pouring

Commercially prepared paints have wonderful pourability. However, they have less flexibility than do pure acrylics and should only be used on panels. House paints, even latex formulas, do contain volatile solvent compounds so extra ventilation is necessary when using them.

APPLICATION

Four main factors control the look of airborne paint application:

PAINT VISCOSITY Stiff paint holds its shape and better reveals direction and force of a throw.

PAINT TEXTURE If the paint is loaded with sand or sawdust, the final form is more complex and less evocative of water-splashes.

DISTANCE FROM THE HAND TO THE PAINT SURFACE More distance means less control and greater numbers of sub-splatters (the result of paint is torn apart on the flight to the surface).

THE TOOL USED TO SEND THE PAINT TO THE SURFACE Tools include brushes, large spoons, hands, cups, large plastic containers, or buckets. Among other tools, Pollock used a turkey baster and cans with holes punched in the bottom.

In all cases, drop cloths should be underneath the support and perhaps along the walls. It is worth practicing throws on a test surface. Body involvement will vary, depending on scale, from a wrist flick to athletic, swinging full-body hurling. The trajectory can be from the sides or from above. Be mindful of the compositional ramifications of approaching the surface from any point along its edges.

RECOVERY FROM A BAD POUR

Pouring techniques are inherently unpredictable. However, pre-planning affords some means of recovery from an unpleasing pour.

- One possibility is to initially stretch canvas with larger-than-expected dimensions with the assumption that the final work will be cropped.
- Quickly wipe wet paint that fails to compose itself into a large bucket, kept just for this purpose. Rinse off and wipe down the support.
- Recovery is often possible when a pristine smooth surface is not required. By simply pouring atop a previous mistake, the support, at least, is not wasted. However, many layers of acrylic will create a busy, bumpy final surface which can be very unpleasant.
- While acrylic cannot be re-dissolved for removal, it's possible to aggressively sand it.

DRYING

Undisturbed drying for a day or more allows the acrylic medium to reach its clear, non-milky state. During the drying process, the top film may dry before the middle and bottom, creating "crazing." Other points:

- If the floor or table are not perfectly level, use shims and a carpenter's level to level the drying surface with respect to gravity, unless seeking runs.
- To avoid contamination of the surface from airborne dust, insects, and the like, a rigid material such as foam core, raised at least a half foot above the painting, is recommended.
- Because the paints are often thick and non-dissolving, it is advisable to raise the support out of any puddles of paint that may have accumulated around the bottom edges—unless leaf-like appendages hanging from the edges are acceptable. Use blocks.

Active Drying

One of the attractions of poured abstraction is the absence of gesture or evidence of the painter's brush. The color-forms express the interaction of gravity and liquids in an almost idealized way. Flowing water is strongly evoked. An untouched pour on a non-flat surface is indeed a very scary and brave enterprise with "success" being highly unlikely.

Suzanne Joelson, *Same River Twice*, 2003, acrylic on canvas, 39 × 40 inches (99.1 × 101.6 cm.). Courtesy of the artist.

Joelson begins with an initial application of acrylic while the stretched support is horizontal. She dispenses an unmixed set of acrylic paint from a large, shallow tin tray held at angle. This foundation of chance marks is enhanced and extended by traditional brush technique.

ABOVE Maggie Michael, *Canon*, 2003, latex and ink on canvas, 84 × 72 inches (213.4 × 182.9 cm.). Courtesy of G Fine Art, Washington D.C., and the artist.

Michael gets a unique result from the extreme self-leveling properties of commercial latex paint. A poured form (she calls them "paint bodies") will spread to a large, slightly raised area while retaining a defined contour. This is distinct from diluted acrylic, which will level but will run wildly in all directions.

The specific chemistry of acrylic paint dictates that a large, poured color will spread and settle to a certain thickness. During drying, a crazing (tear) in the top layer of the paint film will create incidents of dramatic tension. Latex house paint tends not to craze.

After the color is laid down, one can act on the paint in a variety of ways.

- One technique to use after the initial pour is to tilt the surface. Tilting the rigid panel or stretched canvas will flow paint over a larger expanse of the surface after the initial flat pour.

- Repeated banging of the underside of the canvas, as well as tilting or shaking the canvas or panel, levels the paint, diminishing thicker paint peaks.
- A simple alternative to tilting is to move the panel is a circular motion, keeping it flat; this swirls the colors into circular pools.
- Some degree of guiding the wetness and channeling the movement may be tolerated without loosing the sense of paint freedom. It is thought that Morris Louis guided his flowing paint with a stick.
- Even thick impastos will "travel" rapidly because of gravity. The impasto should not be expected to remain flexible over the sharp curve of stretcher bars if the work is restretched.
- A dynamic drying may move the paint and promote pigment separation while it is evaporating. Use of fans, hair dryers, or breath is possible in ways similar to techniques use by watercolorists.

[P]aint . . . which skipped the step of having brush dipped into it; paint transferred from can to canvas with no contact with the artist's traditional transforming techniques. You can visualize the picture being made—there were just no secrets. It was amazing how much energy was freed by this bluntness, this honesty, this complete obviousness of the process by which the picture was made.

Philip Leider, art historian

Jane Callister, *Drift*, 2002, acrylic on canvas, 36 × 48 inches (91.4 × 121.9 cm.).
Courtesy of Susanne Vielmetter LA Projects Los Angeles, and the artist.

Callister works directly on horizontal supports. Generally the support receives an all-over tonal ground. The poured acrylic is coaxed together occasionally with tilted movements or by drawing into the wet paints. Callister pays attention to the viscosity of the paint mixture knowing that this affects the flow rate of the color on the canvas as it is raised. Callister's Postmodern stance allows a dialogue between apparent abstraction (paint as paint) and representation (painted illusion). Shapes shimmer between landforms and painterly incident.

13

staining with paint

A final distinction—not between abstract and representational paintings but between two types of abstraction—can account for the shift in thinking about abstract painting that occurred around 1959. Abstract painting can be treated as either a verb or a noun, a process or a product. *Frances Colpitt, art historian*

Staining, like poured paint, is a kind of process painting. In the evolution of abstract painting techniques, stain techniques developed after poured paint. While early drip techniques led to a proliferation of allover composition, stain technique led to an acknowledgment of the resolute flatness of the resulting optical field. And if poured paint gives a sense of glistening water, a stained painting gives a sense of colored air—of weightless emotion and a "dissolving" surface.

With stain techniques, we can experience—on a grand scale—paint phenomena similar to those associated with watercolors. As is true of watercolors, the texture of the color-forms in stain paintings are inseparable from the support matrix. Previous to staining, there always existed a tacit sense of separation between color-form and support. In other words, the color-forms' texture had been determined by the painter's hand, or, in Pollock's case, arm. Aesthetically, a stain painting projects a sense of timeless existence in its suggestion that the color-form has always been a part of the fabric.

The focus here is the stain technique using acrylic paint. While early experiments used thinned oil, acrylic solution (Magna), or alkyd paint, I do not recommend such materials because of the fact that oil-based paints rot fabric. Moreover, extensive staining with oils requires large quantities of dangerous solvents.

COLOR FIELD PAINTING AND THE BEGINNINGS OF THE STAIN TECHNIQUE

Color Field painting, which often employs the stain technique, has traditionally stressed color and flat stretches of space. The first Color Field painters had less interest than Abstract Expressionists in the expression of big emotion. But "emotion," like so many things, is relative. Describing a Color Field painting as "less emotional" when compared to a "highly emotive" Abstract Expressionist work does an injustice to both genres of painting. Color Field painting is emotional too, but its emotion has a "quiet" and "meditative" quality. Color Field paintings seem to unfold according to their own needs and do not appear to serve as repositories for their painters' psyches. (This shift of focus from the painter to the painting in the original Color Field paintings has been termed by art historians "post-painterly abstraction.")

Helen Frankenthaler, *Grand Tour*, 1983, acrylic on canvas, 97 × 142.75 inches (246.4 × 362.6 cm.). Courtesy of the artist.

Frankenthaler is the acknowledged originator of the staining of raw canvas. Her landmark work, *Mountains and Sea* of 1952, inspired Morris Louis and Kenneth Noland. Her early work was painted with dilute oil paints on raw canvas, and the oil paint binder eventually created a "bleed" or "halo" around the color. Acrylic paint, which did not exhibit such behavior, was to become the standard vehicle for stain painters. Art historian Karen Wilkin has commented on Frankenthaler's work: "These associations are turned into resonant layers of color that seem remarkably dense while remaining distinct; the effect is rather like looking down into deep water."

masked areas

Masking the surface with a clear or tinted medium creates forms or areas that repel a stain. This is a resist technique that offers a wide range of potential effects, especially the exploration of the design potential of negative space. Resists, either clear or colored, can be used to introduce the compositional force of drawing into a stain painting. Since the edge of a large resist will dry before the inner region, it is possible to blot out the still-wet inner resist. The effect is of a masked area with an inner "explosion" of color.

Stain techniques give rise to big paintings. In such large paintings, optical spaces can become an engulfing visual field. Once the painter sets up a disciplined, limiting procedure, specific paint outcomes grow as flowers in a garden.

> The result of this system of control by the macro-structure in the work of [Morris] Louis, [Kenneth] Noland and [Frank] Stella is that for the first time color can be fully orchestrated. The intervals, cadence and textures of the colors begin to assert themselves . . . In Louis' stripe paintings the colors virtually form visual chords.
>
> *John Coplans, critic*

SUPPORTS FOR STAIN PAINT

Because color and form "fuse" with the support in stain painting, this technique requires increased attention to the paint-receiving surface. The factors of concern for the support are absorbency; stability; character of the under-surface; and dampness of the receiving ground.

Absorbency

Stain techniques require an absorbent material such as raw fabric or prepared wood, paper, or board that has not been gessoed. In order for the stain to soak in quickly, the surface to be stained must be capable of absorbing water. Absorbency differs among fabrics according to fiber content. For example, cotton duck is more absorbent than linen. Not all surfaces are absorbent; some surfaces actually repel water. The water-repellent quality of fabrics containing linen and polyester make those materials fundamentally unsuited to the stain technique. Applying an absorbent ground to these fabrics can make staining possible, however.

Absorption is not without its drawbacks, for it is this very quality that makes a painted surface prone to collecting dust and dirt over time. For this reason, absorbent painted surfaces need to be treated to protect them from being damaged. Moreover, when the painting ground is porous, there are limited options for erasing or recovering from an unintended mark. Stains, like watercolor or calligraphy, need to get the gesture right the first time.

RAW CANVAS This is the most popular choice for acrylic paint-based stains because canvas is highly accepting of them in much the same way that paper is accepting of watercolor. Archival issues related to unprotected raw canvas have led the development of "absorbent ground" mediums. These mediums are neutral-tinted acrylics that are highly permeable. Application of an absorbent ground medium is similar to the application of a conventional acrylic ground layer and precedes the stain application. Use of absorbent ground mediums gives conservators a shot at cleaning dirtied regions later on. An absorbent ground definitely should be used with oil-based stains.

PANEL When we think of stain painting, generally we imagine color wedded to canvas. But oil and acrylic stains can be used on panels too. A rigid support may be sized, prepared with a conventional ground, and then covered with an absorbent ground. Stains on such smooth surfaces have the potential to display extraordinary detail of pigment-vehicle separation and backruns, as can be seen in watercolors.

Stability

A stable support is designed to accept paint and keep it in place. As with poured paint, in stain painting, unstretched fabric is generally used on a specially prepared under-surface placed on the floor or large table. A good stain painting under-surface is a large, rigid panel made of foam core or polyurethaned homosote to which a fabric ground can be temporarily attached. Many painters make an under-surface by securing a waterproof, heavy-gauge vinyl sheet to plywood, while others work over carpeting, which encourages some loss of paint from the backside.

Fabric stretched on a frame is not well suited to stain painting, as uneven staining can occur where the fabric meets the stretchers. Moreover, as with poured paint, the weight of the liquid on the fabric can cause the stain to run and puddle in the center, where it could make contact with stretcher bars and crossbars.

Character of the Under-Surface

Pay special attention to the under-surface described in the previous section. Since the thinned-paint stain is likely to bleed all the way through to the bottom (back) of the fabric ground, capillary action can create unwanted effects. For example, paint can be "sucked away" from the canvas and proceed to the under-surface, which can result in uneven paint tone. This phenomenon is especially disconcerting when the diminution of tone follows the lines of a crossbar or stretcher bar.

Factors to consider in the under-surface include:

- Uneven contact with the under-surface = uneven paint tone. If the under-surface does not make uniform contact with the canvas, the stain will not be even-toned. Similarly, unless unevenness of tone is desired, the undersurface should not be textured (for example, avoid wood plank floors).
- Unlevel under-surface = uneven paint tone. If the under-surface is not perfectly flat with respect to gravity, the stain can run "downhill" and will not be even-toned. Heavier, inorganic pigments are especially prone to unwanted separation between pigment and binder under such circumstances.

- Absorbent under-surface = less stain on the fabric ground. If the under-surface is absorbent, it will remove a certain depth of hue from the stain.

Dampness of the Receiving Ground

The degree of resistance between the stain and the ground needs to be controlled. The degree of the ground's wetness also determines how accepting the ground will be to the staining mixture.

WET SURFACE A moist ground is more accepting of stain in the ground's weave or grain. However, clearly defined edges cannot be achieved on a pre-wet surface Instead, the stained areas will appear to have a "halo."

Jaq Chartier, *Stain Chart (9/02)*, 2002, stains, paint, and acrylic on wood panel, 28 × 35 inches (71.1 × 88.9 cm.). Courtesy of Schroeder Romero, Brooklyn, NY, and the artist.

Chartier controls staining dyes between layers of acrylic medium on panels. The dyes are used specifically for their ability to bleed into the medium. It is not surprising that Chartier's work grew from a familiarity with oil and wax surfaces.

Tom Barron, *Evening Exit*, 1991, acrylic and pastel on canvas, 31.5 × 22 inches (80 × 55.9 cm.). Courtesy of Andrea Marquit Gallery, Boston, and the artist.

Barron employs a trademark wet-in-wet staining with haloing evident on many of the forms. The paintings are life studies, all rooted in direct observation, much as Hans Hofmann's work. We get a sense of ephemeral reality, as if solids are dissolving before us. Barron always works on absorbent acrylic ground that mimics raw canvas without the associated archival problems.

DRY SURFACE A dry support has more surface tension than a moist one. Dry surfaces resist the spreading stain and the stain can "bead" at the edges. This beading will dry to a darker-toned contour edge. This is quite the opposite effect of a bleed.

STAIN PAINT PREPARATION

When using staining techniques, paint preparation is crucial; pigment is exposed almost as a naked fact. To make a stain, the artist will generally mix a very wet, non-viscous paint made of pigment and medium. The particular acrylic medium selected will have an inherent viscosity that can usually be altered with additional water. Care should be taken that enough medium is present to affix or "glue" the pigment to the support; pure pigment in water will flake off.

Absorbency is increased when flow-release additives are mixed into the stain. A flow-release additive, which is a type of soap, reduces the surface tension between paint and support, thus allowing speedier absorption. Flow-release additives also increase "open" time for the paint film, extending the working time of the color.

Because of the low viscosity of a stain mixture, the pigment has greater opportunity to settle within the medium matrix. Heavy inorganic pigments, such as cobalts or larger sized chunks of pigment have the potential to travel with the draw of gravity during the drying process. This effect may be desirable and can be encouraged by including particulates (silica, powders, beads) for increased separation effects.

When the paint mixture is not thoroughly blended, two things can occur. First, uneven reflectivity happens when there is insufficient mixing of water into medium; after drying, the stained surface will exhibit varying degrees of matte-to-gloss texture. Second, insufficient mixing of pigment into medium results in uneven color.

STAIN APPLICATION

Stains display varying characteristics according to the type of application. The edges of the color-forms will be soft or hard, creating either solid forms or misty fields. Evenness of tone is another characteristic. Because the initial application is crucial to the final painting, test the paint mixture

for hue, staining power, and thoroughness of mix on a small swatch of the support material.

Traditional Application of Solid Forms

When the receiving surface is dry, matte forms with visible contours may be created. Contours can be softened by working them over with a brush or by lifting paint from the surface with some absorbent material.

Staining also can be used to simulate the even blending quality that has traditionally been considered the sole province of oil paints. After a stain is applied, the same color or a new color may be introduced on top of it. Again, a lesson from the world of watercolor: If you want the new color to integrate as an intense region in the field, make sure the second paint mixture has a similar pigment-to-water ratio to that on the "receiving" stain. Otherwise, a water-ring, or "backrun" will result.

Modifying Tonal Gradation

If an unevenly toned stain is desired, it is easy to achieve. Blotting creates a lighter tone. Use a blotter that does not shed any particles. Choose cloth over paper; a dry or lightly damp sponge is best. Dropping in more concentrated pigment solutions will make portions of a wet stain deepen.

To create an even gradation from pastel to rich tone, position the canvas at an angle so that gravity pulls the wet stain. A very even stain can be achieved by misting paint on a pre-moistened support surface.

Reducing the Presence of the Artist's Hand

To reduce the human presence or sense of authorship in a painting, one must give up some degree of control during application. Process painting tools for applying a stain include:

 buckets
 brushes
 sponges of various sizes
 syringes and/or spray bottles.

Process painting is a phenomenological approach, with paint marks produced aleatorically. Numerous strategies can be employed to reduce the impact of

Gary Stephan, *Untitled*, 2004, oil on canvas, 48 × 54 inches (121.9 × 137.2 cm.). Courtesy of the artist.

Stain has the power to act as atmospheric background. Stephan's work uses staining in broad regions to underscore and unite drawing that is sometimes spacious and sometimes intricate. Stephan's paintings also exchange foreground and background. In the left corners, the blue appears as background. The stain across the lower-middle area reinforces an interpretation that the mid-level blue forms are in the foreground.

Arthur Yanoff, *Steerage to Ellis Island—High Expectations*, 2001, acrylic, caran d'ache, collage on canvas, 47 × 23.75 inches (119.4 × 60.3 cm.). Courtesy of the artist.

Just as traditional painting employs imprimatura to establish an initial middle tone, Yanoff often lays down a stain of color upon which painterly incident will dance in an airy suspension. Drawing with chalk and collage enlivens the approach. Yanoff: "My paintings are based on direct observation of the subject, and this often takes me into areas of abstraction in terms of the actual results. Still, I don't consider a painting realized unless I sense something of the original source woven into its fabric."

the hand or arm of the painter on the material properties of paint and surface. A number of materials may be introduced to create texture. Watercolorists are familiar with the trick of throwing salt on a pool of wet paint to create a speckled texture. Sand or grit work in a similar manner, and familiar objects can be used to leave fossil-like imprints.

RECOVERY

Rarely does an artwork succeed with an initial quick effort, and painted gestures are often at odds with the original intention. Recovery means partial removal or modification of a paint layer.

Removal of Paint

When the painting ground is porous, application of stains can be similar to traditional watercolor or calligraphy. As a result, there is little option for erasing or recovering from an unintended mark. It is possible, while the area is still wet, to rub, blot, or scour a stain, but doing so creates unevenness of tone. To create an even gradation from pastel to rich tone, position the canvas at an angle so that gravity pulls the wet stain.

Since less binder is present than with a normal acrylic or oil paint, it may be possible to reduce some tone after the paint is dry by "erasing," or by using physical abrasion. This is possible with inorganic, large-particle pigments but unlikely to succeed with organic pigments. Pale stains on absorbent medium can also be covered with a re-application of the medium.

Cropping

The highly uncontrollable nature of stained paint techniques has led many practitioners to compose after the paint is dry by cutting, or cropping, the canvas, thereby defining the limits of the pictorial incident. We can preview potential crops by laying down masking tape or boards on the stained work. We can also use digital photography and computer-image manipulation to study the effects of potential crops.

DRYING

The drying time of a stain will be much quicker than for thick, layered paint. Ambient humidity is always a factor in drying time. Fans or hair dryers may be used to speed drying time, but the use of these may affect the evenness of tone, especially at the edges. Tilting the surface is an option while the paint is wet to control the flow-location of soaked colors.

As mentioned before, the absorbency of the painted ground presents archival issues. Varnish presents one option of solving the absorbency problem once the painting is finished. Applying varnish will probably reduce matte/gloss variation in the stained areas of the painting. Care must be taken in the application of varnish, however, because often the binder-to-pigment ratio in a stain is low and brushing can dislodge the fragile color.

When the painting ground is porous, application of stains can be similar to traditional watercolor or calligraphy. As a result, there is little option for erasing or recovering from an unintended mark.

Craig Fisher, *Painting Not Yet Titled*, 2003, acrylic on raw canvas, 64 × 52 inches (162.6 × 132.1 cm.).
Courtesy of Florence Lynch Gallery, New York, and the artist.

Fisher seeks an anti-compositional effect even when working directly. He applies color with the hope that he can succeed in that most difficult task: to empty the gesture by removing any trace of intention. Fisher achieves distance between the rational, self-organizing mind through several means: applying stains to the wrong side of the canvas, scraping a fresh paint incident with cardboard, introducing resists that complicate a stain, and/or applying paint with no sense of top, bottom, left or right.

14

painting in layers

For me there is no one "technique" that makes every painting work, no matter how technically proficient I might become. Making a painting work is always a negotiation with the painting itself. I always start with a plan but, if I am not open to tweaking, altering or even abandoning the plan, it is more likely that I can lose the painting.

David Row, artist

After an initial intoxication with poured paint and stained canvas, abstract painters experimented with a huge number of non-traditional materials and methods, including layering. Paintings composed of numerous definite layers contrast starkly with stained-paint works.

Layering techniques vary, and the result is a variety of coloristic and textural effects. Paintings using layering techniques often evoke a sense of revealed secrets, of facts partially hidden. One can sense the implied depths of paint and color as latent energy.

Layered paint construction touches on both traditional and process-oriented techniques. The layering techniques discussed in this chapter include:

- brushed-on layers of paint, both opaque and translucent
- scraped-off paint, wet or dried
- optical blends, from brush dragging or pointillism
- monoprint or "lift"
- crazing
- collage and other mixed media.

Layers of paint should follow the guidelines for sound paint construction looked at in chapter 4.

> [T]he first coat should be the coarsest in texture, the second a finer grain and the third, finest. Likewise, a superimposed coat must be as flexible and susceptible to expansion and contraction as the undercoats.
>
> *Ralph Mayer, authority on materials and techniques*

BRUSHED-ON PAINT

The topmost paint layers may range in transparency from opaque through glazes. Layers may be poured, brushed, or squeegeed, either evenly or with ridges. Generally, acrylics find greater advantage than oils in multi-layer constructions for two reasons. Thicker layers can be built without fear of cracking and the faster drying time of acrylic paint allows more layers to be built in less time than other mediums.

Joanne Mattera, *Uttar 12*, 2000, encaustic on panel, 18 × 18 inches (45.7 × 45.7 cm.).
Courtesy of Margaret Thatcher Projects, New York, and the artist.

Semi-transparent paint film is one of the hallmarks of layered painting. The encaustic paint technique results in an exemplary semi-transparent film; this type of paint uses beeswax and resin to suspend the pigments. The fundamental technical difference between encaustic and either oil or acrylic paints is that encaustic sets but does not polymerize. As such, encaustic may be reworked with the reapplication of heat. "Scraping and incising are essential to my method," says Mattera. "The soft wax invites incursions into its surface. More importantly, affecting the material in this manner lets me create a painting that is compelling on its own terms, rather than simply because the pigmented wax is so beautiful. . . . I chose encaustic after having worked with conventional oil and acrylic paints because I respond to the luminosity of its color and the lushness of its surface. These qualities would seem to run counter to my grid-based reductionism, but in fact they create a lush minimalism in which, for me, opposites amplify one another."

Caio Fonseca, *Pietrasanta Painting CO3.14*, 2003, mixed media on linen, 28 × 38 inches (71.1 × 96.5 cm.). Courtesy of Paul Kasmin Gallery, New York, and the artist.

Curtains of flat forms create a sense of shifting a pictorial space where foreground and background exchange position. Although Fonseca only uses opaque paint forms, the numerous breaks in the field reveal the lower paint structure.

Opaque Layer

Flat, solid, and opaque paint generally does not communicate a sense of layering. How, then, do we make opaque paint seem to be hiding something? One method is to lay down the opaque color on top of very palpable texture. Another cue that suggests layers is to let underlying forms "peek through" in many places.

Translucent Layer

Neither oil nor acrylic binding vehicles are clear, and both impart some tone. Oil glazes will have an amber cast, while acrylics will exhibit some milkiness if built up quickly. Oil paint can be made less opaque with substantial addition of resin or wax mediums. Thinning oil paint with solvent should be done only to the point where it is still a suffi-

cient binder. (Chapter 5 gives mixing guidelines for making semi-opaque veils of color.)

Whether using oil or acrylic, one must first test the degree of translucence in the over-coat mixture. Thickness of the paint film, the character of the binder, the amount of pigment, and the pigments' innate transparency contribute to the character of the translucency.

SCRAPED-OFF PAINT

Scraping refers to techniques wherein paint is laid down deliberately for later removal. Because scraping works in a brutally indiscriminate fashion, it often distances the painter's hand from the composition and introduces a note of random adventure.

Walter Darby Bannard, *Bee Glade*, 2002, acrylic on canvas, 53.5 × 25 inches (135.9 × 63.5 cm.). Courtesy of the artist.

Recalling the premeditation of indirect painting methods, Bannard counterpoints layer upon layer of warm/cool combinations to reach a visual summation. The sense of swinging-arm gesture, so apparent in the initial squeegee drawing of the dark ridges, has evaporated. We are left with a sense of a coral reef grown over centuries of accumulation, far removed from human determination.

David Row, *Algorithm & Blue*, 2003, oil on linen and panel, 16 × 20 inches (40.6 × 50.8 cm.).
Courtesy of Von Lintel Gallery, New York, and the artist.

David Row's work incorporates screens and scraping techniques reminiscent of silk-screening, a sensibility that evokes Pop Art surfaces. In a sense, this is a reversal of Roy Lichtenstein's paintings, which quoted Abstract Expressionism. Row uses scraping to develop veils of space and to distance the hand and gesture from the image.

One can scrape wet or dried paint. Oil and acrylic paints are both suitable for this technique, and the paint can range from opaque to very transparent.

The support surface is important in scraping. Due to the pressure on the support, a panel (or unstretched canvas tacked onto a stable flat surface) is preferable.

Scraping Wet Paint

A visceral charge to the surface results from scraping wet paint; the paint's viscosity becomes apparent as it is "torn" from its resting place. Usually some rigid, flat-edged tool, such as a squeegee, is used. Scraping lends a sense of direction or movement. The viscosity of the paint coupled with the type of scraping tool crucially affects how the scraped wet paint spreads across the picture plane and how it sinks into any texture on the support. The under-layer colors may be dry. If the underlying colors are still wet, the scraping tool will pick up and blend some of those colors.

Scraping Dry Paint

Sanding or grinding the dry top layer will render some underlayers visible. Paint with a relatively soft, porous paint film makes this sanding easier. Lighten the paint with some easily sanded material, such as silica or sawdust (similar to the treatment for incised texture). This erosion technique may also be used as a form of editing or recovery from paint application that doesn't work visually.

OPTICAL BLENDING

As the viewer lengthens the distance from a painting's surface, the eye begins to "fuse" small coloristic incidents. Sometimes, a pleasing effect is created when, depending on the distance from the painting, the viewer can successfully reveal and conceal individual marks within a greater whole.

Vicky Perry, Erosion example (detail from *Bold As Love*), 1987, acrylic on canvas. Courtesy of the artist.

This detail exemplifies the pre-planning requisite for indirect painting. Three layers of paint were set down in anticipation of heavy sanding. First, thickened pink was formed into ridges. This was followed by an all-over black coat. The final topcoat was a simple, thin, opaque yellow. Sanding down the ridges revealed cross-sections of the paint construction.

Steve Karlik, *Untitled (30)*, 2003, oil and acrylic on wood panel, 18 × 46 inches (45.7 × 116.8 cm.). Courtesy Pentimenti Gallery, Philadelphia, and the artist.

For Karlik, the disciplined work is created in an improvatory way. Karlik works with the support in a horizontal orientation. Alkyd paint is poured onto the panel, dried, then sanded down. The paint is so thin that it is self-leveling, but at times Karlik helps level it out with a large sheet rocking knife. Layers (from eight to sixteen in number) are built up to create a palpable presence of paint. The final surface is buffed with steel wool. Some regions are eggshell finish, while others display a gloss.

This optical blending is part of the appeal of broken color, a term introduced in chapter 11.

Optical blending and broken color are generally developed from either dragging paint in one sweeping, painterly motion or a pointillistic accumulation of numerous small additions of paint.

Dragging

The effect called broken color consists of lightly brushing a layer of color over a base color. A prismatic combination of adjoining colors is created.

When the base color is dried, the top color should lightly graze the paint surface. Only the topmost raised areas of the base texture accumulate new paint. Holding the brush at an extreme angle to the picture surface effectively picks up texture, barely grazing the base texture. A light, feathering motion prevents the top color from completely covering the base color.

When the base color is still wet, the dragging stroke lifts up some of the first color and blends both colors as the drag proceeds along the surface. Usually, a single bold gesture is used.

Pointillism

Pointillism is the build-up of paint by the cumulative effect of small paint daubs, which can be applied from a brush, straight from the tube, from a palette knife, or by overlapping splatters.

When we look at a pointillistic painting, the eye/mind mixes adjoining colors to create a third color impression, in much the same way as we perceive broken color. However, while broken color is relatively spontaneous and painterly, pointillism usually involves a methodical application of points of color. For this reason, pointillistic paint construction can convey a temporal sense of the extended creative process. It also demonstrates a dense gestalt from extensive accumulation. The pointillistic daubing of warm color spots next to cool color mixes to gray. But this gray impresses us as "active," as compared with a simple opaque coat of paint.

Francine Tint, *Stone Wall*, 2001, acrylic on canvas, 15 × 13 inches (38.1 × 33 cm.). Courtesy of the artist.

The sweeping motion of the wet-in-wet stroke evokes the force of a rocket launch. The modest scale of this work heightens the force of the brushstroke, wet top coat over wet base colors. Blending is on the fly. Direction is unequivocal. Critic Margaret Sheffield describes the work as having "[T]he tactile reality of landscape."

The painting "breathes" color because of the airiness between each deposit of paint, laid in gently with the tip of a palette knife. Sagerman observes, "My paintings are comprised of dabs of oil paint, applied individually with a palette knife, that I allow to accumulate over the course of many months. Moving from an earlier spiritual affinity with field painting, my work has come to a painterly conceptualism and a resolutely non painterly approach. The ceaselessly repetitive activity of my studio practice is an existential puzzle to me. I fall back frequently upon motifs garnered from Jewish mysticism." The material that builds body in the oil paint, which goes under the name of Tixogel, is composed mainly of a clay that makes a paste when mixed with stand oil.

Rainer Gross, *Falanga Twins*, 2004, oil and pigments on canvas, 36 × 36 inches each (91.4 × 91.4 cm.). Courtesy of the artist.

Gross transforms the monoprint technique in a conceptual direction. His technique involves the use of oil paint. Twin panels are prepared. One is treated to a series of pigment/water washes which dry to a moon-like cratering (there is no binder yet). The second panel is loaded with oil paints and linseed oil. The twins are pressed together, each incorporating some of the other's paint layers.

Rainer Gross pulling a "print".
Photo courtesy of the artist.

MONOPRINT

A monoprint-like technique creates optical and literal textures. Sometimes referred to as "lifting" color, this is another alleatory technique. The process is outlined here.

- The support may already have some dry color and texture.
- Cover the support with a deep layer of wet paint. The wet layer may be a mix of several colors, but the paint must all be of the same binder type (all oils or all acrylics).
- Cover the thick, wet paint layer with some material such as plastic wrap, paper, or even stiff cardboard. You may choose to press gently or massage more vigorously.
- Lift the material off. The speed and angle of the lift effects the results. High speed generates droplets of incident and lower ridges. A low angle and low speed develops higher ridges.

SURFACE FILMS

Because paints dry by evaporation, the topmost layer of molecules can "polymerize" or set before the lower mass of paint. This creates a skin of paint that will interact with the continuing drying process.

Crazing

The splitting of a top layer of paint film before the underlayers are dried is called crazing. (This cracking is reminiscent of some desert floors.) As a natural phenomenon related to evaporation, crazing results in fractal patterns. Magnifying an individual crack reveals a sub-pattern similar to the overall pattern.

We can exert some control over the location of these breaks. Cracks often form at points where the top coat is thinner and weaker and at the same time the underlayer is thicker and will take longer to dry. If you are inclined to intervene, an incision or a stick dragged through the still-wet top layer will sometimes thin the top film and encourage crazing in that area.

For intentional crazing, certain acrylic mixtures are more likely to create big crazes. A medium with a relatively high proportion of flat silica will be thicker and dry more slowly, thus resulting in large crazes. Acrylic mediums that are resistant to crazing are commercially available.

For oils, special paint additives can be purchased that include a premixed bottom coat and topcoat. When we encourage crazing with oil paints, we are purposefully violating the "fat over lean" rule and so must be careful that the resulting paint film is not going to suffer delamination. Use with caution.

Jules Olitski, *Bathsheba Reverie-Yellow and Gold*, 2001, acrylic on canvas, 24 × 30 inches (61 × 76.2 cm.). Courtesy of Knoedler and Company, New York, and the artist. Art © Jules Olitski/Licensed by VAGA, New York, NY.

Olitski, a well-known pioneer of acrylic painting technique, mastered numerous effects in a Color Field context. In this painting, he accentuates crazing effects with iridescent powders glazing the picture plane.

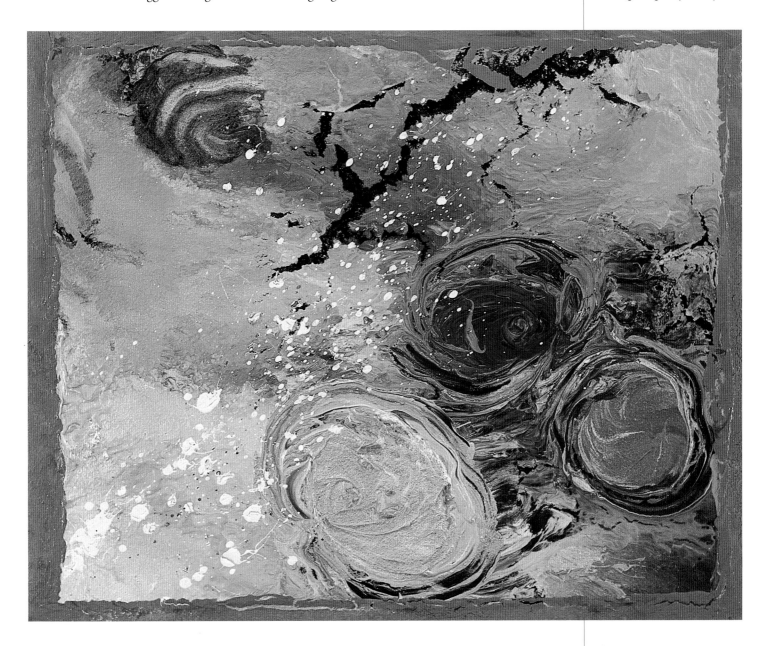

Peter Bradley, *Untitled*, 1974, foam and acrylic on canvas, 98 × 98 inches (248.9 × 248.9 cm.).
Courtesy of the artist.

Inches-deep texture is achieved with a collage technique of foam covered in acrylic paint. The painting responds dramatically to differences in lighting. Here, strong, raking light promotes a sense of sunrise in some wordless terrain. The subdued palette allows the materials to speak eloquently as an interplay of lights and darks, shadows and highlights. To build up the expanse, Bradley found sources for foam to glue to the support. This minimized the weight of the painting—no three inch-thick loads of pure acrylic gel—and brought production cost way down. In other cases, Bradley uses carpet cushioning; its mechanically repetitive, weave-like patterned surface is reminiscent of Picasso's Cubist collages that incorporated simulated caning.

Pat Adams, *World Without End*, 1992, oil on linen, 65 × 98 inches (165.1 × 248.9 cm.). Courtesy of Zabriskie Gallery, New York, and the artist.

Adams builds the work with three types of operations that, working together, create an interplay between paint incident and deliberate touch. First, a logical framework is proposed with a red, yellow, and blue double-disc geometry. Next, an obscuring layer of blotted paint and raked glazes places the composition in a suggestive, ambiguous condition. A final layer clarifies the composition, building "morphological runs." The raked paint layer predicts the white stripes as well as a single linear crossing. Smaller, hard-edge circles recall the initial double-disc geometry and the splatters in pigment dusting. Adams's account is eloquent: "In the beginning, the double disc of *World Without End* provoked the pleasures of red, yellow, blue—the irreducible primaries. But a darkening of vision overtook the color, and the surface was excoriated in inescapable dismay. Isobutyl methacrylate glazes, overlaying the original centered double disc, served to bind mica, sand, pigment, charcoal to canvas. The new surface was raked, scoured in lateral flailings, calling up memories of titanic drawings by geological events across high rock walls."

Crusts

An extreme form of crazing, a crust is where small parts of dry paint film sit surrounded by the bottom color. Often the top color differs from the bottom color. Crusts look like satellite photographs of oceans and islands. To get the top paint to dry much more rapidly than the bottom paint, spread a dusting of powder over thick, wet acrylic paint. Dry paint pigments or iridescent powders are usually used. When using metallic bronze powder, a trail of tarnish surrounds the crust like a halo.

Follow the application of pigment powder by accelerated surface drying with a hair dryer. The "wind" from the dryer tears sections of the film apart and pushes them over the wet underpaint. Note: Pigment can become airborne in this process, so use a respirator or mask in a studio designed to contain the flying powders.

Additional movement of the crusts of dry paint film can be gained by tilting or banging the canvas on the underside. A number of these techniques benefit from the use of a spray varnish, after drying, because of irregular surface texture and to control future tarnish of metallic pigments.

COLLAGE

Painters have long incorporated non-paint elements into their paint layers. Collage, from the French word meaning "to paste," originally developed using mostly flat materials. This technique was especially notable when used by the Cubists.

One reason to add three-dimensional elements to a collage is to increase the bulk or change the texture of the paint. Another reason for adding foreign material is to introduce fragments of the world in a way that may startle the viewer. When using unusual substance in an oil painting, consider whether the acid of the oil paint will deteriorate the material. You can isolate the material with a protective acrylic coat before immersing it in an oil paint film.

Acrylic paint will readily accept material for collage application. The acrylic medium is, in fact, a wonderful glue.

One note of caution: When collage or another technique introduces a highly variegated surface, conservation becomes difficult. Dirt and dust will collect in all the surface irregularities. Consider the use of an overall varnish. Acrylic artworks should get an isolation coat.

15

approaches to the practice of painting

[An artwork is] a corner of nature seen through a temperament.

Emile Zola, writer

We cannot hope to encapsulate all the feelings that are brought to bear on the enterprise of abstract painting. But it is helpful to be aware of at least some of the forces governing our aesthetic decisions. And we should acknowledge that, sometimes, we do not consciously choose an artistic effect. Sometimes we are just lucky.

SOURCE MATERIAL

Our overall approach to painting can be the stuff of artist's statements and critical writings. Or it can be left to chance and subconscious machinations. Studio practice flows from a mind-set. Cognitive, emotional, intuitional, and physical preferences contribute to form approach, or mind-set. Temperament may be somewhat immutable, so it is helpful to be objective about our preferences. This objective attention may strengthen a practice or reveal contradictions and obstacles to progress.

We are inspired by the visible world, by emotions, by concepts, by formal elements of painting, and by other paintings. "What the work is about" may run a spectrum from extrinsic (the natural visual world), through the personal (the artist's mental world), to things solely intrinsic to the art object's form (surface, color, scale, and various formal qualities).

As a major direction of art, abstraction began as a simplification and generalization from nature.

Mondrian's "Ocean and Piers" paintings, for example, drew their compositions from direct observation of the visible world. Many painters today still derive initial structure or colors from observation.

An alternate type of observation is painting inspired by the emotional landscape. Pollock said, "I am nature." In this situation, the painter has dispensed with recognizable forms from visual observation. The painter is attuned to emotions or moods.

Some painting decisions flow almost entirely from concepts, with little regard for sensual concerns. This is an ideological mode of creating, often concerned with innovation or revolution in an art historical sense. (In fact, a conceptual thread is found in all painting.)

These [paintings] are the primary colors. Every plane is a discrete plane and there will be no more representation.

Alexander Rodchenko, artist

Still another focus is on formal concerns. Perhaps a work starts with a design or sketch. As the painting develops, the focus is on refining the design. The focus is on optical sensations and formal problem-solving.

There is always a sense that a painting is proceeding from the art of the past. Sometimes, a painting is a direct response to another painting. Painters have borrowed ideas, quoted compositions, lifted techniques, and mutated intentions.

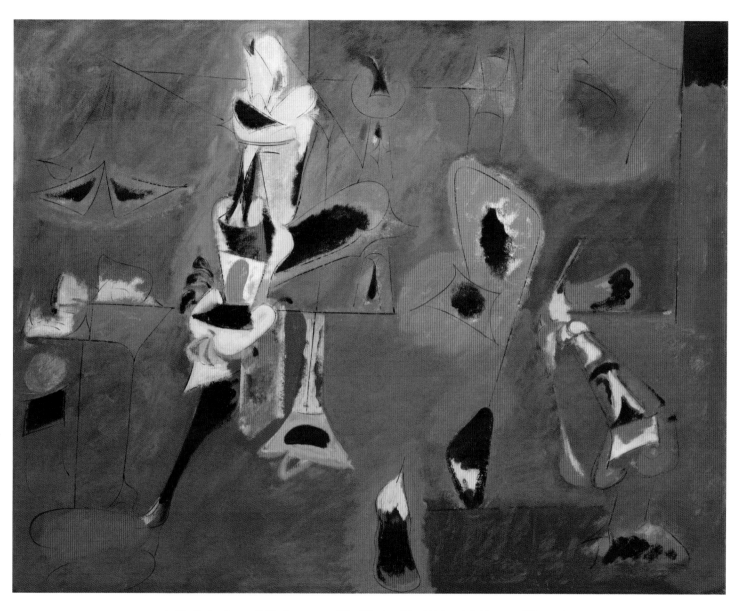

Arshile Gorky, *Agony*, 1947, oil on canvas, 37 × 47 inches (94 × 119.4 cm.). © Museum of Modern Art.
Licensed by SCALA/Art Resources, NY, Artists Rights Society (ARS), New York. Collection of Museum of Modern Art (Ailsa Mellon Bruce Fund).

Arshile Gorky: "Abstraction allows man to see with his mind what he cannot physically see with his eyes. . . . Abstract art enables the artist to perceive beyond the tangible, to extract the infinite out of the finite. It is the emancipation of the mind. It is an explosion into unknown areas."

> I have tried to employ the codes of Minimalism, Color Field painting, and Constructivism to reveal the sociological basis of their origins.
>
> *Peter Halley, artist*

Because we humans are complex, our creations are amalgams of most of the above source materials. The emphasis may differ among individuals, and within each of us, the emphasis may shift over time. Regardless of the source of inspiration, approaches involve the degree to which the artist's ego or personal presence is manifest.

DEGREE OF HUMAN PRESENCE

The degree of human presence evident in the artwork may be viewed as a point along a spectrum.

Although all creative processes involve willfulness associated with ego, the final paintings exhibit greater or lesser degrees of human ego. At one end of the spectrum, work can be emotionally charged. At the other end, it can be introspective.

We might characterize these two aesthetic poles as active and passive presence. In the active case, the painting is clearly referring to its maker, expressing self-involvement. In passive presence, we are barely aware of the human element in a conceptual, decision-making sense.

> When one does not describe or depict anything human—then, through complete negation of the self, a work of art emerges that is a monument of Beauty, far above anything human, yet most human in its depth and universality!
>
> *Piet Mondrian, artist*

Josette Urso, *Backyard/Dark View* 2002, oil on panel, 10 × 11 inches (25.4 × 27.9 cm.). Courtesy of Lyonsweir Gallery, New York, and the artist.

Urso creates abstract landscapes from direct observation. Packing primed paper along with other plein-air tools, Urso paints on site to crystallize the sense of a specific location. The abstraction distills many sensory experiences and viewpoints under the severe time constraints of location work.

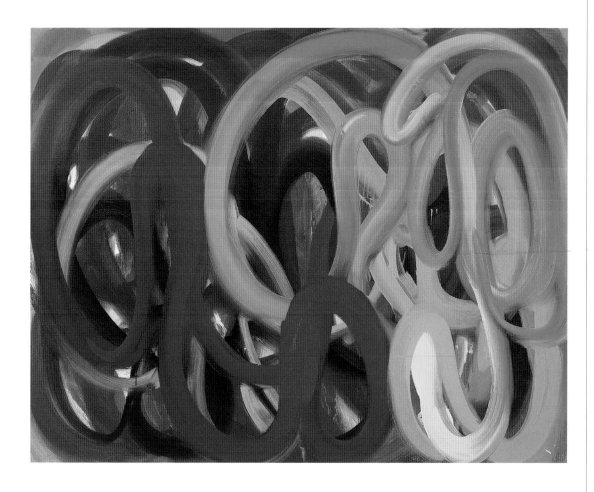

Davie takes on the macho tradition of big gesture. A color sense that summons inspiration from every corner of the environment remakes Action Painting. Davie: "In terms of form, I have always used the repetition of line, gesture, stroke, or stripe to caress and delineate form. I say caress because there is an erotic quality to my work which suggests the covering of a figural form or mass. I use a paint formula which will allow the paint to flow freely and not dry too fast. This way I can get a stroke which will go from left to right or visa versa in one movement."

Visceral

An expressionistic gestural composition retains the visceral aura of the creator's physical presence, and we cannot resist empathically re-creating the performance. A painting clearly reveals the athletic moment when paint is thrown down. Color does not just fall; it splatters with evident directional force. We can experience ways that other high-speed painting methods force the mind to take a backseat to the body in the physical reworking of a composition. Even confusing situations—as when working on two or more paintings at once—can force one to yield to instinct.

> [P]ainting reflects an encounter with the world, the result of which may be an expression of the allusive logic of the perceived world. . . . One does not simply see with the eyes or hear with the ears but engages in a synthetic communion with the perceived object.
>
> *Frances Colpitt, art historian*

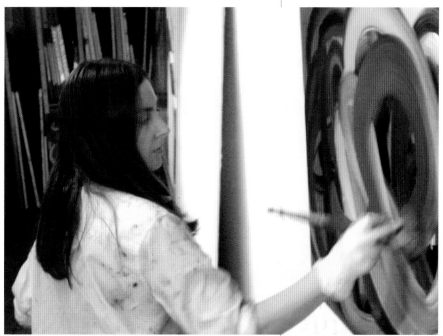

Karin Davie at work in her studio, 2004.
Copyright © Karin Davie. Courtesy of the artist.

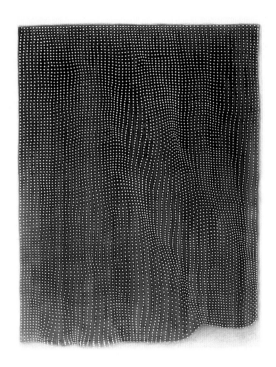

Linn Meyers, *Untitled,* 2003, ink, acrylic, and colored pencil on Mylar, 18.5 × 23.5 inches (47 × 59.7 cm.). Courtesy of Margaret Thatcher Projects, New York, and the artist.

A sense of the impersonal creator is achieved through methodical, accumulative painting. While there is little evidence of human touch, Meyers' geometry becomes strikingly alive. The submerged ego emphasizes pure invention; there exists a driving, even obsessive, research and evidence of her performance-like logic in her works. A row of dots begins an edge; each subsequent edge enhances and accumulates the imprecision of the preceding row. The result is areas of tighter and looser "weave" or density among the dots.

Archetypal

Slightly less athletic are works that conjure a narrative of symbols. Here, we sense the painter's presence, but more as a mind than as a physical presence. Surrealism's automatism is a pictorial language of the psyche. In surreal abstract work, we can sense a purgative desire to intuitively paint visual diaries. In the work of Arshile Gorky, each stroke is imbued with a sense of revelation. Forms seem to involve individual obsessions.

Meditative

At a far end of the spectrum is detachment. A sense of the impersonal creator is achieved through gestureless, methodical painting and geometric forms. The art seems self-made or grown as plants or crystals. Contrast a painting by Jackson Pollock with one by Morris Louis. In Pollock's, we see active presence (wrist or arm drawing), while with Louis we encounter a passive human attendance but an active paint presence in his use of highly dilute paint to respond to the effects of gravity, particle separation, and evaporation. Linn Meyers' work exemplifies the latter approach.

Two other choices to approach remain: between order and chaos and between obsession and re-evaluation.

ORDER AND CHAOS

A spectrum of taste runs from order through to chaos. One's practice may range from improvatory to methodical. The expressive content of a work may be relatively clear before painting begins or it may develop over the course of the painting process.

Why would we pursue chaos in painting? Precisely because it is very difficult for most humans to produce disorder, randomness, or chaos. Being organized and self-regulating creatures, we require a conscious effort to get beyond habitual routines.

Why would we ever pursue order in painting? Because deliberate methods and clean results are always at odds with the random entropy of our physical world, of nature. Spills happen. Materials will not live up to expectations.

Impulses that support an improvisatory practice are:

■ a belief in the stifling effect of deliberation on imagination—that too much thought obstructs he emotional flow
■ a belief that working instinctively will imbue artwork with a vitality and a desirable lack of closure—one often calls it mystery
■ the suspicion that design is a conservative element
■ the perception that a particular painting technique or medium may preclude prolonged forethought. Acrylic and alkyd paints' drying times are short; to make a produce a seamless, wet-in-wet surface with such paints, the painting must be completed in one working session.

What's interesting about developing a painting practice that seems ordered, limited, or somewhat methodical is that we become free to concentrate deeply on the few variables that are not predetermined. Painters often limit themselves in order to highlight what is uncontrollable or eccentric. When we introduce a method or plan into our practice, it's a bit of wishful thinking—like supposing we are standing still when, in fact, we are on a planet hurtling through space and spinning on its axis.

OBSESSION AND RE-EVALUATION

Obsession is required to plumb the depths of an artistic question. A resolute will is what drives "inner-directed artists" to carry on their research.

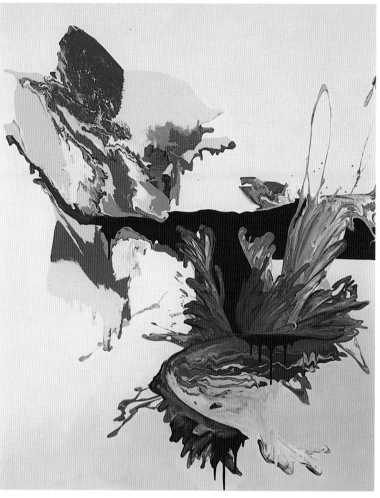

Jane Callister, *Slieau Lhean (Witches Hill)*, 2004, acrylic on canvas, 60 × 48 inches (152.4 × 121.9 cm.). Courtesy of Susanne Vielmetter LA Projects, Los Angeles, and the artist.

Managing poured paint is like riding a wave; timing is everything. The trick is to be so present that we can find the image that is a potential in the pour without losing the integrity away of gravity's effects. The alla prima approach suits a temperament that enjoys the challenge of the unexpected.

dangers of courting chaos

The dangers of cultivating chaos, and thus avoiding thoughtful decisions, is similar to that of driving without a map.

- **One risks creating derivative work, even clichés. Improvisation is not synonymous with mindless physicality.**
- **The painting may never get finished.**
- **The work may be technically unsound and fall apart in time.**
- **There may be unproductive costs in time and supplies that attend a lack of forethought.**

Stan Gregory, *Cream Buck Lie*, 2002, oil and tinted gesso on canvas, 51 × 51 inches (129.5 × 129.5 cm.). Courtesy of Sundaram Tagore Gallery, New York, and the artist.

In the tradition of geometric abstraction, yet influenced by Jean-Louis David and Jean-Auguste-Dominique Ingres, as well as Islamic and Japanese calligraphic traditions, Gregory seeks a formalist expressivity. He uses a limited set of variables. Here, dark lines of predictable trajectory connect over a pale background. The shape is often a square, sometimes on a 45-degree angle that invokes Mondrian's lozenges.

The downside to obsession is lack of critical distance. We, as artists, have a constant need to re-evaluate. If personal dogma is allowed free rein, the result is didactic work. Artwork may be so self-referential as to be imprisoned in a private language and mute to others. Extremely self-involved painting does not explore the world. What results is tedious iterations of problems that have already been "solved" by previous works.

Poons seeks to plumb the depths of an artistic question until he is "capable of nothing more." Poons first reached prominence with the dot paintings of the 1960s. Following the dot paintings, Poons spent five years developing ellipses and loose, painterly compositions. Subsequently, his work mutated dramatically. A huge stylistic leap in the 1970s led the artist to create the poured "Elephant Skins" and "Cascade" series. This was followed in the 1990s by another complete shift to deeply surfaced, mixed media works of mythic form and color. Recently, Poons has moved to a pared-down, painterly surface that seems to generate a complex two-dimensional grammar for delivering an epic tale. What guides Poons in his investigations is a belief that painting, as an arena of "mistakes," is where we are driven to discover our unique errors.

Another pitfall is an academic approach that has lost all mystery or drama. Frank Stella cautions us that university-prepared artists (UPAs) may be unfamiliar with getting their hands dirty. An excessive reliance on books, mentors, or school is a way of ceding mental authority to an outside source. The raw drive to break into fertile, innovative territory is found within—in isolation and risk.

Sitting on the corner of College Avenue, wondering to myself, "How could one so smart be so stupid."

Justin Sane, songwriter

Somehow, obsession must be supported by a self-critical scrutiny. If painting is an expression of life, there will be growth after struggle.

First, it was the dot pictures. . . I was known. . . I was talking to one of the artists in the gallery. I said, "I don't know what the hell to paint. I'm worried. I don't know what to do." And the person said to me, "You don't have to worry about what to do, you're Poons." And I looked at him, and I said to myself, "You're so wrong. That isn't why I'm doing this."

Larry Poons, artist

16

beyond technique

I do have trouble with [early Modernism's] dicta, their pleadings, their impassioned defense of abstraction. My feeling is that these reasons, these theoretical underpinnings of theosophy and antimaterialism, have done abstract painting a disservice which has contributed to its present-day plight. *Frank Stella, artist*

With today's potent paints and brilliant surfaces, technique can tempt us, becoming an end in itself. To elevate an object above craft, we need to guide our work with critical decisions, empathy, and every kind of intelligence. The technician does well to conspire with the philosopher.

Art is energized with conceptual direction—sometimes from religion, or science, or psychology, or critical theory, sometimes with all of these. At the same time, art is specific and object-bound. For example, while we contemplate a work, we may focus on ideas about our social organization, mechanisms of power, and the limits of willful action. Yet all the while our eyes are grazing on pulsing colors that load up our senses with their imperfect borders and irrational textures. A private experience at a subliminal, sensory level is joining up with ideas.

> I think now of the Lake and of Saugatuck. Those things cohere. They form a continuity. The Lake is with me today. The memory of a feeling. And when I feel that thing, I want to paint it.
>
> *Joan Mitchell, artist*

What are the challenges that abstraction faces? One is the question of pictorial space. Since Minimalism, previous ideas of what is essential to painting need to be redefined. Flatness is an important component of a great deal of abstract painting, but not the only one. In some cases, flatness is really not the major issue that a painting may be exploring.

> [F]latness . . . ought not to be thought of as the "irreducible essence of pictorial art" but rather as something like the minimal conditions for something's being seen as a painting. . . . [This] is to claim [that] essence . . . is largely determined by . . . the vital work of the recent past.
>
> *Michael Fried, art historian*

Another challenge to abstraction is the question of referencing. Abstract work refers to the minutia of everyday sensory experience in order to achieve meaning or to convey feeling.

> [T]he traditional way of defining abstract art as depicting nothing in external reality is now outmoded . . . feelings don't arise out of vacuums.
>
> *Piri Halasz, critic*

Frank Stella, *The Marriage of Reason and Squalor* (second version),
1959, enamel on canvas, 90.75 × 132.75 inches (230.5 × 337.2 cm.).
© 2004 Frank Stella/Artists Rights Society (ARS) New York,
Collection of the artist.

Stella: "I tried to keep the paint as good as it was in the can."

Jonathan Lasker,
The Value of Pictures, 1993,
oil on linen, 96 × 132 inches
(243.8 × 335.3 cm.). Courtesy of
Sperone Westwater, New York,
and the artist. Collection of the
High Museum, Atlanta.

Lasker reflects: "For me, abstract painting finished with the black paintings of Frank Stella. . . .The goal of modern painting, which represented nothing but its own pure form, had been attained. . . . To me, this existential objecthood was now ready to be depicted as subject matter in discourse with the additional component of the subjective psyche."

We can think of a spectrum of representation rather than a barrier between abstract art and representational art. Both art forms share so much: pictorial space, color, texture, and associative powers. On allowing suggestions of images in the abstract work, artist Gerhard Richter says:

We only find paintings interesting because we always search for something that looks familiar to us. I see something and in my head I compare it and try to find out what it relates to. . . . When we don't find anything, we are frustrated and that keeps us excited and interested . . . that's how Malevich and Ryman work as well. And only like that. You can interpret the Black Square by Malevich as much as you like, but it remains a provocation.

This does not mean to suggest that today abstract art can only be viable when it is infused with symbolism or when it is consciously simulating or when it discourses self-consciously on art history. Rather, formal abstraction now exists in a non-adversarial stance with other approaches. In mutual acceptance, abstraction and representation do not deny or rebel against each other. Our chosen methods become personal, not polemical.

If flatness is an arbitrary essence, if referencing cannot be denied, if illusion cannot be banished, what then, is the essence of painting? It is likely that the notion of essence must be jettisoned. Painting seems unable to be defined by an essential formal element (flatness, stasis, color, texture). We have a working (more or less) definition of "painting" arrived at by consensus—surely a moving target. We are really interested in whether a specific work is successful, not if it is a painting or a sculpture.

If we conclude that flatness and pure self-reference are not the keystones of abstract painting, does that mean Mondrian's attempt to create an ideal truth in painting was a failure? Absolutely not. His search for painting's bedrock reality created a framework within which some of the world's most beautiful paintings were born.

Only by gaining control over illusion could he [Mondrian] learn to make relationships speak the clear language of his own elevated feeling. . . expression and control of the picture object stand as one and the same thing in Mondrian's painting. Control of feeling in the flat of the picture does not remove feeling as the subject. On the contrary, it makes "Feeling" a free subject, responsive to pure artistic intuition and pure artistic intuition alone. What sponsors intuition—whether it is nature, geometry, or primary colors—will change over Mondrian's career, but the operation of intuition and its arena—the flat—will remain constant.

Kermit Swiler Champa, art historian

The emotional density of Mondrian's work grew from his idealist impulses. And the daily practice of painting provided counter-balance to his philosophic excursions. The artwork forced his idealism to be tested by a physical reality—pigments and optical (retinal) processes.

We may abandon an idealistic search for "essence" but retain the idealism. For even when we reject the certainty of fixed ideals, we are being idealistic.

It is impossible to exist without idealism. I always imagined that I was one of the few who could live without idealism in order to discover later that all the time I was full of illusions. Even when I was against [idealism], I believed in my opposition to it. It's a difficult subject.

Gerhard Richter, artist

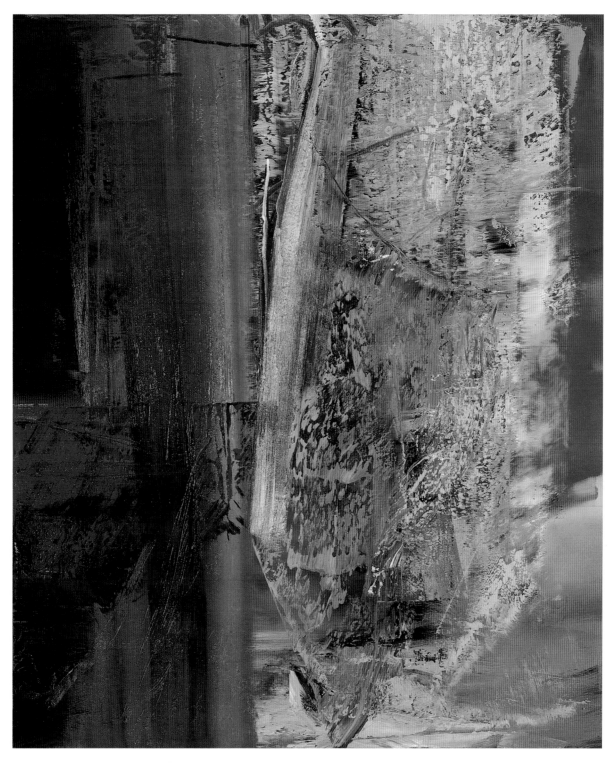

Gerhard Richter, *Oelberg (598)*, 2002, oil on canvas, 118.1 × 98.4 inches (300 × 249.9 cm.).
Courtesy of Marian Goodman Gallery, New York, and the artist.

In an interview by art theorist Benjamin Buchloh, Richter expresses his admiration for Barnett Newman. Buchloh suggests myths and faith surround such admiration. Richter replies: "Acts of faith are unavoidable. They're part of us." Buchloh: "Do your paintings invite acts of faith, or analyses? Which matters more to you?" Richter: "Either would be fine with me. In your case they invite you to analyse, others find them an invitation to perform acts of faith."

pigment properties

INDIVIDUAL PIGMENTS' LIGHTFASTNESS, STAINING CHARACTER, AND TRANSPARENCY

DESCRIPTION	COMPOSITION	LF	ST/SD	T/SeT/O/SO
Alizarin crimson	1:2 Dihydroxyanthraquinone on alumina base (PR 83)	III	ST	T
Azo yellow (aureolin)	Benzimidazolone yellow (PY 151)	I	ST	T
Burnt sienna	Calcined natural iron oxide (PBr 7)	I	SD	SeT
Burnt umber	Calcined natural iron oxide containing manganese (PBr 7)	I	SD	SeT
Cadmium orange	Cadmium seleno-sulfide (PO 20)	I	SD	O
Cadmium red	Cadmium seleno-sulfide (PR 108)	I	SD	O
Cadmium red light	Cadmium seleno-sulfide (PR 108)	I	SD	SO
Cadmium yellow	Cadmium zinc sulfide (PY 35)	I	SD	O
Cadmium yellow light	Cadmium zinc sulfide (PY 35)	I	SD	O
Cerulean blue	Oxides of cobalt and chromium (PB 36)	I	SD	O
Chinese/titanium white	Titanium dioxide (PW 6) and zincoade (PW4)	I	SD	O
Cobalt blue	Oxides of cobalt and aluminium (PB 28)	I	SD	SeT
Dioxazine purple	Carbazole dioxazine (PV 37)	II	ST	T
Gamboge	Benzimidazolone yellow (PY151) and benzimidazolone orange (PO 62)	I	ST	T
Hooker's green	Chlorinated copper phthalocyanine and isoindolinone yellow (PG 7) (PY 110)	I	ST	T
Ivory black	Amorphous carbon/charred animal bone (PBk 9)	I	SD	O
Lamp black	Nearly pure amorphous carbon (PBk 6)	I	SD	SO
Naphthol red	Naphthol AS-D (PR 112)	II	ST	SeT
Neutral tint	Quinacridone violet and chlorinated copper phthalocyanine (PV 19) (PG 7)	I	ST	SeT
Payne's gray	Amorphous carbon & silicates of sodium/aluminum with sulphur (PBk6) (PB 29)	I	SD	SO
Permanent green light	Chlorinated copper phthalocyanine and benzimidazolone yellow (PG 7) (PY 51)	I	ST	SeT
Phthalocyanine blue	Copper Phthalocyanine (PB 15:3)	I	ST	T
Phthalocyanine green	Chlorinated Copper Phthalocyanine (PG 7)	I	ST	T
Prussian blue	Ferriammonium ferrocyanide (PB 27)	I*	SD	T
Quinacridone red	Quinacridone red (PR 209)	I	ST	T
Quinacridone rose	Quinacridone violet (PV 19)	I	ST	T
Quinacridone violet	Quinacridone violet (PV 19)	I	ST	T
Raw sienna	Natural iron oxide (PBr 7)	I	SD	SeT
Raw umber	Natural iron oxide containing manganese (PBr 7)	I	SD	SeT
Sap green	Chlorinated copper phthalocyanine and isoindolinone yellow (PG 7) (PY 110)	I	ST	T
Sepia	Calcined natural iron oxide and nearly pure armorphous carbon (PBr 7) (PBk 6)	I	SD	T
Ultramarine blue	Complex silicate of sodium and aluminum with sulfur (PB 29)	I	SD	T
Van Dyke brown	Synthetic iron oxide (PBr 6)	I	SD	SeT
Viridian	Hydrous chromium sesquioxide (PG 18)	I	SD	T
Yellow ochre	Natural hydrated iron oxide (PY 43)	I	SD	O

LF = Lightfastness Key: I Excellent II Very Good III Acceptable (pale tints may fade in direct sunlight)
ST = Staining; SD = Sedimentary; T = Transparent; SeT = Semi-transparent; O = Opaque; SO = Semi-opaque
*Traditionally considered permanent; actual lightfastness is dependent on a wide range of factors.
All colors are permanent, intermixable, and fully compatible with other oil, acrylic, and watercolors.

Information courtesy M. Graham & Co., West Linn, Oregon

FAT AND LEAN COLORS

(Classifications apply to R&F Pigment Sticks)

VERY LEAN Cobalt Green, Cerulean Blue, Neutral White, Mars Violet, Titanium-Zinc White, Jaune Brillant, Brilliant Yellow, Dianthus Pink, Naples Yellow, Azure Blue, Cadmium Orange.

LEAN Turquoise Blue, Chromium Oxide Green, Cadmium Yellows and Reds, Mars Orange, Red, and Black, Cobalt Violets, Cobalt Yellow, King's Blue, Veronese Green, Manganese Violet, Neutral Grey Pale and Light.

AVERAGE Warm Pink, Siennas, Umbers, Indigo, Courbet Green, Ultramarine Blue and Violet, Cobalt Blue and Turquoise, Graphite, Cadmium Greens, Neutral Grey Medium and Deep, Ivory Black, Prussian Blue, Mars Yellows, Viridian, Payne's Grey.

FAT Iridescent colors, Warm Rose, Sanguine Earths, Sepia, Green Earth.

VERY FAT Brown Pink, Alizarin Crimson, Phthalo colors, Quinacridone Magenta, Rose Madder.

SUPER FAT Lamp Black, Intense Carbon Black

FAST AND SLOW DRIERS

Here R&F colors are grouped according to their drying rates. These may differ slightly from those of tube oil colors because of varying amounts of wax content. The drying range is based on paint thickness and absorbency of the support surface.

VERY FAST (1–4 DAYS) Umbers, Cobalt Yellow, Indigo, Neutral Greys.

FAST (2–10 DAYS) Cadmium Green, Cerulean Blue, Cobalt Blue, Cobalt Green Light, Cobalt Turquoise, Cobalt Violet Deep, Courbet Green, Flake White, Manganese Violet, Neutral White, Payne's Grey, Phthalo Green, Phthalo Blue, Prussian Blue, Sanguine Earths, Siennas, Viridian.

AVERAGE (6–17 DAYS) Brown Pink, Cadmium Green Pale, Cadmium Lemon, Cadmium Yellow Light and Medium, Dioxazine Purple, Green Earth, Iridescent Pearl and Pewter, King's Blue, Mars Yellow Deep, Mars Orange, Mars Violet, Mars Black, Sepia, Titanium-Zinc White, Turquoise Blue, Ultramarine Violet, Veronese Green, Yellow Ochre.

SLOW (7–27 DAYS) Alizarin Crimson, Azure Blue, Dianthus Pink, Iridescent Silver, German Silver, Brass, Gold, Copper, Bronze, Ivory Black, Mars Yellow Light, Mars Red, Phthalo Blue, Phthalo Turquoise, Rose Madder, Warm Rose.

VERY SLOW (10–50 DAYS) Brilliant Yellow Extra Pale, Cadmium Orange, Cadmium Yellow Deep, Cadmium Reds, Chromium Oxide Green, Cobalt Violet Light, Graphite Grey, Jaune Brillant, Naples Yellow, Quinacridone Magenta, Ultramarine Blue, Warm Pink.

SUPER SLOW (45–90 DAYS) Lamp Black, Intense Carbon Black.

Information courtesy R&F Handmade Paints, Inc., Kingston, NY, and supplemented with information in Mark David Gottsegen, *The Painter's Handbook* (New York: Watson-Guptill Publications, 1993).

supplies

Robert Doak & Associates, Inc.
89 Bridge Street
Brooklyn, NY 11201
tel.: 718 237-1210; 718 237-0146

A. P. Fitzpatrick
142 Cambridge Heath Road
London E1 5QJ, England
tel.: 020 7790 0884
e-mail: APFColours@aol.com

Gamblin Artists Colors Co.
P.O. Box 625
Portland, OR 97207
tel.: 503 235-1945; fax: 503 235-1946
http://www.gamblincolors.com/index.html
e-mail: gamblin@gamblincolors.com

Golden Artist Colors, Inc.
188 Bell Road
New Berlin, NY 13411–9527
tel.: 607 847-6154; fax: 607 847-6767
http://www.goldenpaints.com

M. Graham & Co.
P.O. Box 215
West Linn, OR 97068–0215
tel./fax: 503 656-6761
http://www.mgraham.com/index.htm
e-mail: colormaker@mgraham.com

Guerra Paint & Pigment
510 East 13th Street
New York, NY 10009
tel.: 212 529-0628
http://guerrapaint.com

Kremer Pigments
Store address in New York, NY :
 228 Elizabeth Street
 New York, NY 10012
 tel.: 212 219-2394 or 800 995-5501;
 fax: 212 219-2395
Headquaters in Aichstetten, Germany:
 Dr. Georg Kremer, Dipl.-Chemiker
 Farbmühle, D-88317 Aichstetten/Allgäu
 tel. + 49 (0)7565-1011; fax. + 49 (0)7565-1606
http://www.kremer-pigmente.de/englisch/homee.htm
e-mail: kremerinc@aol.com

Nova Color Artists' Acrylic Paint - Artex
 Manufacturing Company
5894 Blackwelder Street
Culver City, CA 90232-7304
tel.: 310 204-6900; fax: 310 838-2094
http://www.novacolorpaint.com/pages/map.html
e-mail: sales@novacolorpaint.com

R&F Handmade Paints, Inc.
506 Broadway
Kingston, NY 12401
tel.: 800 206-8088; 845 331-3112;
 fax: 845 331-3242
http://rfpaints.com
e-mail: info@rfpaints.com

Williamsburg Art Materials, Inc.
1711 Monkey Run Road
East Meredith, NY 13757
tel.: 607 278-6154; 800 293-9399;
 fax: 607 278-6254
http://www.williamsburgoilpaint.bizland.com
e-mail: williamburg@oilpaint.com

Woolfitt's Art Enterprises, Inc.
1153 Queen Street
West Toronto, Ontario, Canada M6J1J4
tel.: 800 490-3567; 416 536-7878;
 fax: 416 536-4322
http://www.woolfitts.com

sources of quoted material

1 What Is Abstract and What Is Real?

"Art no longer cares to . . ." Herschel B. Chipp, ed., *Theories of Art: A Source Book by Artists and Critics* (Berkeley and Los Angeles: University of California Press, 1968), p. 341.

"Painting is, I think, inevitably . . ." R. Kudielka, ed., *Bridget Riley: Dialogues on Art* (London: Zwemmer, 1995), p. 63.

"Properly treated, formalism is not . . ." loc. cit., p. 28.

"I use abstraction to depict . . ." Hans-Michael Herzog, ed., *Jonathan Lasker: Gemälde/Paintings 1977–1997* (New York: Cantz Editions, 1998), pp. 1–40.

"I have painted unhappy marriages . . ." Jonathan Lasker, *Jonathan Lasker Paintings 1977–2001* (Milan, Italy: Alberico Cetti Serbelloni Editore, 2002), p. 154.

"The important thing for critics . . ." Fairfield Porter, *Fairfield Porter, Realist Painter in an Age of Abstraction* (Boston: Little, Brown and Company and Museum of Fine Arts, Boston), p. 43.

"Everyone knows that the future . . ." Frank Stella, *Working Space* (Cambridge, MA: Harvard University Press, 1986), p. 97.

"[A]s I contemplate the blue . . ." Maurice Merleau-Ponty, *Phenomenology of Perception*, tr. by Colin Smith (London: Routledge, 1962), p. 214.

"[Mark] Rothko's relationship with his . . ." Philip Ball, *Bright Earth* (New York: Farrar, Straus and Giroux, 2002), p. 328.

"Everything I paint comes from . . ." Thomas Nozkowski, interview with David Cohen for exhibit "Thomas Nozkowski Drawings," January 23 to March 1, 2003 (New York: New York Studio School, 2002), online: http://www.nyss.org/NOZKOWSKI/essay.html.

"When you look at a . . ." Karen Wilkin, *Kenneth Noland* (New York: Rizzoli, 1990), p. 24.

"[T]he [picture plane] . . ." Wassily Kandinsky, *Point and Line to Plane*, trans. by Howard Dearstyne and Hilla Rebay (New York: Dover Publications, 1979), p. 116.

"All grammars leak . . ." Edward Sapir, *An Introduction to the Study of Speech* (New York: Harcourt, Brace, 1955), p. 39.

"One must really be engaged . . ." Gerhard Richter, in conversation with Irmeline Lebeer, from Douglas Crimp, "The End of Painting" (*October* #16). Reprinted in Frances Colpitt, *Abstract Art in the Late Twentieth Century* (New York: Cambridge University Press, 2002), p. 93.

"In 'True Lad' . . . the space . . ." Donald Lindeman, Spring 2003 (Artcritical.com [online publication]).

"In order to move forward . . ." Pat Lipsky, unpublished remarks, August 1, 2004.

2 The Tradition of Abstract Painting

"When [Mondrian] paused before a . . ." Carter Ratcliff, *The Fate of a Gesture: Jackson Pollock and Postwar American Art* (New York: Westview Press, 1996), p. 53.

"You will understand I was . . ." Joop M. Joosten, Robert P. Welsh, *Piet Mondrian, Catalogue Raisonné of the Work of 1911–1944*, volume 2 (New York: Harry N. Abrams, 1998), pp. 310–311.

"I had last year's damaged . . ." ibid.

"Such a move [to redefine . . ." Julian Bell, *What Is Painting?* (New York: Thames and Hudson, 1999), p. 178.

"A desire to determine all . . ." Kermit Swiler Champa, *Mondrian Studies* (Chicago: The University of Chicago Press, 1985), p. xvii.

"There's also . . . a very tough . . ." Piri Halasz, "Abstract Painting in General; Friedel Dzubas in Particular" (*Arts Magazine*, September 1983), p. 83.

"I just did the black . . ." John Adams Griefen, unpublished writings (Brooklyn, NY, 2003).

"I still feel a bit . . ." Peter Halley, Interview with Dan Cameron, "80s Then" (*ArtForum*, March 2003), p. 212.

"flight from transcendence," Frederic Jameson, *Postmodernism* (Durham, NC: Duke University Press, 1991), p. 250.

"What you see is what . . ." Peter Selz and Kristine Stiles, eds., *Theories and Documents of Contemporary Art* (Berkleley and Los Angeles: University of California Press, 1996), p. 121.

"[My painting] was a polemic . . ." Interview by Robert Storr, from *Gerhard Richter, Forty Years of Painting* (New York: The Museum of Modern Art, 2002), p. 302. Reprinted by permission from *Gerhard Richter: Forty Years of Painting* © 2002, The Museum of Modern Art, New York.

"[A]bstraction is a possibility rather . . ." Arthur Danto, "Art after the End of Art" (*Artforum*, April 1992), p. 67.

"At their best, paintings are . . ." from a 1999 essay by Jonathan Lasker, "Crimes and Apparitions." Reprinted in Jonathan Lasker, *Jonathan Lasker Paintings 1977–2001* (Milan, Italy: Alberico Cetti Serbelloni Editore, 2002), p. 161.

"[T]he problem of abstraction . . ." John Rajchman, "Unhappy Returns: John Rajchman on the Po-Mo Decade" (*Artforum*, April 2003), p. 232.

3 The Psychology and Physiology of Seeing

"The retinal image is the . . ." Trevor Lamb and Janine Bourriau, eds., *Colour: Art and Science* (New York: Cambridge University Press, 1995), p. 130.

"[Abstraction] made strenuous demands . . ." Julian Bell, *What Is Painting?* (London: Thames and Hudson, 1999), p. 198.

"Vision requires two eyes and . . ." Bruce MacEvoy (Color Psychology, 2004), http://www.handprint.com/HP/WCL/color1.html. © 2004 Bruce MacEvoy.

"I'm a visual artist interested . . ." Gilbert Hsiao, artist statement, Minus Space online gallery: http://www.minusspace.com/hsiao/hsiao.html#statement.

"What we call realism is . . ." William V. Dunning, *Changing Images of Pictorial Space: A History of Spatial Illusion in Painting* (Syracuse, NY: Syracuse University Press, 1991), p. 36.

"I am assuming, that . . ." Trevor Lamb and Janine Bourriau, eds., *Colour: Art and Science* (New York: Cambridge University Press, 1995), p. 197.

4 Painting with Oils

"The only thing that is . . ." John Rewald, ed., *Paul Cézanne, Letters*, trans. by Marguerite Kay (Philadelphia: Da Capo Press, 1995), p. 183.

"The three basic and equally . . ." Kurt Wehlte, *The Materials and Techniques of Painting*, trans. by Ursus Dix (New York: Van Nostrand Reinhold Company, 1982), p. 45.

"scraping adds a kind of . . ." David Row, unpublished remarks, 2003.

5 Painting with Acrylics

"Part of my thesis is that materials . . ." *Color and Culture* (Berkeley and Los Angeles: University of California Press, 1999), p. 267.

"I had to grind away . . ." Jo Crook and Tom Learner, *The Impact of Modern Paints* (New York: Watson-Guptill Publications, 2000), p. 146.

"My paintings start with pouring . . ." Graham Peacock, unpublished remarks by email exchange, 2004.

6 Color

"In terms of range of form possibilities . . ." Kenworth W. Moffett, *Kenneth Noland* (New York: Harry N. Abrams, 1977), p. 31.

"I seldom think about color . . ." J. D. Serwer, *Gene Davis: A Memorial Exhibition*, (Washington, DC: National Museum of American Art, 1987), p. 44.

"It is now that red . . ." John Golding, *Paths to the Absolute* (Princeton, NJ: Princeton University Press, 2000), p. 36.

"Gene Davis . . . felt [stripes] provided . . ." John Gage, *Color and Culture* (Berkley and Los Angeles: University of California Press, 1999), p. 267.

"I think there is a . . ." Bridget Riley, *The Mind's Eye: Bridget Riley Collected Writings 1965–1999* (London: Thames and Hudson, in association with Serpentine Gallery and De Montfort University, 1999), p. 101.

"The most revolutionary aspect of . . ." Bruce MacEvoy (Color Psychology, 2004), http://www.handprint.com/HP/WCL/color3.html#newton. © 2004 Bruce MacEvoy.

"The many elements in the . . ." Bill Komoski, "Q & A" (Feature, Inc., April 12, 2001).

"Broad slabs of highly saturated pigment . . ." Kevin Finklea, unpublished statements, June 2002 (Philadelphia).

"[M]y [MacEvoy's] artist's color wheel starts . . ." Bruce MacEvoy, unpublished statements concerning his Artist's Color Wheel, June 7, 2004.

"Any other color combinations . . ." Johannes Itten, The Art of Colour (New York: John Wiley and Sons, Inc., 1961), p. 22.

"If you think of colour . . ." Peter Halley, interview with Martin Gayford (online: Telegraph UK, Artists on art, Peter Halley on Picasso's 1931 Still Life on a Pedestal Table), http://www.telegraph.co.uk/arts/main.jhtml?xml=/arts/2001/11/03/bamg03.xml.

"When pigments are mixed into . . ." Mark David Gottsegen, The Painter's Handbook (New York: Watson-Guptill Publications, 1993), p. 121.

"I've called the series Uttar . . ." Joanne Mattera, unpublished interview, October 5, 2004 (New York).

"I have laid most emphasis . . ." Trevor Lamb and Janine Bourriau, eds., Colour: Art and Science (New York: Cambridge University Press), p. 191.

"lime green and avocado induce . . ." Jill Morton (online: Quirks of the Color Quest, October 2000), "Color Matters® Chatter," http://www.colormatters.com/chatquest.html.

"orange is disliked . . ." ibid.

"In some . . . cultures, moreover, a . . ." Trevor Lamb and Janine Bourriau, eds., Colour: Art and Science (New York: Cambridge University Press, 1995), p. 191.

7 Form

"Form is all we have . . ." "Gerhard Richter Goes to War," interview with Richter by Jan Thorn-Prikker (New York Times, July 4, 2004, sec. 2, col. 1, p. 26).

"Painting has many problems, but . . ." Hans Hofmann, in "The Color Problem in Pure Painting—Its Creative Origin," reprinted in Karen Wilkin, ed., Hans Hofmann: A Retrospective (New York: George Braziller, Inc., 2003), p. 42.

"My drawings are done almost . . ." Monique Prieto, unpublished remarks, 2004.

"Abstraction—of any kind, geometric . . ." Sol Le Witt, quoted by Mark Daniel Cohen in "Sol Le Witt's Rational Mysticism" (online: NY Arts), http://nyartsmagazine.com/articles.php?aid=27.

"The point digs itself into . . ." Wassily Kandinsky, Point and Line to Plane, trans. by Howard Dearstyne and Hilla Rebay (New York: Dover Publications, Inc., 1979), p. 32.

"What happens on canvas escapes . . ." Pat Passlof, exhib. cat. (New York: Elizabeth Harris Gallery, 1998), p. 7.

"Whereas the straight line is . . ." Wassily Kandinsky, Point and Line to Plane, trans. by Howard Dearstyne and Hilla Rebay (New York Dover Publications, Inc., 1979), p. 81 .

"I construct lines and color . . ." Joop M. Joosten and Robert P. Welsh, Piet Mondrian, Catalogue Raisonné of the Work of 1911–1944, volume 2, (New York: Harry N. Abrams, 1998), p. 105.

"One of the best teachers . . ." Thomas Nozkowski, interview with David Cohen for exhibit "Thomas Nozkowski Drawings," January 23 to March 1, 2003 (New York: New York Studio School, 2002), online: http://www.nyss.org/NOZKOWSKI/essay.html.

"[O]il paint introduced . . ." Terry Fenton, Jules Olitski and the Tradition of Oil Painting (Edmonton, Alberta, Canada: The Edmonton Art Gallery, 1979), p. 12.

"The violently colored, near-surrealistic paintings . . ." Terry Treachout, "Observations, Kandinsky's Mistake" (Commentary, 2004), p. 54.

"Instead of overly romanticizing painting . . ." Steve Karlik, unpublished remarks, 2004.

8 Texture

"I really have come to . . ." Peter Halley, unpublished interview, August 18, 2004 (New York).

"Boxer felt no sentimentality or . . ." Joyce Weinstein, unpublished interview, November, 2004.

"ur-images, morphological run . . ." Pat Adams, unpublished interview, November 2004 (Bennington, VT).

"To me it's a little . . ." Peter Halley, unpublished interview, August 18, 2004 (New York).

9 Composition

"The willing beholder responds to . . ." E. H. Gombrich, Art and Illusion, A Study in the Psychology of Perception (Princeton, NJ, and Oxford, Eng.: Princeton University Press, 1960), p. 202.

"I am very interested in . . ." Pat Lipsky, unpublished remarks, August 1, 2004 (New York).

"as high as a man . . ." Peter Selz and Kristine Stiles, eds., Theories and Documents of Contemporary Art (Berkeley and Los Angeles: University of California Press, 1996), p. 91.

"Quaytman began working at a . . ." Lilly Wei, "Quaytman's crossing: a recent exhibition of paintings by the late Harvey Quaytman surveyed the four-decade career of an inveterate abstractionist who explored the 20th century's geometric traditions in sublimely self-referential works" (Artforum, March 2004), online: http://www.findarticles.com/p/articles/mi_m1248/is_3_92/ai_114006952.

"The primacy of literal over . . ." Michael Fried, Art and Objecthood (Chicago and London: The University of Chicago Press, 1998), p. 81.

"[Frank] Stella began to increase the . . ." William Rubin, quoted by Philip Leider in "Literalism and Abstraction: Frank Stella's Retrospective at the Modern" (Artforum, April 1970), pp. 44–51. Reprinted in Frances Colpitt, Abstract Art in the Late Twentieth Century (New York: Cambridge University Press, 2002), p. 19.

"If, in a visual composition . . ." Gunther Kress and Theo van Leeuwen, Reading Images: The Grammar of Visual Design (New York: Routledge, 1996), p. 193.

"Pollock and De Kooning's ability . . ." Frank Stella, Working Space, (Cambridge, MA: Harvard University Press, 1986), p. 155.

"I like to use historical . . ." Bob Colacello, "Eric Freeman: no bells, no whistles, just painting" (INTERVIEW, May 2003).

"While the remarkable chromatic harmonies . . ." Karen Wilkin, "Life after formalism: in the 1960s, Anthony Caro, Helen Frankenthaler, Kenneth Noland, Jules Olitski and Larry Poons . . ." (Art In America, November 2001), p. 110.

"They push, pull, distort, contort . . ." Karin Davie, unpublished interview, May 22, 2004 (New York).

"I am sure that our . . ." Arnold Schoenberg, 2004, quoted by Terry Treachout, "Observations, Kandinsky's Mistake" (Commentary, 2004), pp. 52–53.

10 Pictorial Space

"The new illusionism both subsumes . . ." Michael Fried, Art and Objecthood (Chicago and London: The University of Chicago Press, 1998), p. 79.

"There's always been a spatial . . ." Bill Komoski, "Q & A" (Feature, Inc., April 12, 2001).

"The experience of looking at . . ." Lucy R. Lippard, "The Silent Art" (Art in America, January-February 1967), pp. 34–43. Reprinted in Frances Colpitt, Abstract Art in the Late Twentieth Century (New York: Cambridge University Press, 2002), p. 59.

"[L]et us be witnesses to . . ." Jean-François Lyotard, The Postmodern Condition (Minneapolis: University of Minnesota Press, 1984), p. 82.

"The creation of an illusion . . ." William V. Dunning, Changing Images of Pictorial Space: A History of Spatial Illusion in Painting (Syracuse, NY: Syracuse University Press, 1991), p. 202.

"[T]he abstract picture seems . . ." Robert C. Morgan, ed., Clement Greenberg Late Writings (Minneapolis: University of Minnesota Press, 2003), p. 61.

"The stains are evidence. . ." James Cohan Gallery website: http://www.jamescohangallery.com/artists/ingridcalame.

"[W]e can no longer see . . ." Charles Altieri, Postmodernisms Now: Essays on Contemporaneity in the Arts (University Park, PA: Pennsylvania State University Press, 1998), pp. 59–60.

"I'd like to think that . . ." Peter Halley, interview with Don Cameron, "80s Then" (Artforum, March 2003).

"In general, my paintings are . . ." Bridget Riley, The Mind's Eye: Bridget Riley Collected Writings 1965–1999 (London: Thames and Hudson, in association with Serpentine Gallery and De Montfort University, 1999), p. 122.

"I think that an artist . . ." Robert Kudielka, ed., Bridget Riley: Dialogues on Art (London: Zwemmer, 1995), p. 28.

11 Brush and Easel Paint Construction

"Paint bears physical record to . . ." Jonathan Lasker, *Jonathan Lasker Paintings 1977–2001* (Milan, Italy: Alberico Cetti Serbelloni Editore, 2002), p. 157.

"My work takes . . ." Karin Davie, unpublished interview, May 22, 2004 (New York).

"both visceral and cerebral . . . explosively . . ." Margaret Sheffield, "Francine Tint at Atelier A/E" (*Art in America*, February 1, 2002), p. 126.

"There's a good deal of . . ." Jonathan Lasker, unpublished interview, July 18, 2004 (New York).

"In fact, [masking tape] has . . ." Jo Crook and Tom Learner, *The Impact of Modern Paints* (New York, Watson-Guptill Publications, 2000), p. 147.

"Just about everything I paint . . ." Kevin Finklea interviewed by Matthew Deleget, October 2, 2004. Minus Space online gallery: http://www.minusspace.com/.

"A painting is finished . . ." Peter Selz and Kristine Stiles, eds., *Theories and Documents of Contemporary Art* (Berkeley and Los Angeles: University of California Press, 1996), p. 33.

12 Poured Paint

"By 1950, at the height . . ." Jerry Saltz, "Let It Drip," (*Village Voice*, November 1, 1998), p. 143.

"Pollock's very radicalness made it . . ." Kenworth W. Moffett, *Morris Louis in the Museum of Fine Arts, Boston* (Boston: Museum of Fine Arts, Boston, 1979), p. 3.

"Well, [without using brushes] I'm . . ." Jackson Pollock, 1996, Peter Selz and Kristine Stiles, eds., *Theories and Documents of Contemporary Art* (Berkeley and Los Angeles: University of California Press, 1996), p. 24.

"[Pollock] was an edge conscious . . ." John Golding, *Paths to the Absolute* (Princeton, NJ: Princeton University Press, 2000), p. 137.

"employed various mediums to reconcile . . ." Jane Callister, unpublished statements, 2004.

"Paint, that is, which skipped . . ." Philip Leider, "Literalism and Abstraction: Frank Stella's Retrospective at the Modern" (*Artforum*, April 1970), pp. 44–51. Reprinted in Frances Colpitt, *Abstract Art in the Late Twentieth Century* (New York: Cambridge University Press, 2002), p. 14.

13 Stain

"A final distinction . . ." Frances Colpitt, *Abstract Art in the Late Twentieth Century* (New York: Cambridge University Press, 2002), p. 42.

"These associations are turned into . . ." Karen Wilkin, "Life after formalism: in the 1960s, Anthony Caro, Helen Frankenthaler, Kenneth Noland, Jules Olitski and Larry Poons. . ." (*Art In America*, Nov. 2001), p. 110.

"The result of this system . . ." John Coplans, "Serial Imagery" (*Artforum*, Octpber 1968), pp. 34–43. Reprinted in Frances Colpitt, *Abstract Art in the Late Twentieth Century* (New York: Cambridge University Press, 2002), p. 42.

14 Layers

"For me there is no . . ." David Row, unpublished statements, May 18, 2004 (New York).

"[T]he first coat should be . . ." Ralph Mayer, *The Artist's Handbook of Materials and Techniques* (New York: Viking, 1940), p. 196.

"Scraping and incising are essential . . ." Joanne Mattera, unpublished statements, 2004 (New York).

"[T]he tactile reality of . . ." Margaret Sheffield, "Francine Tint at Atelier A/E" (*Art in America*, February 1, 2002), p. 126.

"My paintings are comprised of . . ." Rob Sagerman, unpublished statements, 2004 (New York).

"In the beginning . . ." Pat Adams, from a talk given to Friends of Yaddo, Zabriskie Gallery, New York, April 16, 1992.

15 Approaches to the Practice of Painting

"[An artwork is] a corner . . ." Emile Zola, *Mes Haines* (1886), in *Collection des Oeuvres Complétes* (Paris: Edwin Mellen Press, 1992).

"These [paintings] are the primary colors . . ." Benjamin H. D. Buchloh, "The Primary Colors for the Second Time: A Paradigm Repetition of the Neo-Avant-Garde" (*October* 37), p. 44.

"Abstraction allows man to see . . ." The Painter's Keys website (Surrey, B.C., Canada: Robert Genn, Studio Beckett Publications), http://www.painterskeys.com/auth_search.asp?name=Arshile%20Gorky.

"I am nature . . ." Carter Ratcliff, *The Fate of a Gesture: Jackson Pollock and Postwar American Art* (New York, NY: Westview Press, 1996), p. 69.

"I have tried to employ . . ." Melinda Rose Silva, "Peter Halley's Mini Adventure" (*Contemporary Magazine*, September 1983), online: http://www.contemporary-magazine.com/september/mini.html.

"When one does not describe . . ." Piet Mondrian. *The New Art—The New Life: The Collected Writings of Piet Mondrian*, ed. and trans. by Harry Holtzman and Martin S. James (Reprint ed. Philadelphia: Da Capo, 1993) p. 15.

"[P]ainting reflects an encounter with . . ." Frances Colpitt, *Abstract Art in the Late Twentieth Century* (New York: Cambridge University Press), p. 166.

"In terms of form, I . . ." Karin Davie, unpublished interview, May 22, 2004.

"[T]here are inner-directed artists . . ." Robert C. Morgan, *End of the Art World* (New York: Allworth Press, 1998), p. 178.

"In the mid-Eighties I felt . . ." Bridget Riley, *The Mind's Eye: Bridget Riley Collected Writings 1965–1999* (London: Thames and Hudson, in association with Serpentine Gallery and De Montfort University, 1999), p. 114.

[UPAs] Kenneth Baker (*San Francisco Chronicle*, June 17, 2004), online: http://sfgate.com/cgi-bin/article.cgi?f=/c/a/2004/06/17/DDGLA76M3N1.DTL.

"Sitting on the corner of . . ." Justin Sane, "College Avenue" from the recording "Life, Love, and the Pursuit of Justice" (A-F Records, 2002).

"First, it was the dot . . ." *Larry Poons, Paintings 1963–1990* exhib. cat. (New York: Salander O'Reilly Galleries, Inc., 1990), p. 21.

16 Beyond Technique

"I do have trouble with . . ." Frank Stella, *Working Space* (Cambridge, MA: Harvard University Press, 1986), p. 131.

"I think now of the . . ." Eleanor Munro, *Originals, American Women Artists by Eleanor Munro* (Philadelphia: Da Capo Press, Perseus Book Group, 2000), p. 247.

"[F]latness ought not to be . . ." Michael Fried, *Art and Objecthood* (Chicago: The University of Chicago Press, 1998), p. 169.

"[T]he traditional way of . . ." Piri Halasz, 1999, "A Painter & A Theory: Jackson Pollock & The Implications of Multi-Referential Imagery" (*Night Magazine*, no. 42, 1999).

"I tried to keep the . . ." Peter Selz and Kristine Stiles, *Theories and Documents of Contemporary Art* (Berkeley and Los Angeles: University of California Press, 1996), p. 120.

"For me, abstract painting . . ." Jonathan Lasker, *Jonathan Lasker Paintings 1977–2001* (Milan, Italy: Alberico Cetti Serbelloni Editore, 2002), p. 154.

"We only find painting interesting . . ." Interview by Robert Storr, from *Gerhard Richter, Forty Years of Painting* (New York, NY: The Museum of Modern Art, 2002), p. 304. Reprinted by permission, from *Gerhard Richter: Forty Years of Painting* © 2002 The Museum of Modern Art, New York.

"Only by gaining control over . . ." Kermit Swiler Champa, *Mondrian Studies* (Chicago and London: The University of Chicago Press, 1985), p. xvii.

"It is impossible to exist . . ." Interview by Robert Storr, from *Gerhard Richter, Forty Years of Painting* (New York, NY: The Museum of Modern Art, 2002), p. 307. Reprinted by permission, from *Gerhard Richter: Forty Years of Painting* © 2002 The Museum of Modern Art, New York.

"Acts of faith are . . ." Gerhard Richter, *The Daily Practice of Painting, Writings and Interviews 1962–1993*, Hans-Ulrich Obrist, ed.; David Britt, trans. (Cambridge, MA: MIT Press, 1998), p. 158.

index

Abstract Expressionism, 16, 18, 19, 70, 95, 134
abstraction
 challenges to, 150, 152
 historical, 20
 within Postmodernism, 20–21
 post-painterly, 122
 as practice, not doctrine, 13
 and reality, 11
 use of term, 11
 of visual data, by mind, 24
abstract painting
 aesthetic dialogue, 14–15
 events and forces leading to, 18–19
 lack of depth in, 92
 as new visual paradigm, 29
 relation to "nature" of content, 14
 shared technical methods of traditional painting and, 100
 in the studio, 8, 11
 tradition, development of, 18
 traditions of, 16
 and visual speed, 87–88
acrylic paintings, 53
acrylic paints, 42
 brushes and other application tools, 49
 glaze mixtures, 52
 mediums, gels, and pastes, 46–47
 mixing of, 50–53
 opaque mixtures, 51–52
 for pouring, 118
 pre-mixed, 42–43
 safety in handling and mixing, 44
 stirring, 51
 studio-mixed, 44
 systems, 13
 thin and thick paint, 105
 translucent mixtures, 52–53
 ways to thicken, 75
Adams, Pat, 74, 141
alkyds, 34, 35, 105
alla prima, 106
Altieri, Charles, 99
American Society for Testing and Materials (ASTM), 32, 40, 61

Baker, Lucy, 120
Ball, Philip, 14
Bannard, Walter Darby, 43, 133
Barron, Tom, 126
Bell, Julian, 18, 22
Bohary, Jim, 105
Boxer, Stanley, 73
Bradley, Peter, 140
brushes
 for acrylic paints, 49
 used in oil painting, 35–36
Buchloh, Benjamin, 153

Calame, Ingrid, 12, 91, 96, 97
Callister, Jane, 115, 120, 121, 147
Cézanne, Paul, 30
Champa, Kermit Swiler, 18, 152
Chartier, Jaq, 125
Christensen, Dan, 48
chroma, 57, 59
 adjusting, for acrylic paints, 50
collage, 141
color, 8, 11
 chroma, 50, 57, 59
 contrast, 60
 cultural conditioning and perception of, 61–63
 economics of, 62–63
 form and, 64
 harmony, 60–61
 hue, 39, 50, 57, 59
 and the mass media, 63
 for oil painting, 32–33
 perception, 27–28
 primary colors, 28
 relative, 59–61
 science, 57
 theories, early, 54, 56–57
 three dimensions of, 57–59
 traditions of, 62
 value, 57, 58–59, 105
Color Field painting, 16, 64, 122
Colpitt, Frances, 122, 145
composition
 anti-, 90–91
 cropped, 90
 defined, 80
 and marks on picture plane, 84, 86
 physical shape, 82–83

rhythm, 88–89
 scale and, 82
 and visual speed, 87–88
 visual weight and direction in, 86–87
contour, 69–70
Coplans, John, 124
crazing, 139. See also crusts
crusts, 141. See also crazing
Cubism, 16, 29, 42, 89

Dada, 18, 20
Danto, Arthur, 20
Davie, Karin, 90, 101, 145
Davis, Gene, 56
delamination, 105, 139
DeLuccia, Paula, 51
Dove, Arthur, 16
dragging, 136
Dunning, William V., 24, 95
Dzubas, Friedel, 19

edges
 of painting, 89–90
 painting hard, by hand, 109
encaustic, 105, 131

fabric, stretched, 36–37, 49
Fenton, Terry, 70
Finklea, Kevin, 59, 109
Fisher, Craig, 129
flatness, 150, 152
Fonseca, Caio, 77, 132
form, 8, 11
 biomorphic, 70
 and color, 64
 geometric, 70
 and simplicity of shape, 70
formalism, 122
Frankenthaler, Helen, 123
Freeman, Eric, 87
Fried, Michael, 82, 92, 150
Furness, Richard, 30

Gage, John, 56, 62, 63
gels, 35, 47
gesture, 70, 100, 104, 145
glazing, 52, 107
Golding, John, 56, 115
Gombrich, Ernst, 80
Gorky, Arshile, 143, 146
Gottsegen, Mark David, 61, 155
Greenbaum, Joanne, 33, 57, 65
Greenberg, Clement, 7, 19, 115

Greene, Stephen, 86
Gregory, Stan, 29, 147
Griefen, John Adams, 19
Gross, Rainer, 138
grounds
 for acrylic paints, 49–50
 for oil paints, 38–40
Guggenheim, Peggy, 18
Guston, Philip, 7

Halasz, Piri, 150
Halley, Peter, 20, 61, 72, 79, 84, 98, 99, 110
Hofmann, Hans, 64, 95
Hsiao, Gilbert, 23, 88
hue, 39, 57, 59
 adjusting, for acrylic paints, 50

imprimatura, 38, 105, 128
Itten, Johannes, 61

Joelson, Suzanne, 119

Kandinsky, Wassily, 15, 16, 18, 54, 64, 67, 68
Karlik, Steve, 71, 135
Komoski, Bill, 58, 93
Kress, Gunther, 84

Lasker, Jonathan, 8, 10, 11, 21, 100, 103, 152
layered paint construction
 brushed-on paint, 130, 132
 collage, 141
 monoprint, 138
 optical blending, 135–136
 scraped-off paint, 132, 135
 surface films, 138–139, 141
Leider, Philip, 120
LeWitt, Sol, 67
Lichtenstein, Roy, 134
Lindeman, Donald, 15
line, 64, 67–68
Lippard, Lucy R., 88
Lipsky, Pat, 15, 58, 82
Louis, Morris, 37, 42, 55, 90, 114, 115, 120, 146
Lyons, John, 28
Lyotard, Jean-François, 96

MacEvoy, Bruce, 22, 57
 color wheel, 60
Mahaffey, Rae, 107

Malevich, Kasamir, 8, 18
Marden, Brice, 21
masking, 109–110
 for staining, 124
Mattera, Joanne, 62, 131
Mayer, Ralph, 130
mediums, 105
 and conditioners for acrylic paints, 46–47
 loading, for acrylic paints, 51
 for oil paints, 33–35
Merleau-Ponty, Maurice, 13
Meyer, Melissa, 39, 41, 104
Meyers, Linn, 146, 146
Michael, Maggie, 119
Miller, David, 74
Minimalism, 16, 19, 54, 150
Miró, Joan, 18, 92
Moffett, Kenworth W., 54, 112
Mollon, John, 22
Mondrian, Piet, 7, 17, 18, 54, 63, 68, 92, 142, 144, 152
monoprint, 138
Morgan, Robert C., 148

nap, 78
Nares, James, 35, 70
Neal, Irene, 116
Neoplasticism, 16, 18
Newman, Barnett, 7, 63, 67, 153
Newton, Sir Isaac, 57
Noland, Kenneth, 14, 94
Nozkowski, Thomas, 14, 31, 68, 83, 111

oil paintings
 colors, 32–33
 meaning of hand in, 100
 protecting, 40
 rules of thumb for creating durable, 30, 32
 sizes, 38
 underpainting, 38
oil paints
 application tools, 35–36
 mediums for, 33–35
 for pouring, 118
 safety with, 40
 solvents, 33
 supports for, 36–38
 systems, 13
 thin and thick paint, 105
 ways to thicken, 75

Olitski, Jules, 139
Olitski, Lauren, 45, 118
Ortiz, Lori, 63

painting
 construction of, 100
 de Stijl and Suprematist, 95
 edges of, 89–90
 hard-edge, 109
 indirect method of, 107
 method of direct, 106–107
 motion while, 103
 pressure while, 103
 process, 80
 search for purity or
 essential in, 18
 speed while, 103
 styles of, 18
 techniques, 13
 three dimensions of, 8, 11
painting approaches
 chaos, 146, 147
 degree of human presence,
 104, 144–146
 obsession and re-
 evaluation, 146,
 148–149
 order, 146
 source material, 142, 144
Passlof, Pat, 68
Peacock, Graham, 47
perception
 cultural conditioning and
 color, 61–63
 depth, 24
 language and, 27
 of light and color, 27–28
Perry, Vicky, 37, 78, 135

perspective, 24
 linear or scientific, 92
 photography, invention of,
 18
pictorial space, 92
 conceptual space, 96, 99
 flat space, 95
 optical space, 95–96
 three-dimensional space,
 92, 95
pigments, 44, 61
 adjusting strength of, for
 acrylic paints, 50
 dispersed, 44–45
 dry, 45–46
 mixing, 51
plane, 64, 68–69
point, 64, 67
pointillism, 136
Pollock, Jackson, 7, 18, 89,
 96, 113, 142, 146
 and post-, 112, 115
Poons, Larry, 28, 115,
 148–149
Pop Art, 20, 134
Porter, Fairfield, 11
Postmodernism, 16, 19–21
 abstraction within, 20–21
poured paint, 112
 application, 118
 drying process for, 119–120
 preparation, 118
 and recovery, 119
 surface for, 115, 117
Pousette-Dart, Richard, 69
Prieto, Monique, 66, 89
primer, 38
primary colors, 28

Quaytman, Harvey, 27, 81

Rajchman, John, 21
Ratcliff, Carter, 16
recovery, 119
 with stain painting, 128
Reed, David, 96, 103, 108,
 117
referencing, 150, 152
reflectivity, 78
Renaissance, 18, 70, 92
resins, 34–35, 105
rhythm, 88–89
Richter, Gerhard, 15, 20,
 64, 152, 153
Riley, Bridget, 9, 44, 57,
 63, 99, 109, 148
Rodchenko, Alexander, 142
Row, David, 34, 130, 134
Rubin, William, 83

Sagerman, Rob, 137
Saltz, Jerry, 112
Sane, Justin, 149
Sapir, Edward, 15
scale, 80
 and composition, 82
 considerations of, 83
Schoenberg, Arnold, 91
Schon, Micky, 106
Scott, Bill, 25
scraping, 132, 135
scumble, 51, 107
sealing wash, 38
sgraffito, 77, 109
shape
 physical, 82–83
 simplicity of, 70

sizes, 38
solvents, 33, 40
stain painting, 122
 application, 126–128
 drying, 128
 preparation, 126
 recovery, 128
 supports for, 124–126
Stella, Frank, 13, 56, 83, 86,
 96, 149, 150, 151
Stephan, Gary, 127
stretcher bars, 36–37, 49, 83
supports
 acrylic paint, 49
 for oil paints, 36–38
 sizing flexible and rigid,
 for acrylic paint, 49
 for stain painting, 124–126
Surrealism, 18, 20, 146
symmetry, 89
 detecting, 24

Takenaga, Barbara, 26, 71
technique, 7, 13–14, 15
 beyond, 150, 152
 masking, 109–110
texture, 8, 11
 categories of, 72
 defining characteristics of,
 78
 gradient, 24
 impressed, 77–78
 nap, 78
 thin and thick paint, 75
Theosophists, 18
Timperio, Richard, 76
Tint, Francine, 53, 102, 136
Treachout, Terry, 70

underpainting, 38
 oil paint over acrylic, 40
university-prepared artists
 (UPAs), 149
Urso, Josette, 144

value, 57, 58–59, 105
van Leeuwen, Theo, 84
varnishes
 for acrylic paintings, 53
 for oil paintings, 40
vision. See also visual
 psychology
 culture and, 28–29
visual psychology. See also
 vision
 color perception, 27–28
 light perception, 27
 object recognition, 24, 26
 and physiology, 22
 space perception, 24
visual grouping, 24

Warhol, Andy, 63
Waterston, Darren, 85
Wehlte, Kurt, 33
Western art, 16
wet-in-wet method, 51,
 106–107
wet-on-dry method,
 106–107
Wilkin, Karen, 95
Wölfflin, Heinrich, 69
wood panels
 for acrylic paints, 49
 for oil paintings, 37–38

Yanoff, Arthur, 128